WHISTLER ON ART

WHISTLER ON ART

Selected Letters and Writings

1849–1903

of James McNeill Whistler

Edited and introduced by

NIGEL THORP

Fyfield *Books*

in Association with
The Centre for Whistler Studies
Glasgow University Library

First published in 1994 by
Carcanet Press Limited
208–212 Corn Exchange Buildings
Manchester M4 3BQ

in association with
The Centre for Whistler Studies
Glasgow University Library
Hillhead Street
Glasgow G12 8QE

A CIP catalogue record for this book
is available from the British Library
ISBN 1 85754 094 8

The publisher acknowledges financial assistance
from the Arts Council of Great Britain

The type-face and design of this book
are based on those chosen by Whistler
for *The Gentle Art of Making Enemies*

Set in New Caledonia by Koinonia, Manchester
Printed and bound in England by SRP Ltd, Exeter

PREFACE

The selection of correspondence presented here will greatly enhance the appreciation and enjoyment of Whistler's work. In the University of Glasgow it is our privilege to have on display not only some of his finest paintings, but also the palettes and brushes which he used. It is clear from this volume that Whistler painted also in words, and that his pen was just as active as his brush and his needle.

Whistler's surviving correspondence numbers over ten thousand letters, more than half of them written by Whistler himself. I am pleased to see the letters now being collected together in the Centre for Whistler Studies, and to welcome the cooperation of the Freer Gallery of Art, Washington, in working towards their publication. The production of a work of this size will take time, but I welcome this chance to enjoy a foretaste of its riches.

W. Kerr Fraser
Principal, University of Glasgow

ACKNOWLEDGEMENTS

Research towards an edition of Whistler's correspondence has been supported with grants from the British Academy and the John Sloan Memorial Foundation. I am indebted to the Center for Advanced Studies in the Visual Arts, National Gallery of Art, Washington, for a Paul Mellon Visiting Senior Fellowship to conduct research in Washington; and, above all, to the University of Glasgow, for setting up the Centre for Whistler Studies and for supporting work towards the edition.

My warmest thanks go to my colleagues Martin Hopkinson, Margaret MacDonald, Dr Linda Merrill, and Catherine Mooney, for their ready help over the present selection, and also to Dr Robyn Marsack, who provided the impetus to make it happen.

I am grateful to the following for permission to reproduce letters and texts in their care:

Freer Gallery of Art: 50, 55, 56, 63, 73.

Glasgow University Library: 1-4, 6, 7, 9, 10, 12, 16-27, 29, 30, 32, 35-39, 41-47, 51, 53, 54, 60-61, 64, 65, 67, 71, 72, 74, 75.

Harry Ransom Humanities Research Center, University of Texas at Austin: 70.

Library of Congress, Pennell Whistler Collection: 8, 11, 13, 14, 33, 48, 49, 52, 57-59, 66.

Library of Congress, Rosenwald Collection: 31, 34.

British Museum: 40.

Parkin Gallery: 62.

Pierpont Morgan Library, New York: 28.

Tate Gallery Archives: 68, 69.

Wadsworth Athenaeum, Hartford, Connecticut: 5.

Walters Art Gallery, Baltimore: 15.

CONTENTS

ILLUSTRATIONS

(between pages 8 and 9)

1. *James McNeill Whistler*. Photograph by H.S. Mendelssohn, South Kensington, c. 1886. – GUL PH1/107.
2. James McNeill Whistler, *The Doorway*. Etching, 1879-80.
3. James McNeill Whistler, *La Belle Jardinière*. Lithograph, 1894.
4. James McNeill Whistler, *Variations in Flesh Colour and Green; The Balcony*. Oil, 1865. (Freer Gallery of Art, Washington) from Whistler portfolio *Nocturnes – Marines – Chevalet Pieces*, 1893. – GUL PH5/4/7.
5. James McNeill Whistler, *Arrangement in Brown and Black: Portrait of Miss Rosa Corder*. Oil, 1878. (Frick Collection, New York) from Whistler portfolio *Nocturnes – Marines – Chevalet Pieces*, 1893. – GUL PH5/4/8.
6. James McNeill Whistler, Letter (last page) to Marcus Huish, The Fine Art Society, c.26 January 1880. – GUL LB3/8.
7. James McNeill Whistler, *Harmony in Blue and Gold. The Peacock Room*. 1877. – GUL, Whistler 246.
8. James McNeill Whistler, *Etchings and Drypoints, Venice, Second Series*. Exhibition catalogue, The Fine Art Society, London, 1883. – GUL EC1883.1.
9. *Anna Matilda Whistler*. Photograph by F. Weisbrod, Frankfurt, 1864–65.– GUL PH1.56.

All illustrations are from the University of Glasgow: no. 1 and nos 4–9 from Glasgow University Library, Whistler Collection (GUL); nos 2 and 3 from the Hunterian Art Gallery.

The butterfly. Whistler developed his butterfly monogram in the late 1860s from the pattern of his initials: he used it as his signature on his works as well as in his letters and publications. The butterflies in the text are original to each item and are representative of the evolution of the design. Where the drawings cannot be reproduced, their occurrence is marked by the word '*[butterfly]*'.

INTRODUCTION

'Everything that Mr Whistler has written about painting deserves to be taken seriously.'

Arthur Symons's view of James McNeill Whistler (1834-1903) would have surprised the public of Whistler's early and middle years. In early 1903, when the artist, after several illnesses, had only months to live, Symons was reviewing a history of nine-teenth-century art. Whistler's reputation was by then secure, for the general tide of critical opinion had flowed in his favour during the last decade of his life. Symons knew, however, that he was addressing a public that had had long experience of Whistler's sallies into print on matters that in their view had more to do with the music-hall than with Art, and it was still necessary to remind them that he was a serious painter.

Whistler attracted public attention irresistibly and inevitably. His witticisms, his dandyish presence, his colourful activities and his repeated lawsuits were guaranteed regular attention in the press. His letters to editors appeared for forty years; his exhibition catalogues, in their brown-paper wrappers, were notorious for the amusement that they gave the public at the expense of the critics; and in 1890 he published *The Gentle Art of Making Enemies*, in which he collected letters, reviews, legal argument, comment and exposition on art that had appeared over the past decades. No other artist conducted a personal campaign in this way. He presented himself as the 'gentle Master of all that is flippant and fine in Art', and the raillery bemused public and patrons alike.

Whistler was celebrated for his etchings from an early age: the controversies centred on his career as a painter. In the early 1860s he saw works that he prized being rejected by the Royal Academy and the Paris Salon. He came under the spell of Japanese art when there was no tradition of its appreciation in

England. In the 1870s he turned to painting impressions of night – his 'Nocturnes' – in conflict with the Victorian taste for moral narratives, and this led increasingly to him being seen as an eccentric who sketched portraits and phantasmagorical scenes in uncontrolled daubs of paint, beyond public comprehension. The notorious Whistler-Ruskin trial of 1878, despite being won by Whistler, set the seal on this view. He continued to be admired for his graphic work, but it was not until the early 1890s that his stature as a painter changed. In 1891, the Corporation of Glasgow bought his portrait of Thomas Carlyle, and the French Government bought his portrait of his mother; his exhibition at the Goupil Gallery the following year was a triumphant success. The art world, and the public, were slowly learning to appreciate his painting and share a view that had previously been held by a mere handful of artists and collectors.

Whistler knew that he was an innovator, far in advance of the public understanding of art. Indeed, he doubted whether the public at large could be expected to share in the appreciation of what demanded long study and the cultivation of aesthetic sensibility. None the less, he repeatedly set out his views on the general truths of art, in the hope that some, at least, could begin to understand them. 'Art,' he said, 'is the *science* of the beautiful': it is not concerned with narrative, or sentiment, but with the harmonious treatment of line, colour and form.

He accompanied his views with sharp attacks on the art of his time, as he sought to goad people into opening their minds as well as their eyes, to make them look *at* a picture, rather than *through* it. As a result, he came into conflict with the daily world of other artists, critics and dealers, and their simple requirement of making a living by catering to contemporary Victorian tastes: Whistler, equally simply, did not see their need to do so.

The publications that followed his death in 1903 dwelt on Whistler the showman, with little informed discussion of his art.

The French critic Théodore Duret, who had known Whistler well and was one of the few both to understand his art and to write about it with intelligent sympathy, could only exclaim with despair at the way in which the English-speaking world seemed to be interested only in Whistler the person. Whistler's influence, however, was considerable; his insistence, in particular, that art should be independent of all non-artistic concerns, has led to his being seen as a precursor of the abstract art of the twentieth century.

Although public interest in Whistler waned between the two World Wars, a number of important exhibitions and publications in the last thirty years have brought his work back to public attention. These began with the Arts Council exhibition in 1960 and have included the catalogue raisonné of his paintings and extensive studies of his etchings and lithographs. With the building of the Huntorian Art Gallery at the University of Glasgow, there is now better access to the largest collection in Europe of Whistler's work; and the re-opening of the Freer Gallery of Art in Washington in 1993, after extensive renovation which included the conservation of the famous Peacock Room, has brought the chief collection of his work in America back into public view. The momentum is being kept up by the publication of the catalogue raisonné of Whistler's drawings, pastels and watercolours, and by the largest exhibition of Whistler's work since the Memorial Exhibition of 1905, which is being held in London, Paris and Washington in 1994-5. The publication of his extensive correspondence, of which the present volume gives a foretaste, is being undertaken by the University of Glasgow and the Freer Gallery of Art. This will contribute further towards a fuller understanding of Whistler's work and of his place in the artistic history of the nineteenth and twentieth centuries.

Whistler was an American, born in Lowell, Massachussetts, in 1834, and he retained a strong sense of identity with the land of

his birth. He lived there, however, only for some fifteen years, in his youth. From 1843 to 1849 he was in Europe, chiefly in St Petersburg, where his father George Washington Whistler was supervising the construction of railways in Russia for the Tsar. For holidays the Whistlers went to Britain, where they had family ties; when the Russian winters proved too severe for James Whistler's constitution, he was sent to live in London with his sister Deborah and her husband Francis Seymour Haden. In both cities he was captivated by art, and at the age of fifteen he wrote to tell his father of his wish to become an artist (No. 1). Within months, however, Major Whistler's death from cholera and overwork brought the family's luxurious residence in St Petersburg to an end, and in the summer of 1849 his widow took James and his brother Willie back to a simple country life in Connecticut. Whistler's passion for art survived his subsequent education at the U.S. Military Academy at West Point, and in 1855 he left America once more, to study art in Europe. Later in his life he spoke of wishing to visit America again, but with the exception of a brief stop during a journey to South America in 1866 – an episode in his career that has still to be explained – he never returned.

Once back in Europe, Whistler lived mainly in Paris, studying and copying pictures in the Louvre. He frequently crossed over to England, where in 1857 he visited the Art Treasures Exhibition in Manchester and was able to study numbers of works by Velàzquez. His great admiration for the Spanish court painter influenced his own painting throughout his life, particularly in his portraits, and he kept study photographs of work by Velàzquez in his studio. He also developed his interest in etching, and it was a set of twelve etchings known as *The French Set*, many of them made during an expedition to Alsace and the Rhineland in 1858 (No. 3), that first brought his work to public attention. The spontaneity of these street scenes and portraits comes from Whistler's practice of making his etchings directly on the plate, rather than

transferring them from sketchbooks. They also show his admiration for Rembrandt and other Dutch masters, which stayed with him throughout his life. The following year, 1859, he moved to London to work on a second set of etchings, *The Thames Set,* in which he concentrated on detailed views of decaying riverside buildings.

In his first years in France Whistler had been much impressed by the powerful realism of the painter Gustave Courbet. He shared this view with his friends Henri Fantin-Latour and Alphonse Legros, and the three artists created an informal 'Société des Trois' for mutual encouragement. Whistler's paintings of the late 1850s and early 1860s show much of Courbet's influence, with landscapes painted *en plein air* and subjects taken from the life of the street.

His ambition for his own work to be seen in the most prominent public exhibitions of the day led him to submit paintings to the Royal Academy in London and the Salon in Paris. The first paintings that he exhibited at the Royal Academy, including *At the Piano* in 1860, and *The Coast of Brittany* in 1862, were well received. In the early 1860s, Whistler met Dante Gabriel Rossetti and others of the Pre-Raphaelite circle in London, but his view of art remained separate from theirs. Rejecting Courbet's realism, he developed new interests, particularly through his study of Japanese art (No. 9). His letters to Fantin record his progress in this period, sometimes painfully slow, as well as his enthusiasm for his friend's work (Nos 8, 11). His appreciation of the graceful Greek terracotta figures from Tanagra, which were also a strong influence on another painter friend, Albert Moore, led him still further away from Courbet (No. 12).

The Japanese preference for tonal harmonies, together with the flatness of Japanese perspective, became established among the underlying principles of his work. This exotic element was emphasized by his inclusion in his paintings of this period of Chinese and Japanese decorative motifs, such as costumes and fans, and blue and white china taken from his own collection. As

his work developed, however, he encountered increasing opposi-
tion. His *White Girl*, for instance, was rejected by the Royal
Academy in 1862 (Nos 5, 6), and also by the Salon in 1863,
though it went on to become one of the centrepieces of the Salon
des Refusés later that year in Paris. His portrait of his mother,
painted after she had left America to live with her artist son in
Chelsea, was only accepted by the Academy in 1872 after the
portrait painter Sir William Boxall (see Nos 1, 2) had threatened
to resign. By 1873 Whistler stopped submitting to the Academy
altogether. His reputation was to be made, not by being part of an
existing school or tradition, but by being, characteristically, him-
self. In the teeth of the high Victorian taste for over-abundant
detail and for moral narratives, he stood for a simple and aes-
thetic approach to all matters of art and design, which extended
beyond painting and graphic art to the design of interiors, furniture,
books, inscriptions, and even items of daily use such as a parasol.

Whistler's most important patron in his early years was F.R.
Leyland, a Liverpool ship-owner and a patron also of the Pre-
Raphaelites. Sharing Whistler's enthusiasm for blue and white
china, Leyland commissioned the architect Thomas Jeckyll to re-
design the dining room of his London house, in Prince's Gate, to
display his own collection. Having bought Whistler's *Princesse du
Pays de la Porcelaine* to hang in the room, Leyland allowed
Whistler to change the decoration of the room in order to accom-
modate it; this resulted in Whistler's complete transformation of
the room into the celebrated Peacock Room (No. 16). A dispute
over the cost of the work, however, caused Whistler to break off
his relations with Leyland.

Whistler came increasingly to emphasize the formal and
decorative aspect of his work in all mediums. His search for
atmosphere led to his night-time scenes, in particular those of the
Thames, which he called *Nocturnes* (No. 14). This term appealed
to him on account of its musical overtones, and it underlined his

view that it was not the business of painting to be concerned with narrative or historical detail (No. 18). For Whistler, a painting should be appreciated on its own terms, as an arrangement of colours and lines and shapes. On occasion, he extended the idea of arrangement to include the frame as well (No. 15), and subsequently also to the design of an entire exhibition.

Whistler's wit, his dandyism, and his regular appearance in the newspapers, gave him unusual prominence as a Society figure. In the eyes of many, this public profile detracted from serious consideration of him as an artist. For much of his career he was widely regarded as an eccentric, and critics, as well as the public, found his newer paintings impossible to understand. The *Nocturne in Black and Gold. The Falling Rocket* was seized on by the influential critic John Ruskin as an example of 'wilful imposture'. Ruskin expected to see paintings give evidence of careful labour as well as a recognizable subject, and though he had championed Turner's impressionistic work, he derided Whistler in print as a 'coxcomb'. Whistler, seeing his professional reputation to be at stake, sued Ruskin for libel – and won (Nos 20, 21).

Ruskin had attacked Whistler for asking the outrageous sum of 200 guineas for a work that was completed in two days. Whistler's rejoinder, during the trial, was that the sum was asked not for the labour of those two days, but for the knowledge of a lifetime. Ironically enough, Whistler seldom achieved the result he desired in his painting with only two or three sessions. He could demand of his sitters to endure fifty, sixty and even a hundred sittings. Rather than the £1000 damages that he sought from Ruskin, he was awarded only a symbolical farthing. His legal costs, coming on top of the expenses of building a new studio house, the White House, in Tite Street, Chelsea (No. 19), spelt financial ruin, and in 1879 he was declared bankrupt.

His first steps back to solvency were aided by a commission from the Fine Art Society for a set of etchings of Venice. The poetic

visions that he produced of the city in 1880 are some of his most celebrated works, with an endless modulation of tone and texture in each plate (No. 22). In addition, the pastels that he made there show a more energetic use of colour than any of his other work of the time (No. 23). On his return to London, the etchings and pastels were exhibited at the Fine Art Society to wide acclaim.

While painting was hotly discussed in France, Whistler's fondness for polemics did not find a ready audience in England. In the Ruskin trial, he had looked for support of his position from English artists and found them wanting. His philosophy of art was set out in his *Ten O'Clock* lecture in 1885, one of what came to be a series of publications in which he expounded his views and challenged the competence of art critics who had no experience of painting (Nos 30, 32, 33, 35, 36). Although a small group of followers came to be established around the 'Master' in the 1880s, his distance from the art establishment of the day only increased. His work was seen in Sir Coutts Lindsay's new Grosvenor Gallery, and in occasional one-man shows, such as those at the Fine Art Society and the Dowdeswell Galleries in 1883 and 1886 (Nos 28, 34). Even when elected President of the Society of British Artists, in 1886, his reforming zeal failed to win over the majority opinion and, after two years, he was forced out of office (Nos 39, 41).

From the mid-1880s, and particularly after his marriage in 1888 to Beatrix Godwin, he took up again an earlier interest in lithography, under the guidance of the printer Thomas Way (Nos 55 – 58). None the less, London at this time was losing its appeal for Whistler, who had come to the end of his patience with British art (No. 46). Although he was a founder member, in 1891, of the Chelsea Arts Club, he and his wife established themselves in Paris, where he had many friends in artistic circles. The honour of having the portrait of his mother bought in 1891 by the French Government, and his appointment to the Légion d'Honneur, secured his entry into the highest social circles (No. 47).

At the same time, in early 1892, Whistler held the most success-
ful exhibition of his painting career in London. The critics were
routed, the public had been won over, and his lifelong views were
vindicated. One result of the exhibition was that prices for his work
increased dramatically, and Whistler was galled to see many of the
English owners sell them, profiting enormously from the reputa-
tion that had taken him so long to establish (Nos 50, 51). This only
confirmed his view that English collectors were tradesmen rather
than connoisseurs, and he thereafter did all that he could to make
sure that his work would not remain in England (No. 60).

Beatrix Whistler was herself an artist, and the years of their
marriage were in personal terms the happiest of Whistler's life
(No. 61). His work at the time was becoming more intimate in
scale, though the increasing numbers of his portrait commissions
included many full-lengths. The early death of his wife in 1896
from cancer left Whistler distraught (No. 63).

He continued with mostly small-scale works, taking up shop
fronts and seascapes again. He also championed the cause of
international art by accepting the Presidency of the International
Society of Sculptors, Painters, and Gravers, which introduced
many foreign artists to London at the turn of the century (Nos
67-69). He had the added satisfaction of seeing the foremost
collection of his own work being assembled by the American col-
lector, Charles Lang Freer, who formed the intention of making
the collection a permanent memorial to his art (No. 73). Freer
donated his entire collection to the Smithsonian Institution,
Washington, where it is now housed in the Freer Gallery of Art.

In his last years Whistler also gave instruction at the Académie
Carmen in Paris, so named for being established by a former model,
Carmen Rossi. Students flocked there from America and from
across Europe, but Whistler, increasingly unwell, could only rarely
be present, and early in 1901 the Académie closed (No. 74).

His last honour was given to him only three months before he

died, with the award of an Honorary Doctorate from the University of Glasgow (No. 75). Although he had visited Glasgow as a boy, in 1849, his contact with the city developed as a result of the enthusiasm for his work from the late 1870s shown by the group of Scottish artists around John Lavery and E.A. Walton, both of whom became his friends. In 1891, when Whistler had become one of the most influential artists of his time, they urged the Corporation of Glasgow to buy his portrait of the Scottish historian and philosopher Thomas Carlyle – the first of his paintings to enter a public collection. Scottish collectors such as J.J. Cowan and William Burrell had bought his work without then selling it to make a profit, and while Whistler instructed his dealers not to sell to English collectors, he was happy to see his paintings go to Scotland. After his death, his artistic estate, with all his papers and correspondence, was presented by his family to the University of Glasgow, where his work now forms the central collection of the Hunterian Art Gallery. In recognition of the international importance of the Whistler collections, the University has created the Centre for Whistler Studies.

Despite his lightness of tone in public, there is no doubting Whistler's seriousness of purpose as an artist. His private correspondence shows the artist in his day-to-day preoccupations with individual works, his wrestling with technique, and his eagerness to experiment, as well as his response to the art world at large. He wrote extensively to his family, to friends, to dealers and patrons: some 5500 of his letters have been recorded so far, with more still coming to light, and there are few of them that have no bearing on his art.

Whistler's executrix, his sister-in-law Rosalind Birnie Philip, refused to allow the publication of his correspondence during her lifetime. The present selection of Whistler's writings includes numbers of his letters alongside his chief publications, in order to show the range of his concerns in his own words. The personal

nature of many of the letters means that matters beyond his art appear as well, but in order to preserve their context the letters have been given in full: an exception has been made only in the case of the two letters written by Whistler's mother, which are included here because of the close view they give of Whistler at work, but which go on to discuss family matters that are beyond the scope of the selection. The letters and texts are arranged chronologically, to give some sense of the progression of Whistler's career: as a collection, however, they can do no more than give an impression of the scope of his artistic concerns at any moment. They cover the techniques of painting, etching, and lithography, his choice of his titles, advice on composition, instructions for interior decoration, the role of the patron, the proper conduct of a dealer, exhibition and book design, and the right of the artist to decide when a work is complete. Chiefly, however, they show his complete devotion to his art, and his unending search for perfection.

Note on the texts
The published letters reproduce the text of the original as closely as possible, both in spelling and in punctuation. Whistler's sometimes erratic spelling of English reveals the influence of French, which he spoke fluently; his writing of French is not punctiliously correct and has also been left unaltered. He often wrote in great haste, and single letters or complete words were on occasion left out: where their absence is an obstacle to understanding, they have been inserted in square brackets. The occasional repetition of a single word is the only correction to have been made silently. The date forms at the head of the letters have been regularized for convenience. Passages omitted from the two letters written by Anna Whistler are indicated by suspension points within square brackets: [...]. Suspension points in Whistler's letters are given as in the original. Not all the originals have yet been traced, however; references to the sources are given in the notes.

SELECTED PUBLICATIONS

Barbier, Carl, ed., *Correspondance Mallarmé-Whistler*. Paris, 1964.

Berman, Avis, *James McNeill Whistler*. New York, 1993.

Curry, David Park, *James McNeill Whistler at the Freer Gallery of Art*, New York and London, 1984.

Fine, Ruth E., ed., 'James McNeill Whistler. A Re-examination.' *Studies in the History of Art*, vol. 19, Washington, 1987.

Getscher, Robert H., and Paul G. Marks, *James McNeill Whistler and John Singer Sargent: Two Annotated Bibliographies*. New York, 1986.

Hopkinson, Martin J., *James McNeill Whistler at the Hunterian Art Gallery*, Glasgow, 1990.

Kennedy, Edward G., *The Etched Work of Whistler*. San Francisco, 1978.

Kennedy, Edward G., *The Lithographs by Whistler*. New York, 1914.

Laver, James, *Whistler*. London, 1930.

Lawton, Thomas, and Linda Merrill, *Freer. A Legacy of Art*. New York, 1993.

Lochnan, Katharine A., *The Etchings of James McNeill Whistler*, New Haven and London, 1984.

Mahey, John A., ed., 'The Letters of James McNeill Whistler to George A. Lucas.' *The Art Bulletin*, vol. 49, no. 3, September 1967, pp. 247-57.

MacDonald, Margaret, and Joy Newton, 'Correspondence Duret-Whistler.' *Gazette des Beaux-Arts*, vol. 129, November 1987, pp. 150-64.

Merrill, Linda, *A Pot of Paint. Aesthetics on Trial in Whistler v. Ruskin*. Washington and London, 1992.

Newton, Joy, ed., *La chauve-souris et le papillon. Corres-pondance Montesquiou-Whistler*. Glasgow, 1990.

Pennell, Elizabeth and Joseph, *The Life of James McNeill Whistler*. London and Philadelphia, 1908.

Pennell, Elizabeth and Joseph, *The Whistler Journal*. Philadelphia, 1921.

Spencer, Robin, *Whistler: a Retrospective*. New York, 1989.

Sutton, Denys, *Nocturne. The Art of James McNeill Whistler*. London, 1963.

Taylor, Hilary, *James McNeill Whistler*. London, 1978.

Whistler, James McNeill, *The Gentle Art of Making Enemies*. London, 1890, 1892.

Young, Andrew McLaren, and Margaret MacDonald, Robin Spencer, Hamish Miles, *The Paintings of James McNeill Whistler*. New Haven and London, 1980.

1. To his father, George Washington Whistler.
His wish to be a painter.

62 Sloane Street [London]
26 January 1849

My dear Father, I recieved a parcel yesterday from Capt. Kruger, Hull, which you sent me from St Petersburg, containing the Books and Skates, for which I thank you very much, and I am particularly glad to have recieved Sir Joshua Reynolds's discourses. How do you like Mr Maxwell's work, Father? I myself have only had a glance at it yet but daresay it is very interesting though Sis says some parts are written in rather a bad taste. Well, my portrait is nearly finished and I am quite sure you will be better pleased with it, than any that has yet been taken. Seymour, Sis and I went to see it the other day: Seymour was very much pleased with it; it is very like and a very fine picture, Mr Boxall is a beautiful Colourist, and is one of the first Artists. The background in the picture is very fine, such a warm tone, very like one of Gainsboroughs. It has not a *dry* opaque look, but a beautiful creamy surface, and looks so rich! I wonder what Karitzky would say to it? Of course he will see it. Do you see him often now? I hope he is quite well; give my love to him.

I wish, dear Father, that both you and Karitzky could have gone through the Vernon Galery together! You would have been so delighted! but I told you about that in one of my former letters. – We recieved letters from St Petersburg last Saturday, but none have come from home this week! Mother writes you had all been to Mr Winans' for the Christmas fête. Mr W– seems to have been very Magnificent! bracelets etc. but I did not exactly understand what Willy's presents were? How did he enjoy it? he is better now, I hope, no longer any Rheumatism. But you dont say anything more about sending him to England. My Holidays have

finished and I set to work again on Monday. Tell Willie he must be sure to write to me, for I have not recieved a letter from him for a *very* long while. – The baby was vaccinated the other day and Mama says she bore it very well, giving a good reason for the same, viz: she was asleep during the performance.

Saturday evening 27th. I have just come home from a party where they had a Conjuror; I dare say Willy would have enjoyed his tricks, some of which were very nicely done. Captain and Miss Parland called yesterday, she seemed to be anxious about the little Morgans, who, she said, had the Measles, I hope they are better, and that Willy will not forget to give my love to them. How do you like the new Draftsman that Karitzky recommended? So Haden-skough has turned out an ungrateful thief – fancy a man asking for money to bury his Child that was not dead! What has become of him? have you heard anything of him since he left? but of course he has taken to drinking again, and has ruined himself. –

Has the American Minister been presented to His Majesty yet? – Dr Boot spoke to me about him, when I was there one day, he seemed that he knew all about his behav[i]our, and I believe he mentioned your name, so I suppose you wrote to him. I think it is a great shame they should send out such a man as he is, I suppose the English hold him up as a specimen and say "that's American"! – Do you think that the American Government will work the Mines in California? I should not think it would look on peace-ably and let everyone run off with the Gold. You know there is not only Gold, but *Platinum*, Silver and Iron! I suppose the Irish will be running over in flocks to California! I think it would be a capital thing for us all to go and set[t]le down [in] California, when we go home again! I wish, dear Father, you would tell me in your next all about the Treaty of Peace with Mexico; was not California ceeded to the United States on condition of their paying the expenses of the war? – And what are the Pennsylvania Bonds? –

Have you been to any Exhibition at the Academy lately? I wish

you would tell me all about it (if you have) in your next. Did I mention, in my last, that Mr Boxall is going to take me to Hampton Court, where Raphael's Cartoons are? I shall tell you what I think of them then. – Fancy being so near the works of the greatest Artist that ever was! I wish you could go with me! and Karitzky too, how much we should enjoy it! I hope, dear Father, you will not object to my choice, viz: a painter, for I wish to be one so *very* much and I dont see why I should not, many others have done so before. I hope you will say "*Yes*" in your next, – and that dear Mother will not object to it. –

And now, dear Father, I must wish you

Goodbye

Give my love to dear Mother and Willie and tell her I shall write to her next.

Remember me to all friends, don't forget Dr Rogers and Karitzky.

For/
My Father
Major Whistler
St Petersburg

2. To his mother, Anna Matilda Whistler.
Art education in London.

62 Sloane Street [London]
17 March 1849

My dear Mother,

I send you a little sketch of a Young Sweep – one who cleans the crossings in the Streets: we were preparing some sketches for a Scrap Book and this is one of them, but as I can easily make another copy, and thinking you might perhaps like to have one, I enclose this. Thank Will for his nice letter to me, and tell him I shall answer it after Father's.

You know I have lately attended some lectures on Painting by Mr Leslie at the Royal Academy, well I like them very much and hope to go next Thursday again to hear the last one. One evening he gave a kind of history of British Art; he spoke of Reynolds, of Hogarth, of Stothard and of Bewick's Wood cuts. In speaking of Hogarth, he described the Marriage piece in "The Rake's Progress" (you can see the picture in Father's "Works of Hogarth") the scene is in a little old church, and, as Mr Leslie said, any common Genius might make cracks and cobwebs about the walls, but *Hogarth* made a crack through the *Commandments* and a cobweb over the hole of the *Charity box*!! Mr Leslie showed us the first sketch of West's "Death on the Pale horse;" it is perhaps a fine thing but of Death himself, I think Mr L– said, West might have made something more sublime, and I think so too. – Do you know that Seymour has given me such a nice present: a 10s Print from one of Fuseli's works called "The Lazar House," it is taken from Milton and is really a fine thing tho' much exaggerated. –

How you would like to see the Babie, dear Mother, her hair has grown and is going to be of a pretty flaxen colour and Sis intends it to be curly, so that she is to be the pretty Miss Haden. I began

a sketch of her which Seymour finished and made really very like her; when I have done a nice likeness all by myself, I shall send it to St Petersburg, that you may form some faint idea of little Annie before you see her, for I hope that you and Willie, at least, if not dear Father, may be able to come over to England next summer. And so Father has another appointment: one at Cronstadt! well I wonder what they will do without him, when we all go home to America? —

Monday 19th. – Mr Eastwick dined with us yesterday – he is going to leave on Friday and will take any sketches I have ready to send by him, to St Petersburg; I also hope to send a letter by him to Edward. I may perhaps go with Mr Eastwick on Wednesday next to Mr Boxall's that he may report my likeness at *Home* and I am sure he *must* think it very good. –

We have just finished dinner, dear Mother, and while Seymour is reading his paper, and Mr Lloyd his book, Sis is enjoying "The Babie." You should just hear Annie talk; sometimes she comes out with such a Ghaie —— Since I have been writing this she began a short conversation; but I cannot write her language, but I can assure you it is very poetical – musical at least – By the by does Willy continue his music lessons with the German Lady? –

I am reading Tyhlers Universal History and will soon have finished Mrs Jameson History of the early Italian Painters, a small work in two Volumes and being one of the series of Knights Weekly Volume. It is a present from Mr Boxall and is very interesting.

Tuesday 20th. My letter must now go, dear Mother so I have only time to say Goodbye – Give my love to dear Father and Willie and remember me to all friends – Sis thinks I had better keep the sketch and send all together by Mr Eastwick – I must tell you before I let this go of another beautiful present from Seymour, two beautiful pair of pantaloons! But I must now go to my reading with Sis – I shall soon write again – Your affectionate Son

Jemie

3. To his sister, Deborah Haden.
Adventures in Alsace and the Rhineland.

[Paris]
[October 1858]

[sheet missing]
How, after having hopelessly waited for an answer to my letter, during ten long days, Erneste and I made up our minds (and our sacs) for the worst– how we, or rather I, explained to Mynherr Schmitz, that there was no use putting off any longer, – how Mynherr Schmitz suffered severely from doubts as to the value of our property, – how we nearly wept "tears of anguish" on being obliged to trust the same in his coarse unappreciating hands – how we sorrowfully took leave of our host and our collection of drawings, the result of so much happy hearty work – of my series of etchings – my chefs d'oeuvres upon which I had built so bright and so certain a future – how we set off with nothing but a blouse on our backs – with two groschens in my pocket = four sous, which Lina, the pretty little servant girl had the evening before in a sudden and unexpected gush of sympathy thrust into my hand and immediately afterwards burst into tears crying out Ich bin auch eine Fremdin meine Herren ich bin eine Coblentzerin – how we then commenced our journey on foot from Cologne to Aix la Chappelle – only 9 1/4 German meilen, i.e. nearly 50 English miles!

How the real honest hard miseries of this pilgrimage would have effaced all poetry and romance from any minds but our own, I now really think *marvellously* gum-elastic ones! how we walked until *I actually could not* make one *step* more – how the first night I made a portrait in pencil (we happily had saved a sheet of paper) for a plate of soup for Erneste and myself – how we slept in straw and were thankful – how my wretched Parisian

shoes got rid of a portion of their soles and a great part of their upper leather – how I remembered the good Samaritan and the pouring of oil in wounds, how I went thro' agonies and accepted gratefully a piece of "chandelle" from a kind hearted comb-maker instead of the Jewish recipe – how we walked 22 miles one day, and then I was unable to move out of the way of a mob of hooting Prussian children, such as the prophet Elijah would certainly have set all the wolves in his power upon, how we were weary and miserable, – how I *for a glass of milk* had to make the *portrait* of one of my young tormenters – the ugly son of the woman who took our *only two groschen* for a bed which she made on the floor with an armful of straw, and the pillow a chair overturned, which was violently withdrawn the next morning at dawn so that the consequent bang of the head on the ground might awaken us – how for another portrait we had a piece of black *bread* and an egg the white of which went to heal my bruised feet – how sunnier moments were also on our road – how we came upon a Dorf where there was a fair – how I there made portraits of "butchers and bakers and candlestickmakers" for *five* groschen *a piece* that is a little more than *fourpence*!!

What would George Chapman have said to such an utter disregard for the dignity of art! and yet I did my best – and *each one* of the *eighteen portraits* was a drawing such as Seymour would have been pleased to see come from my hand! How at last we reached Aix la Chappelle, where Mr French (who had been absent on a Summer's tour and had therefore not received my letter from Cologne) received us in the most kind and gentlemanly manner and lent me 50 francs – How the French Consul at Liege advanced Erneste 20 more with which sum we finally got to Paris this morning at 4 o'clock, worn out and yet in marvellous health – how my friend charged with the forwarding of my letters in my absence explained that he had actually sent my letter from George to Rotterdam, where it *now is*!! and consequently the

whole fault of our misfortunes is in dreadful negligence of the Post Officers of that city –

All this and more my dear little Sis I will tell you about in detail another time. We have clean consciences and can hold up our heads, for during this extraordinary journey we worked very hard – have made more progress than we could have made otherwise in three times the number of months – Erneste has nearly 100 [...]

[sheet missing]

[...] enfin tout ce que vous voudrez – et puis voilllaa! Shall I say that the man who gardes the life of his Emperor understood the neatness of my argument

My dear little Sis, I only wish I had sent you this a couple of weeks ago instead of putting it away to finish the "next day" – but what will you? I have scarely had a moment since my return – By the way everybody believed me dead and burried! poor Miller had really been very sad and my entré at the Cafe Voltaire on Sunday was of the most triumphant – Comment! tu n'es pas mort! pas mort! C'est toi c'est lui! "Oui c'est toi!" "C'est moi" "C'est lui même" Ah quelle blague attroce Figure toi mon cher! etc. Un café pour le petit Americain – Comment *un* café! Garçon *des* cafés pour notre Americain car il n'est pas mort Larifila! fla! fla!" "Non c'est qu'il dort" "Pour le reveiller trinquons nos verres Pour le reveiller trinquons encore!" Et heu mon cher et ces Anglais hein! leur peinture contes nous ça un peu etc. [...]

[sheet missing]

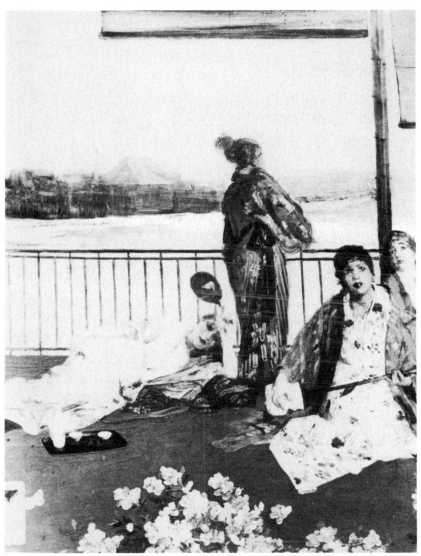

4. James McNeill Whistler. *Variations in Flesh Colour and Green: The Balcony.*
Oil. 1865.

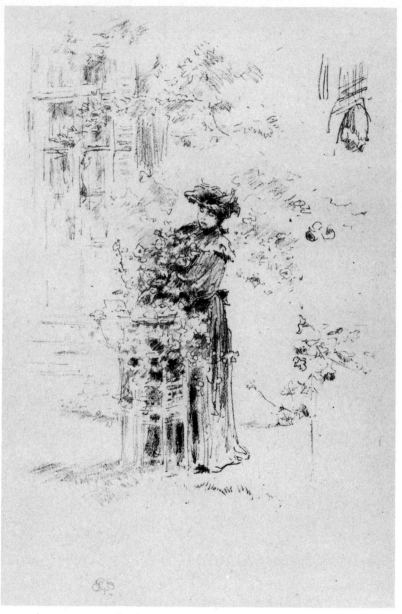

3. James McNeill Whistler. *La Belle Jardinière*. Lithograph, 1894.

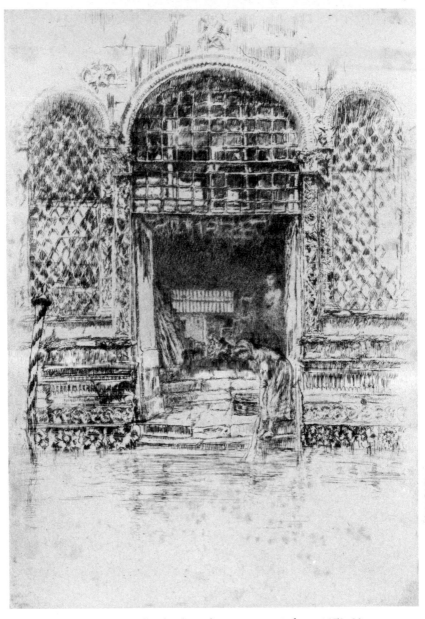

2. James McNeill Whistler. *The Doorway*. Etching, 1879–80.

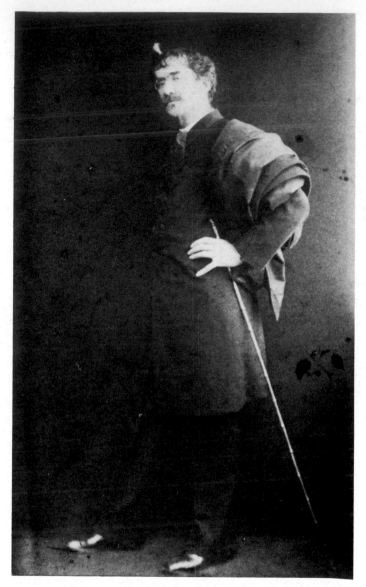

1. *James McNeill Whistler.* Photograph by H.S. Mendelssohn, c. 1886.

5. James McNeill Whistler. *Arrangement in Brown and Black: Portrait of Miss Rosa Corder.* Oil, 1878.

I am frozen - and have been for months - and you can't hold a needle with numbed fingers - and beautiful work cannot be finished in bitterly spongy - also you are starving - or shall be soon - for it wont be - my term of - you that I should have made my money but there long -

Upon had better send me fifty pounds at once and trust to these which will put us all right - If I come back with pictures drawings and etchings then exposition will have succeeded beyond all hope and will then will go to increase the value of the other -

Please write - and address Café Florian -

Very sincerely Yours

J McN. Whistler -

Place St. Marc. Venice. -

The copy I had intended for - mention without ceremony -

Send for Marcelle and make him my letter -

6. James McNeill Whistler, Letter (last page) to Marcus Huish, The Fine Art Society, c. 26 January 1880. [see No. 22]

20.—LITTLE VENICE.

"The Little Venice is one of the slightest of the series."—*St. James' Gazette.*

"In the Little Venice and Little Lagoon Mr. Whistler has attempted to convey impressions by lines far too few for his purpose."—*Daily News.*

"Our river is naturally full of effects in *black and white and bistre*. Venetian skies and marbles have colour you cannot suggest with a point and some printer's ink."—*Daily News.*

"It is not the Venice of a maiden's fancies."—*"'Arry."*

21.—LITTLE COURT.

"Merely technical triumphs."—*Standard.*

22.—REGENT'S QUADRANT.

"There may be a few who find genius in insanity."—

23.—LOBSTER POTS.

"So little in them." *—*P. G. Hamerton.*

24.—RIVA No. 2.

"In all his former Etchings he was careful to give a strong foundation of firm drawing. In these plates, however, he has cast aside this painstaking method."—*St. James's Gazette.*

25.—ISLANDS.

"An artist who has never mastered the subtleties of accurate form." *—*F. Wedmore.*

* The same Critic holds "The Thames is haunted from Maidenhead to Kew, but not from Battersea to Sheerness."

* Therefore Mr. Wedmore is inspired to say—"The true collector must graduate!—and Art-ful-ly acquire the eye to judge of the precious metals which is the province of the preacher is passing."

8. James McNeill Whistler. *Etchings and Drypoints. Venice. Second Series.* 1883. [see No. 28]

"HARMONY IN BLUE AND GOLD.
THE PEACOCK ROOM."

The Peacock is taken as a means of carrying out this arrangement.

A pattern, invented from the Eye of the Peacock, is seen in the ceiling spreading from the lamps. Between them is a pattern devised from the breast-feathers.

These two patterns are repeated throughout the room.

In the cove, the Eye will be seen running along beneath the small breast-work or throat-feathers.

On the lowest shelf the Eye is again seen and on the shelf above—these patterns are combined: the Eye, the Breast-feathers, and the Throat.

Beginning again from the blue floor, on the dado is the breast-work, BLUE ON GOLD, while above, on the Blue wall, the pattern is reversed, GOLD ON BLUE.

Above the breast-work on the dado the Eye is again found, also reversed, that is GOLD ON BLUE, as hitherto BLUE ON GOLD.

The arrangement is completed by the Blue Peacocks on the Gold shutters, and finally the Gold Peacocks on the Blue wall.

7. James McNeill Whistler. *Harmony in Blue and Gold. The Peacock Room.* 1877. [see No. 16]

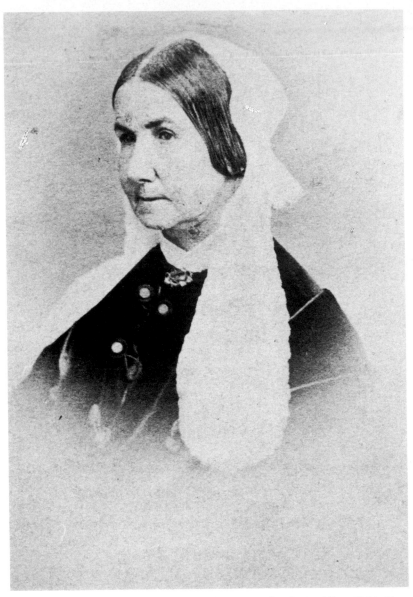

9. *Anna Matilda Whistler.* Photograph by F. Weisbrod, Frankfurt, 1864–65.

4. To his sister, Deborah Haden.
Current work on portraits and etchings.

[Paris]
[c. January 1859]

[sheet missing]

... I'm working hard and my stay in London with you and
Seymour has done me an immense good in "my art" – I have seen
Henry Harrison and have begun his portrait which I hope to
finish when he returns from England where he has gone for a few
days – I have prepared sketches for two pictures and have drawn
one of them in on the canvass all from Nature tell Seymour – I
have very nearly finished a painting of a head from life, which is
likely to be the best thing I have yet done – and I am trying to
make a portrait of Father for George from a lithograph he sent
me – this is very difficult, but with the aid of a glass and a friend
who has promised to sit for me, and who is like Father in color, I
hope to succeed –

My etchings have been very much admired, and I wish
Seymour would send me three fine proofs of each in *black* ink.
Little Martin begs to be remembered, and particularly hopes for
a set – A young friend of mine, Mons. Frank very gentlemanly,
very handsome, and well dressed is going to London, probably
next week, and will call upon you Sis; I will send the songs for mes
enfants by him – He is agreable and doesn't speak the language of
the Islanders, so you must ask him to come from time to time and
like a good little Sis talk to him about his beau Paris, and so pre-
vent him locking himself up with some lighted charcoal, as his
countrymen are wont to do when ennuyéed!

Tell Mr Traer that he shall have the chess book, and beg him
to live in the hopes of seeing me again some of these days – Tell
Seymour to send me with the etchings, a proof of the one of

yourself, and not to forget the photograph, of the little child he promised me – Kiss all the beaux enfants for me, and don't let my wonderful little Annie forget her

Uncle Jim.

5. To George Lucas.
The reception of the 'White Girl'.

7A Queens Road West
Chelsea, London
26 June [1862]

Dear Lucas – I dare say you have given us both up and voted us both ungrateful and selfish long ago. I don't think we are either of us viciously so, and over and over again I had intended to write and thank you for the trouble you took with the easel which arrived safely – Enfin! it's the old story, and I am a deuced bad correspondent as George would tell you – but my friendship does not rust as readily as my pen – and I should like jolly well to see you again old fellow and indeed this autumn we shall probably return to Paris. In the meantime you ought certainly to run across the Channel and let me lead you through the pictures in this great exhibition, – not by the way that there are many there that are worth the trouble – but perhaps a week or two you might manage to spend not unpleasantly in London – Will you come? I think we could get you a cheap room – You know that by Dieppe there are return tickets available for one month, for £2.10.0. –

Now then for my news – though I take it, you have heard it already, through Fantin – "The White Girl" was refused at the Academy! where they only hung the Brittany sea piece and the Thames Ice sketch! both of which they have stuck in as bad a place as possible – Nothing daunted I am now exhibiting the

White child at another exposition where she shows herself proudly to all London! that is to all London who goes to see her. She looks grandly in her frame and creates an excitement in the Artistic World here which the Academy did not prevent, or forsee – after turning it out I mean – In the catalogue of this exhibition it is marked "Rejected at the Academy." What do you say to that! isn't that the way to fight 'em! Besides which it is affichéd all over the town as 'Whistler's Extraordinary picture the WOMAN IN WHITE' [*drawing of man with this notice on a sandwich board*] That is done of course by the Directors but certainly it is waging an open war with the Academy, eh?

Adieu Mon cher – George comes from St Petersburg this September – Tom Winans is in England and will be in London in a day or two if he has not already arrived – One thing more you are altogether mistaken if you class Fantin with loafers of the type of Oulevey – Fantin is in every sense of the word a thorough Gentleman – and I remember his telling you apropos of the commission you were giving him that he was very much engaged with some paintings he had then in hand. – The more you know Fantin, the greater will be your esteem for him, and you can never think too highly of him both as an Artist and a gentleman. – I am about entering into some agreement with Colnaghi the publisher concerning ten of my etchings, which if ratified will bring me in a pot of gold! Will it bother you too much to enquire into the etchings that I left for exhibition on the Boulevards, and tell Monsieur Martinet that I would like to know when he intends hanging them again if he has taken them down for the moment.

There are fifteen of them, will you see that they are not lost or injured? Jo sends her love to you and to Madame, to whom present my compliments.

Tout à vous Jemmie Whistler

6. To the *Athenaeum. The title of the 'White Girl'.*

62 Sloane Street [London]
1 July 1862

[Sir,]
May I beg to correct an erroneous impression likely to be confirmed by a paragraph in your last number? The Proprietors of the Berners Street Gallery have, without my sanction, called my picture "The Woman in White." I had no intention whatsoever of illustrating Mr Wilkie Collins's novel; it so happens, indeed, that I have never read it. My painting represents a girl dressed in white standing in front of a white curtain.

I am, etc.,
James Whistler

7. To his brother, George William Whistler. *His etchings* are *expensive.*

7 Lindsey Row,
Old Battersea bridge, Chelsea – London
7 October 1863

Dear George – I regret excessively that I should have been absent from town until now, and thus have left your anxieties uncalmed all this while! – Your letter of course I found on my return, and, on reading it, sympathised at once with your grief on learning the price of my etchings and dry points, to a whole series of which you had, your memory told you, in a rash moment recklessly pledged yourself as a thoughtless purchaser! Ruin, you say would doubtless be the end of this wild engagement. I see it with

all your own agony and really only wish you had been spared a week's painful suspense – My dear George, you are quite right – two guineas a-piece is a large price for my etchings! Unfortunately though it *is* their price, and they *are* devilish dear – they are expensive objects of luxury, and an extravagance that not everyone ought to permit himself – A family man like you, for instance, might well do without them, and indeed now that I reflect I fear that really I have launched you into art with foolish inconsideration, that I might hereafter have to reproach myself with –

Your daily life requires nothing of the kind, and why should you unwisely begin! – Now my dear brother we will make it all right immediately, – send me back with care, by some express Co. the six etchings nicely packed, without delay – and so far no harm will be done – Also give me a letter to Messrs Carey, to restore to me the case containing the sea piece; and I will see that you are not troubled with the bill from the frame maker, or if he have already sent it, I will return you the sum, together with the £84: – : – and then all will be as it ought to be between us, – for it is absurd that the taste of one brother for his *own* works! should be expensively forced upon the other! – Allons! Give me like a good chap, in your answer, a little drawing of our crest and motto, as I want it very much – dont forget –

Debo, I hear has just come back in good health, I shall see her tomorrow –

Love to Julia –

Your affectionate brother

James A. Whistler

Poor Aunt Alicia is dead! –

8. To Henri Fantin-Latour. *His work is slow.*

[Chelsea]
[c. 4 January 1864]

[sheet missing]

[...] rentrons à Londres – Le retour a été tres amusant – nous ne nous refusions rien, et nous étions très gai – Rentrés chez nous et le travail commencé, le premier évenement qui fit trembler d'indignation la Colonie de Chelsea! fut la découverte du crime du beaufrère, si longtemps caché, et si longtemps connu à nous deux, toi et moi: ces retouches dans "l'Angélus"!!!! Tu vois Legros dans les angoisses du premier moment! cherchant dans les tons de soleil couchant du hasard à la Turner, ces dalles grises et calmes de son église bien aimée!! – Je te laisse à l'imagination ses crispations de fureur! et ma petite jouisance particulière en pensant à la juste vengence des Dieux qui poursuit ainsi avec patience les acheteurs habiles! Le lendemain, après nous être moult excité, nous sommes retourné à Sloane Street, et nous avons remporté l'Angelus à Lindsey Row, et la journée nous avons passé à effacer, moyenant escence, benzine, couteau et razoir toutes les belles corrections en perspective de Haden! – Peu de temps après, rentrée de Haden – et nous attendons sa visite! Deux jours après il vient – lui, une mine gai et empressé, et nous charmants et gracieux! un accueil parfait! Tu conçois combien ceci était habile! les passions comprimées, car il sentait sa drôle de position, il nous parle joyeusement de son voyage sans avoir l'air de voir le tableau qui lui regardait dans les blancs des yeux pendant tout le temps! – C'était posé sur le chevalet dans son état de démolition! car Legros n'avait pas voulu l'arranger avant qu'il n'ait vu le dégat! – Enfin en s'en allant il dit à Alphonse "Ah! vous avez oté tout ça! eh bien! faites le mieux!" sur quoi Alphonse lui répond tranquilement "*Oui!*" – Tu vois ça! tu vois la

(translation:)

[first sheet missing]
[...] so back to London – The return journey was very amusing –
We didn't stint ourselves, and we had a jolly time – Once back
home, and working again, the first event to make the Colony of
Chelsea tremble with indignation! was the discovery of the brother-
in-law's crime, so long hidden, and so long known to the two of
us, you and me: the retouching of the *Angelus!!!!* You can see
Legros' anguish at his first sight of it! seeking out amongst the
random rays of the setting sun, à la Turner, the calm grey flagstones
of his beloved church!! – I shall leave you to imagine his twitches
of rage! and my own little private glee at thinking of the just venge-
ance of the Gods which patiently tracks down the smart purchaser!
The next day, after mickle excitement, we went back to Sloane
Street, and we brought the *Angelus* back to Lindsey Row, and
spent the day with spirit, benzine, knife and razor removing all
the fine perspective corrections made by Haden! – Shortly after,
Haden came back – and we wait for him to visit! Two days later
along he comes – cheerful, and attentive, and the two of us charm-
ing and gracious! a perfect reception! You see how skilful this was!
feelings under check, as he felt in something of an odd position,
he tells us merrily about his journey without appearing to notice
the picture which was staring into the whites of his eyes all the
time! – It was on the easel in all its state of demolition! as Legros had
not wanted to repair it before he could see the damage! – At last
he said to Alphonse as he was leaving "Ah, so you have taken it all
off! well! do it better!" at which Alphonse calmly answers *"Yes!"* –
You can see it all! You can see the scene! the smiles, the greetings,
the brother-in-law's politeness! My own little private delight

scène! les sourires, les bonjours, les politesse[s] du beaufrère! Ma
petite jouissance particulière que je t'ai déjà fait remarquer et
que tu suis toujours! –

Janvier le 5. Continuons: Après ce que tu viens de lire, tu
comprends bien que le sentiment battaileur se devellopait de
jour en jour entre Haden et son dévoué beaufrère! – on se disait
de ces petites choses plaisantes! les occasions se trouvaient
facilement, et je crains que je n'en laissais point échaper sans les
utiliser à fond! – Un jour nous avons dîné à Sloane Street! des
discussions douces sur l'art! moi, une manière légère et sans
révérence! Je fais grande parade de ta belle copie Les Noces,
devant un grand béta de peintre qui était là, peu à peu je fais
parler l'autre, de la figure, tu sais, que Haden disait pas assez
foncée, il était évident qu'il lui en avait fait la leçon! Alors j'étale
là dessus toutes les derisions possible! je parle des idées vulgaires
du "repoussoir"! Combien c'était bien pour les Académiciens (ce
qui veut dire Horseley) et combien c'était absurde dans le vrai
maître etc. etc. !! Ah si tu avais assisté à la conversation tu aurais
été dans tous tes états! Enfin je cautérise encore une fois les
plaies! – Aussi je n'avais point oublié durant la soirée, de dire "Et
qu'est–ce qu'il fait pour vous maintenant Fantin?" "Rien en ce
moment!" – "Ah! mais quelle est la prochaine copie qu'il doit
vous faire?" "Je ne sais pas" – "Mais il doit vous faire autre chose
n'est–ce pas! un Titien je crois?" "Non pas maintenant" – "Ah je
croyais!" Tu vois – En les quitant j'invite Haden et son artiste (un
cousin pauvre de sa famille) à dîner chez moi avec Alphonse,
pour le lundi en huit! – Ils acceptent! C'est une affaire de
cérémonie! et nous nous souhaitant le bonsoir! – Ah! maintenant
Fantin mon ami allume ta pipe!

Janvier le 23. Mon cher, ceci prend un peu trop la tournure
des Trois Mousquetaires, et des "Vingts Ans après" – J'allais te
dérouler tout le panorama de cette glorieuse guerre! mais il
faudrait trouver un secrétaire du reste nous causerons de ça! En

which I have already told you of and which you are still following! –

5 *January*. To continue: After what you have just read, you can understand the spirit for battle daily growing between Haden and his devoted brother-in-law! – the exchange of pleasant little comments! there was no shortage of opportunities, and I fear I let none of them escape without making good use of it! – One day we dined at Sloane Street! gentle discussions on art! I taking it all lightly, and without much ceremony! I made a great thing of your copy of The Wedding, to a great goose of a painter who was there, little by little I get him to talk, you know, about the face, which Haden said was not dark enough, it was clear that he had told him what to think! Well I let fly with all possible kinds of derision! I talk about the common ideas of 'repoussoir'! How it was fine for Academicians (in other words Horseley) and how it was absurd for the real master, etc. etc.!! Oh if you could have listened in to the conversation you would have been beside yourself! Well then I cauterise their wounds once again! – And I had not forgotten during the evening to say "And what is Fantin doing for you now?" "Nothing at the moment." – "Oh, but what is the next copy he's doing for you?" "I don't know" – "But he's supposed to be doing something more for you isn't he! a Titian I thought?" "No not now" – "Oh I thought he was!" You see – As I leave, I invite Haden and his artist (a poor relation of the family) to dine with myself and Alphonse, for the Monday week! – They accept! Much ceremony! and wishing each other good evening! – Ah! now Fantin my good friend light up your pipe!

January 23rd. Mon cher this is all getting to be too much like the Three Musketeers, and "Twenty Years On" – I was going to unroll for you the whole panorama of this glorious war! but I should have to find a secretary and in any case we shall talk about it all! This is a shortened version of events – The enemy opened the campaign with a broadside straight at Lindsey Row, in the

abrégé voici à peu près l'affaire – L'ennemi a ouvert la campagne par une bordé lancé en plein Lindscy Row, en forme d'une lettre bien insolente à propos du dîner auquel on été invité – On trouve soudain des scrupules à l'endroit de Jo! et l'on propose hardiment qu'elle s'absente du festin! Cette dépêche avait pris une semaine pour sa composition, et comme grosièreté était assez réussie rendons justice à tous – A cette attaque vigoureuse j'ai répondu par une entré en cavalerie légère! le lendemain à Sloane Street! – Grande scaramouche! où j'ai déployé de grandes resources d'aimable agacerie, et effecté de graves blessures et où mon agréable galanterie atteint un tel point, que l'ennemi en perdit la tête et m'a fichu à la porte! – Après cette pitoyable bêtise de sa part, l'ennemi a continué sa rapide décadence dans l'estime des braves par une série de balourdises – des lettres de rage impotent et comique – auxquelles j'ai rien répondu! rien! car que dit le sage: "Jamais écrire, jamais brûler"! Tout ça a beaucoup dérangé la vie tranquile et paisible de notre atelier – mais le sérieux était la peine que cela causait à ma soeur! Nous ne pouvions plus nous voir que rarement chez des amis mutuels, et tu sais que nous sommes très dévoués l'un à l'autre – Haden d'un autre part n'était guère à son aise – car une querelle de famille est toujours de mauvais goût, et l'avoir trouvé comme moyen d'afficher sa vertu était un peu risqué! et sa pudeur après un long voyage en petit comité sur le continent avait déjà trop servie pour être reçu comme tout neuf! – Donc ne sachant trop que faire il a la follie d'écrire des lettres – que je collectionne! – Tout d'un coup en plein affaire arrive ma Mère des Etats Unis! – Alors! bouleversement générale!! – J'ai eu une semaine à peu près pour vider ma maison et la purifier depuis la cave jusqu'au grenier! – Chercher un "buen retiro" pour Jo – Un appartement à Alphonse – aller à Portsmouth à la rencontre de ma Mère! enfin tu vois des affaires! des affaires! – jusqu'au cou des affaires! –

Fevrier le 3. Mon cher Fantin deux mots encore et je t'envoie

form of a most insolent letter about the dinner to which he was invited – Suddenly there are scruples about Jo! and he boldly proposes that she should not take part in the feast! It had taken a week for this dispatch to be composed and for coarseness it was rather successful to give him his due – I replied to this vigorous attack with a sally of light cavalry! the next day at Sloane Street! – A great skirmish! in which I deployed great resources of pleasant provocation and caused serious wounds and in which my kind gallantry was so successful, that the enemy lost his head and threw me out of the house! – After this pitiable show of stupidity, the enemy continued his rapid decline in the opinion of the forces with a series of blunders – letters of fruitless and comic rage – to which I made no reply! more! for what does the sage say: "Never write, never burn"! It all much upset the quiet peaceful life of our studio – but the bad thing about it was the grief it caused my sister! We could see each other only rarely at the houses of mutual friends, and you know that we are very devoted to each other – Haden for his part was not much at ease – for a family quarrel is always in bad taste and to have found it a means of proclaiming his virtue was a little risky! and his sense of modesty after a long journey in select company on the continent had already been called into service too much to be seen as altogether new! – So not knowing quite what to do he is foolish enough to write letters – which I collect! – All of a sudden in the middle of all this my mother arrives from the United States! – Well! general upheaval!! I had a week or so to empty my house and purify it from cellar to attic! – Find a 'buen retiro' for Jo – A place for Alphonse – go to Portsmouth to meet my Mother! Well you see the goings-on! some goings-on! goings-on up to my neck! –

February 3rd. My dear Fantin two words more and then I shall send you this long affair – I have had your two letters and I was very pleased to get them – Your picture will be superb! The

cette longue machine – J'ai reçu tes deux lettres, et elles m'ont fait un grand plaisir – Ton tableau sera superbe! La composition très belle, et je vois les têtes peintes par toi d'une couleur magnifique – Le buste sera peut-être difficile à arranger – mais j'ai la plus grande confiance en toi – Ah je voudrais bien savoir un peu de ce que tu sais! Je viens d'avoir une mauvaise journée – est on malheureux de faire mauvais – Quand saurai–je plus! Legros a fait d'énormes progrès – aussi a-t-il produit énormément – et des choses très belles – Il a gagné beaucoup d'argent, et tu en gagneras aussi quand tu viendras – Il nous faut nous trois ici – mais pas d'avantage pour ne pas gâter le marché! Au moment de l'exposition il faut que tu vienne t'installer ici, et tu auras ta récolte de guinées! – En attendant voici une autre commande – Il faut que tu fasses encore deux bouquets de la *même grandeur*, que ceux que tu viens de faire pour M. Ionides – On te les paie 150 fs pièce – fais les *tout de suite* et tu aura[s] l'argent immédiatement – J'ai écrit hier (en recevant ta lettre) à Mons. Ionides et à Dilberoglou, en les priant de t'envoyer l'argent c'est à dire 300 fs. d'un part, et 100 fs. de l'autre Ça fait 400 fs. – tu les recevra demain – Maintenant que je te dise – Ne vas pas gâter tes affaires qui montent, comme tu vois, par un petit prix pour les gran bouquets – Ton point de départ e[s]t maintenant facile – 200 fs pour les petits bouquets (car nous allons demander ce prix après cette prochaine commande) donc pour des grand bouquets tableaux il faut demander en proportion. Il faut établir un prix pour chaque grandeur – Je suppose que les grands bouquets en question devraient être dans les 300, à 350 fs pièce – Pour les Noces de Cana – ne les fais pas *trop grand* pour les 1000 fs. Je n'ai pas encore fait savoir la mesure que tu m'as donné à Dilberoglou exprès pour que tu puisses encore une fois m'écrire – Tu me dis 1. mètre 20. – Est-ce plus grand qu'une toile de 60? Ne le fait pas plus grand – Peut-être même une toile de 50. serait assez – La grandeur ici est pour beaucoup dans les prix!

composition very fine, and I can see the heads painted by you in magnificent colour – The bust will perhaps be difficult to arrange – but I have the greatest confidence in you – Oh I wish I knew a little of what you know! I have just had a bad day – how miserable one is producing bad work – When shall I know more! Legros has made great progress – and so he has produced a huge amount – and good things too – He has made a lot of money, and you will too when you come – The three of us must be here – but no more in order not to flood the market! When the exhibition is on you must come and live here, and you will see a fine harvest of guineas! – Meanwhile here is another order – You must do two flower pictures *the same size,* as those you have just done for Mr Ionides – You will get 150 frs for each – Do them *straight away* and you will have the money immediately – I wrote yesterday (on getting your letter) to Mr Ionides and Dilberoglou, asking them to send you the money that is 300 frs from one, and 100 frs from the other That makes 400 frs – you will receive it tomorrow – Now I must tell you – Do not spoil your fortunes which are rising, as you see, by a low price for the large flowers – The point to start from is easy – 200 frs for the little ones (that is the price we shall ask after this next order) so for the large pictures the price is porportional. There must be a price for each size – I suppose that the large bunches we are talking about should be around 300 to 350 frs each – As for the Wedding in Cana – do not make it *too big* for the 1000 frs. I have not yet let Dilberoglou know the size that you gave me just in order that you should write to me again – You tell me 1 metre 20 – Is that larger than a size 60 canvas? Do not make it any bigger – Perhaps even a size 50 canvas would be enough – The size has a great deal to do with price here!

Back now, after this lesson in how to butter one's bread, back to your picture – Naturally you understand that Legros and I will come to Paris to sit for a couple of weeks before the Salon – so

Revenons, après cette leçon sur les moyens de se beurer le pain, revenons à ton tableau – Naturellement tu comprends que Legros et moi nous viendrons à Paris pour poser quinze jours avant le salon – gardes nous donc deux bonnes places – peut-être Rossetti aussi – il m'a dit qui'il serait très fier de te poser – il a une tête superbe, et c'est un grand artiste – tu l'aimeras beaucoup – De Balleroy est bien, pour les raisons que tu donnes, mais pourquoi Ribot? – Fantin ton tableau va être très beau – la grande masse de lumière fait bigrement bien – Cela va être très bien pour toi, car c'est un tableau qui attirera forcément l'attention sur toi – Je voudrais bien te parler de moi et de ma peinture – Mais dans ce moment je suis tant découragé – toujours la même chose – toujours un travail si pénible et incertain! je suis *si lent!* – Quand aurai-je une exécution plus rapide quand je dis exécution je veux dire tout autre chose – tu comprends – Je produis très peu, parce que j'efface tant – Pour le salon de Paris j'ai l'intention d'envoyer mon tableau de la Tamise que tu as vu un jour avec Edwards – C'est tout changé comme premier plan, et je crois que cela fera bien à Paris – tu l'aimeras j'en suis sûr – il y a un portrait de Legros et une tête de Jo qui sont de mes meilleurs – J'ai un tableau pour l'Académie ici – je t'en enverrai une esquisse prochainement – C'est rempli de superbes porcelaines tirés de ma collection, et comme arrangement et couleur est bien – Cela représente une Marchande de porcelaine, une Chinoise en train de peindre un pot – Mais c'est difficile! et je gratte tant! – Il y a des fois où je crois avoir apris des choses – et puis je suis fort découragé – J'ai envie d'envoyer également au Salon de Paris le tableau avec l'amazone – Qu'en penses-tu – J'ai fait aussi deux petits tableaux de la Tamise – un vieux pont, et un effet de brouillard – Je les ai trouvé bien au moment où je les ai terminé mais maintenant ils ne me plaisent pas beaucoup – Ah Fantin je sais si peu – les choses ne vont pas vite! – Adieu mon ami, écris moi deux mots et plus – parle moi de ton tableau que tu as

keep two good places for us – perhaps Rossetti too – he told me
he would be very proud to sit for you – he has a superb head, and
he's a fine artist – you will like him – De Balleroy is fine, for the
reasons you give, but why Ribot? – Fantin your picture is going to
be great – the great mass of light is excellent – It will do you a lot
of good, as it's a picture which is bound to bring you a lot of
attention – I should like to talk to you about my own painting – But
at this moment I am so discouraged – always the same thing – always
such painful and uncertain work! I am *so slow!* – When will my
execution be quicker when I say execution I mean something
quite different – you understand – I produce very little, because I
scrape off so much – for the Paris Salon I am thinking of sending
my picture of the Thames which you saw one day with Edwards –
The foreground has quite changed, and I think it will do well in
Paris – you will like it I'm sure – there is a portrait of Legros and
a head of Jo which are among my best – I have a picture for the
Academy here – I shall send you a sketch very soon – It is filled
with superb porcelain from my collection, and is good in arrange-
ment and colour – It shows a porcelain dealer, a Chinese woman
painting a pot – But it is difficult! and I wipe off so much! –
There are times when I think I have learned something – and
then I am altogether discouraged – I want also to send to the
Paris Salon the picture with the Amazon – What do you think – I
have also done two little pictures of the Thames – an old
bridge, and an effect of fog – I thought they were all right when I
finished but now I don't care for them – Oh Fantin I know so
little – things do not go quickly! Goodbye my friend, write me
two words and more – tell me about the picture you began yester-
day! – Hardy is just stupid – he supposes that I have nothing bet-
ter to do than reply to his letters so tell him by the way never to
write to me as there is no point – if I had had the time to think of
him I would have paid his bill which in any case is nothing at all –
when I come to Paris soon I shall see to it – he must take good

commencé hier! – Hardy est bête comme Hardy – il suppose que
je n'ai rien à faire que de répondre à ces lettres dis lui donc en
passant de ne jamais m'écrire car c'est inutile – si j'avais eu le
temps de penser à lui je lui aurais payé sa note qui du reste est
une bagatelle – quand je viendrais à Paris prochainement je la
solderai – qu'il ai[t] grands soins de "La Fille Blanche" –

On vient justement d'apporter ta caisse avec les bouquets et
fruits! – tout est sain et sauf! et ravissant de couleur et fraîcheur!
– Ils vont être charmé des bouquets; et les fruits je tâcherai de les
vendre. – Envoie les deux autres bouquets emballés comme
ceux-ci et par la même voie.

Adieu – il est très tard – je crains t'avoir trop fatigué – Ecris
bientôt. Whistler.

care of the "White Girl" –

Your case with the flowers and the fruit has just come! – all is
safe and sound! and the colour and freshness ravishing! – They
will be charmed by the flowers; and I shall try to sell the fruit. –
Send the other two flower pictures packed like these and by the
same route. Goodbye – it is very late – I fear I have worn you out.
– Write soon. Whistler.

9. Anna Whistler to James H. Gamble.
Whistler's Japanese and Chinese work.

7 Lindsay Row
Old Battersea Bridge, Chelsea, London
10 February 1864

My dear Mr Gamble

It is needless to tell you how much I have wished to respond to
your kind letter, while I found it difficult to answer those on busi-
ness during attacks of cold. Accept now my heartfelt thanks for

the friendly interest you continue to show towards Jemie, he will
be most delighted to attend to your commisions, especially to
paint you a Cabinet picture, for painting is irresistible, he had
been so engaged all winter in subjects ordered before I came that
I fear they will not be finished this season; and the Etchings will
have to wait till Summer, but that will be a more favorable season
for shipping them. I enquired of a N. York lady lately her
experience of the expense of Express in reference to a box I wish
to send to my sister Mrs. Palmer, she encouraged me by shewing
it to be reasonable, but said articles she had sent last November
most pressingly needed before Christmas, were not delivered
thro January, so I beg you to inform me whether more than a re-
ceipt will be required to secure your safely getting the package

Are you an admirer of old China? this artistic abode of my son
is ornamented by a very rare collection of Japanese and Chinese,
he considers the paintings upon them the finest speciments of
Art and his companions (Artists) who resort here for an evening
relaxation occasionally, get enthusiastic as the[y] handle and
examine the curious subjects pourtrayed, some of the pieces
more than two centuries old, he has also a Japanese book of
paintings, unique in their estimation.

You will not wonder that Jemies inspirations should be (under
such influences), of the same cast, he is finishing at his Studio (for
when he paints from life, his models generally are hired and he
has for the last fortnight had a fair damsel sitting as a Japanese study)
a very beautiful picture for which he is to be paid one hundred
guineas without the frame that is always separate. I'll try to des-
cribe this inspiration to you. A girl seated as if intent upon painting a
beautiful jar which she rests on her lap, a quiet and easy attitude,
she sits beside a shelf which is covered with Chinese Matting a
buff color, upon which several pieces of China and a pretty fan
are arranged as if for purchasers, a Scind Rug carpets the floor
(Jemie has several in his rooms, and *none others*), upon it by her

side is a large jar and all these are facsimiles of those around me in this room – which is more than half Studio for here he has an Easel and paints generally – tho he dignifies it as our withdrawing room – for here is our bright fire and my post.

To finish now my poor attempt at describing the Chinese picture which I hope may come home *finished* this week – there is a table covered with a crimson cloth, on which there is a cup (Japanese) scarlet in hue, a sofa covered with buff matting, too, but each so distinctly separate, even the shadow of the handle of the fan, no wonder Jemie is not a rapid painter, for his conceptions are so nice, he takes out and puts it over and oft until his genius is satisfied. And yet during a very sharp frost of only a few days I think for two days ice was passing as we look[ed] out upon the Thames, he could not resist painting while I was shivering – at the open window – two sketches and all say are most effective, one takes in the bridge, of course they are not finished, he could not leave his oriental paintings which are ordered and he has several in progress: One pourtrays a group in Oriental costume on a balcony, a tea equipage of the old China, the[y] look out upon a river, with a town in the distance. I think the finest painting he has yet done is one hanging now in this room, which three years ago took him so much away from me. It is called Wapping, The Thames and so much of its life, shipping, buildings, steamers, coal heavers, passengers going ashore, all so true to the peculiar tone of London and its river scenes, it is so improved by his perseverance to perfect it, a group on the Inn balcony has yet to have the finishing touches, he intends exhibiting it at Paris in May, with some of those Etchings which won him the gold medal in Holland last year. While his genius soars upon the wings of ambition, the every day realities are being regulated by his mother, for with all the bright hopes he is ever buoyed up by, as yet his income is very precarious. I am thankful to observe I can and do influence him.

The Artistic circle in which he is only too popular, is visionary and unreal tho so fa[s]cinating. God answered my prayers for his welfare, by leading me here. All those most truly interested in him remark the improvement in his home and health the dear fellow studies as far as he can my comfort, as I do all his interests *practically*, it is so much better for him *generally* to spend his evenings tete à tete with me, tho I do not interfere with hospitality in a rational way, but do all I can to render his home as his fathers was. My being in deep mourning and in feeble health excuses my accepting invitations to dine with his friends. I like some of the families in which he is intimate for a long time and promise, when flowers and birds bloom and sing in the fields I will go as unceremoniously as Jemie has done to return their calls. The Greek Consul is one of his Patrons and I like his wife and daughters and sons. Ionides is the name.

I have had some relief to my deep anxiety about my dear Willie in hearing *of him,* that his health was improved by his having gone to visit his wifes relatives the month of sick leave which was granted him on the day we parted and that a box I had sent him from Bermuda had been received. A Christmas letter from him had reached Baltimore and tho he was so sadly lonely, he was well, oh how my heart yearns for some of the letters I know he has directed to me! I pray mine may reach him and that the Lords presence may be realised by him. I hear wisdom secretly, for I am all day alone, Jemie has lately engaged the Times to read to me after our 6½ o'clock dinner. I must not omit mentioning he goes to church with me and likes the Pastor of Christs Church which we attend, it is a pleasant walk there along the river side. Mr. Robinson is an Evangelical preacher, faithful as a Pastor. I am sorry I cannot attend his Monday evening prayer meetings, but I do not venture out at night. Sunday afternoons I go to my daughters home in a Cab. We are a mile and half further out of London, than is 62 Sloane St. her health is very delicate, but she is a great

comfort to me, ever anticipating my wants, her three boys and one girl I find so interesting, so improved in the three years their Sunday evening exercises are bible and sacred music.

The winter has been remarkably fine, but now again a sharp frost, no snow and scarcely a rainy day, but I feel the cold more in England than our more severe winters, it is so penetrating, and the fogs are so gloomy. I prefer my native land at all seasons, ah shall I ever have a home in it! I treasure memories of happy days at *both* Homelands! how interested I feel in your report of your dear Mother and that she has such a comfort in a good nurse, it must relieve dear Mrs. Mann and yourself of much anxiety. My love to them both. A happy New Year to you all Offer my affectionate remembrance to Mrs. J. Aspinwall. Write me when you have leisure of Homeland fireside circle and our mutual friends.

Thursday 11th. You will not tire of my reporting yet of Jemie, dear Mr. Gamble, he had a trying time yesterday thro its frosty fog and had to abandon his painting, so that he came in to his dinner not in his usual bright way and as "Mother" sympathises, we neither of us had relish for our nice little dishes, however in the evening the parcel delivery came to divert our disappointment, the gold medal which you knew was awarded him for his Etchings, in Holland, came most seasonably, with a flattering letter from the President of the Academy for the Fine Arts. The inscription too on the massive gold medal with James Whistlers name in full, how encouraging! There was no American news in the Times, so that was soon dispatched, then Jemie was inspired to begin a sketch in pencil. After which he read to me the service for Good Friday: at eleven we kissed each other good night, when I left him at his drawing again. This morning I asked him what message to you, he said brightly, my love to Mr. G and tell him I shall be much pleased to paint the picture he has so kindly ordered and also to send the two sets of Etchings as soon as I get thro my pressing engagements. You must not suppose from my

telling you of the prices offered Artists in London my dear friend, that Jemie thinks your offer too small. I can assure you he is gratified by your order and oh with what interest I shall watch his painting which is to have a place at sweet Homeland. He is thinking seriously of selling his Wapping *large* picture to a gentleman in Scotland for 200 guineas, there is so much work upon it and such expenses attend painting, his price was 300 guineas.

Did you hear from Mr. King of the relief it was to me on my reaching Southampton, feeling so alone, so dependent on Strangers, that my own dear Son came on board to bring me home! unless you know what a storm was raging and how near nightfall it was, you cannot quite estimate my feelings of thankfulness to God.

[...]

My pets are the birds of the air, I entice them to our little Garden by crumbs, that they may sing by and by.

How shall I break Jemies cat the naughty game she makes of these poor little birds, she kills them!

Jemies pet cat with collar and bell reminds me of the pets at Homeland. I hope all are well.

I shall feel interested in anything you will write me of my native land and my dear friends. I have been prevented by a second attack of Influenza writing either my friends at Scarsdale or at Jersey City. Yours most truly A M W.

10. To Thomas Winans. *His need to study.*

2 Lindsey Row, Chelsea
[Spring, 1867]

My dear Mr Winans –

We have just returned from a visit in the country and my Mother has shown me your kind letter to her – You are quite right in being surprised at my still being in perplexity as to my money matters – At first sight this is apparently most discouraging if not hopeless – but the explanation is really simple, and the trouble is not at all the result of ill success in my profession or difficulty in disposing of my works –

There appears to be no dispute as to the position I have taken, and I have at this moment plenty of commissions for important pictures – I can get high prices for what I do and in the world am looked upon and spoken of as a most successful man –

But – for the last two years I have been absorbed in study – a most expensive proceeding for one who has no capital to go on – first because study and experiment prevent finished saleable production – and second because this study is made at the daily cost of materials – models who m*ust* be paid and who come to an awful lot! – and rent for a studio I was obliged to take during the winter – In short a continued outgoing and nothing coming in. –

All this study has doubtless astonished many who wonder what I *can* be about and how it is I have shown nothing for so long – either at the Academy or even in my Studio! – but I am sure you will sympathize with my anxiety in my work which will not admit of my being contented with what merely "would sell" –

For instance I had a large picture of three figures nearly life size fully under way – indeed far advanced towards completion – the owner delighted – and every one highly pleased with it — except myself. – Instead of going on with it as it was, I wiped it

clean out, scraped it off the canvas and put it aside that I might perfect myself in certain knowledge that should overcome imperfections I found in my work, and now I expect shortly to begin it all over again from the very beginning! – But with a certainty that will carry me through in one third of the time! – The results of the education I have been giving myself these two years and more will show themselves in the time gained in my future work.

Like the captain of the Missisippi steamboat when he ran on a sandbank, I have had to "back out and grease"!! "Greasing" is expensive and I am always hard up –

Here my dear Mr Winans is the story of the whole business – and if you are not tired of helping me as well you might be, and will trust me with another loan, Five hundred pounds will I think carry me through these difficulties and enable me to work until my pictures shall pay for themselves –

Believe me as ever
Yours affectionately

J.A. McNeill Whistler

I send you a small photograph of the "Cartoon" for one of the pictures I am engaged upon – The figure itself is about small life size and will when painted be clad in thin transparent drapery; a lot of flowers and very light bright colors go to make up the picture –

11. To Henri Fantin-Latour.
True colour comes from the composition of colours.

2 Lindsey Row
Old Battersea Bridge, Chelsea, London
30 Sept [18]68

Eh bien, ils sont arrivés les deux bouquets et je les ai vu – Mon cher
Fantin ils sont étonant! – c'est d'un éclat de couleur inattendu! –
inattendu est bien le mot – car bien que je m'attends toujours à
voir, lorsqu'il s'agit de me montrer de nouvelles toiles de toi, les
fraicheurs et les belles couleurs qui te sont particuliers, j'ai été
cette fois ci plus surpris que jamais par le brillant et la pureté de
ces bouquets! – L'effet dans mon atelier est étourdisant – et il me
semble que tu as trouvé quelque chose de nouveau, dans la
hardiesse de tes couleurs qui pour moi est énorme comme
progres – tu comprends ce que je veux dire – ce n'est plus une
affaire de bien peint du tout – ni ce que l'on appel 'ton' – mais les
couleurs des fleurs sont pris sur nature cranement et posées sur
la toile tel que, pures et crues – sans crainte – comme les Japonais
ma foi! Que c'est joli! les petites fleurs grises sur le fond de gris
clair! et dans le bouquet de celui là il y a des rouges inouis!
l'assiette blanche sur la nappe aussi – c'est charmant.

Mais tu sais je préfère la composition de l'autre toile – pas tu
comprends seulement les objets peints ni même l'arrangement
de ces objets – mais la composition des couleurs qui fait pour moi
la vrai couleur – et voici comment d'abord il me semble que la
toile donnée, les couleurs doivent être pour ainsi dire *brodées* là
dessus – c'est à dire la même couleur reparaître continuellement
ça et là comme le même fil dans une broderie – et ainsi avec les
autres – plus ou moins selon leur importance – le tout formant de
cette façon un *patron* harmonieux – Regardes les Japonais
comme ils comprennent ça! – Ce n'est jamais le contraste qu'ils

(translation:)

Well now, the two flower pictures have arrived and I have seen them – My dear Fantin they are astonishing! – an amazing burst of colour! – amazing is the right word – for although I always expect, when being shown new works by you, to see the freshness and colours that are especially your own, this time I was more surprised than ever by the brilliance and the purity of these flowers! – The effect in my studio is staggering – and I feel you have found something new, in the boldness of your colours which strikes me as enormous progress – you know what I mean – it's no longer a question at all of being well-painted – nor what they call 'tone' – but the colours of the flowers are taken absolutely from nature and placed on the canvas, just as, pure and raw – really – like the Japanese, good Lord! It is so pretty! the little grey flowers against the light grey background! and in that bunch there are some unheard-of reds! the white plate on the cloth too – it's charming.

 . But you know I prefer the composition of the other work – not you understand only the painted objects nor even the arrangement of them – but the composition of the colours which for me is true colour – and this is how it seems to me first of all that, with the canvas as given, the colours should be so to speak *embroidered* on it – in other words the same colour reappearing continually here and there like the same thread in an embroidery – and so on with the others – more or less according to their importance – the whole forming in this way an harmonious *pattern* – Look how the Japanese understand this! – They never search for contrast, but on the contrary for

cherchent, mais au contraire la répétition –

Dans ta sеconde toile le tout est d'abord un patron charmant et pour le reste il n'y a personne qui puisse le peindre comme toi – Mais vois comme c'est parfait – le fond se retrouve dans le bouquet, et la table remonte par les raisins roug[e]atres et va retrouver des tons pareils parmis les fleurs! – les rouges des fruits sont répétés dans plusieurs endroits – et les raisins vert – sont–ils délicats et fins de couleur! vont chercher d'autres verts dans les feuilles! C'est un patron ravissant! – et d'une couleur délicieuse – *Les deux* sont je trouve les plus belles que tu aies faits – Maintenant pour ma critique: je pense que dans le premier le ver[re] qui tient le bouquet est un *peu* noir; – pas comme *ver[re]*, ou pour *la réalité*, mais comme *couleur* pour le *tableau*, et ne se retrouve nul part ailleurs —

Samedi le 31 Oct. Mon cher Fantin j'esperais bien t'avoir envoyé ce petit mot avant – mais pour les lettres tu sais je suis toujours terrible – et maintenant je suis dans le travail jusqu'au cou! – ça fait que j'écris un peu et puis viennent les models et la journée, et le soleil qui se couche bien trop tôt et puis quelqu'un qui entre et rest[e] dîner – et si je sors un instant vlan! la nuit! et moi éreinté, tombant de someil et incapable de rien faire! – Ah que je voudrais bien te voir! – te causer pendant deux jours de suite! j'ai tant de choses à te dire – mais je crains que de cette façon, elles ne te seront jamais *écrites*! –

Je viens de voir un tableau de Legros dans une Exposition d'hiver ici – C'est fort bien! tres bien – "Les demoiselles de Ste Marie" – Un fond d'église – des jeunes filles assises – un moine jouant de l'orgue, ou espèce de claveçin – et un prêtre lisant ou chantant – le tout j'aime beaucoup – la composition en est charmant – le dessin très tiré – et il y a grand progrès – toujours dans les mêmes données – Mais le prêtre par exemple fait tache et n'est pas bien dans l'arangement des couleurs du tableau ni les lignes non plus – Du reste je trouve l'oeuvre de Legros pour ainsi

repetition –

In your second work the whole is above all a charming pattern and as for the rest there is nobody who can paint it like you – Just see how perfect it is – the background is there again in the flowers, and the table comes out again in the reddish grapes and finds the same tones among the flowers! – the reds of the fruit are repeated in several places – and the green grapes – how delicate and fine in colour they are! setting off other greens in the leaves! The pattern is entrancing! – and the colour delicious – *The two* are I think the most beautiful you have done – Now for my critique: I think that in the first the glass that contains the bunch is a *little black*, – not as *glass*, or as regards *reality*, but as *colour* for the *picture*, and does not appear anywhere else —

Saturday 31 Oct. My dear Fantin I had been hoping to send you this little note before – but you know how terrible I am with letters – and now I am up to my neck in work! – which means that I write a little and then the models come and the daylight, and the sun sets far too soon and then someone comes in and stays to dinner – and if I go out for a moment boom! night time! and I'm worn out, dropping with sleep and incapable of doing anything! – Oh how much I should like to see you! – to talk to you for two days together! I have so much to tell you – but I am afraid that, this way, it will never get *written!* –

I have just seen a picture by Legros in a winter Exhibition here – It's fine, very good – "The Young Ladies of Ste Marie" – a church background – girls sitting down – a monk playing the organ, or kind of harpischord – and a priest reading or singing – I like the whole – the composition is charming – the drawing very tight – and there is a lot of progress – albeit with the same elements – But the priest for example is a blot and does not fit the arrangement of colours nor the lines – Besides I think Legros' work is so to speak the work of an old man – and his art, hopeless! –

Doctor Hart has been here – he is enchanted with your two

dire l'oeuvre d'un viellard – et son art, sans espoir! –

Le docteur Hart, a été ici – il est ravi de tes deux bouquets – il les a emporté pour les faire encadrer de suite – Je lui ai donné ton adresse et il est parti en promettant de t'écrire immédiatement. – Il en est si content qu'il est probable qu'il t'aura d'autres commandes – Les fleurs ont eu un vrai succès içi et j'espère qu'il y en aura un bon résultat.–

Nov. 3. Voici encore cette lettre! décidement je vais te l'envoyer bientôt ou ça tournera au journal de l'an dernier et il faudrait plutôt la jeter au feu! Voyons de qui vais–je te parler? – Edwards, je l'ai vu il y a quelque temps, et il est venu me voir – Nous sommes très bien ensemble et il parle de toi toujours avec grande amitié et affection – Il voit Legros mais ne cache point son mépris pour sa poltronerie – Edwards est même enthousiaste pour moi, étant au fond charmé de ce que Haden a été battu par moi! Quant à Legros il ne lui reste je crois presque personne. Une espèce de pitié est sa portion parmi ceux qui lui voulaient du bien, une pitié qui à Paris tuerait un homme. Aleco lui tourne le dos et ne lui parle plus – Il n'est plus reçu chez les Ionides – à l'exception du gros frère Constantin qui est très entêté comme tu sais et s'est rangé du côté opposé contre moi – Chez Rossetti Legros ne vient plus de peur sans doute de me rencontrer – car il me fuit de loin! Il fallait voir comme Madame Edwards riait en me racontant la fuite précipitée de Legros en me voyant à l'Académie cet été! – Tu sais il est probable que je ne le batterai plus – il n'en vaut pas la peine – Même ça fait presque pitié tellement est il démoralisé. – Mais c'est trop longtemps causer Legros –

L'affaire Haden et Legros est trop longue pour te l'écrire, mais je l'ai en Anglais et je te l'enverrai tout de même un jour – quelqu'un te la traduira – En attendant je te dirai que Haden s'est rendu méprisable et ridicule au plus haut degré par tous ces derniers procédés – et a perdu l'estime de presque tout le monde – Legros en revenant de Paris après le Salon a raconté içi, qu'il avait donné

flower pictures – he has taken them off to have them framed right away – I gave him your address and he went away promising to write to you immediately – He is so pleased that he will probably have other orders for you – The flowers have been a real success and I hope the outcome will be good –

Nov. 3rd. The same letter still! I shall certainly have to send it soon or it will turn into the journal for last year and should rather be thrown on the fire! Let's see who shall I tell you about? – I saw Edwards some time ago, and he came to see me – We get on very well and he always talks about you with great friendship and affection – He sees Legros but does not hide his scorn at his cowardice – Edwards is even very supportive of me, being charmed really that I thrashed Haden! As for Legros he has got hardly anybody left. Those who wished him well still pity him, with a pity which in Paris would kill a man. Alecco has turned his back on him and no longer speaks to him – He is not received by the Ionides any longer – except for the fat brother Constantin who is very obstinate as you know and has gone over to the other side – Legros never comes to Rossetti's now doubtless for fear of meeting me – for he keeps out of my way! You should have seen how Mrs Edwards laughed at telling me about Legros' headlong flight on seeing me at the Academy this summer! – You know it's likely that I shall not beat him again – he is not worth the trouble – It almost indeed makes one feel sorry for him he is so demoralised – But that's too long spent talking about Legros –

The Haden and Legros business is too long to write to you about, but I have it in English and I shall send it you all the same one day – someone can translate it for you – In the meantime I shall tell you that Haden has made himself contemptible and ridiculous in the highest degree by all these latest procedures – and has lost the respect of almost everybody – On his return from Paris after the Salon, Legros said here that he had given some kind of soirée or reception, and that Fantin came to it without

là–bas une espèce de soirée ou réunion quelconque, et que
Fantin est venu y assister sans avoir été invité – Enfin qu'il t'avait
reçu avec politesse mêlée de froideur et dignité (tu vois ça d'ici!)
pour ne pas avoir de scène – mais qu'à la fin de la soirée il t'avait
congédié en te faisant comprendre qu'il ne fallait plus y revenir! –

Nov. 19. Je viens de recevoir ta lettre! – Je n'ose pas m'excuser
– Seulement si j'avais pu suposer que tu n'aies pas reçu l'argent il
y a *longtemps*, c'est à dire *immédiatement* après que le docteur
Hart emporta les toiles, je t'aurais certainement écrit un mot de
suite – Il m'avait promis de te l'envoyer sans perte de temps – Je
lui ai écrit *ce matin* en le priant de t'envoyer les 20 livres *de suite*
– C'est un très gentil garçon, et il doit avoir erreur quelconque de
sa part – car il était *très content* de ses tableaux.

Dimanche Nov. 22 – La réponse de Hart m'est arrivée – Il
m'écrit qu'il avait effectivement prié son banquier de placer à
Paris 20 livres à ta disposition et de te faire part où cela te serait
payé – Il parait que les vingt livres ont été de cette façon trans-
plantés mais que l'on avait négligé le plus important c'e[s]t à dire
de te faire part! – Maintenant il a reécrit à son banquier pour
qu'on te remette la somme, et en recevant la réponse
(probablement demain) il t'écrira lui–même – Maintenant il
t'aurais sans doute écrit il y a longtemps pour te remercier pour
les tableaux, seulement *le soir même* qu'il les a vu içi, nous
sommes allé ensemble les donner à l'encadreur qui ne *les a pas
encore rendu!* de sorte qu'il ne les a pas revu depuis! – Il ne les a
même jamais vu qu'à la lampe, et n'ose peut-être pas t'en écrire
sans mieux les conaître. – Voilà – Maintenant j'espère qu'il n'y
aura plus grand délai, et que tu n'auras pas à attendre jusqu'à la
fin de la semaine. Tout à toi Whistler

As tu jamais reçu des photographies que je t'ai envoyé? Plus tard
je t'enverrai une esquisse de ce que je fais. – Je n'ose pas te de-
mander une reponse – mais si tu veux bien m'écrire un mot je
serais bien content –

being invited – Anyhow that he had received you politely but coldly and correctly (you can see that!) to avoid a scene – but that at the end of the evening he had bid you goodnight in a way to let you know that you were not to come back! –

Nov. 19. I have just had your letter! – I dare not try to excuse myself – Only if I had ever supposed that you had not had the money long *ago*, that is *immediately* after Dr Hart took the pictures, I would certainly have written to you on the spot – He had promised me to send it to you without loss of time – I wrote to him *this morning* asking him to send you the twenty pounds *straight away* – He's a good sort, and there must be some mistake on his part – as he is *very pleased* with his pictures.

Sunday Nov. 22 – A reply from Hart has come – He tells me that he had indeed asked his banker to place 20 pounds at your disposal in Paris and to let you know where it would be paid to you – It seems that the twenty pounds was accordingly sent across but that they had left out the most important thing which was to tell you! – Now he has written to his banker again for the sum to be sent to you, and when he gets a reply (probably tomorow) he will write to you himself – Now he would doubtless have written to you long ago to thank you for the pictures, only the *same evening* that he saw them here, we went off together to take them to the framer who *has not yet given them back!* so that he has not seen them since! – He has only ever seen them by lamplight, and does not perhaps want to write to you about them without knowing them better. – So that's that – Now I hope that there will not be much delay, and that you will not have to wait until the week-end. Yours ever Whistler

Did you ever receive the photographs that I sent you? Later on I shall send you a sketch of what I am doing. – I daren't ask you to reply – but if you care to send a word I should be very pleased –

12. To Albert Moore.
Comparison of his own art with that of Moore.

[Liverpool]
[September 1870]

My dear Moore – I have something to say to you which in itself difficult enough to say, is doubly so to write – Indeed for the last few days I have several times sat down to the matter and losing courage given it up – however it must be done at once or set aside forever as your precious time may not be lost – This is an awful opening rather and the affair is scarcely worthy of such solemnity –

The way of it is this – First tho' I would like you to feel thoroughly that my esteem for you and admiration for your work are such that nothing could alter my regard and in return I would beg that if I am making an egregious mistake you will be indulgent – and forgive – believe that I do so with great timidity wishing for nothing more than to be put right – and would rather anything than that a strangeness should come about in our friendship through any stupid blundering letter I might write. –

Well then your two beautiful sketches were shown to me by Leyland, – and while admiring them as you know I must do everything of yours – more than the production of any living man – it struck me dimly – perhaps – and with great hesitation that one of my sketches of girls on the sea shore, was in motive not unlike your yellow one – of course I dont mean in scheme of color but in general sentiment of movement and in the place of the sea – sky and shore etc —

Now I would stop here and tear this letter up as I have done others if I were not sure that you could not impute to me self sufficiency enough to suppose that I could suggest for a moment that any incomplete little note of mine could even unconsciously

have remained upon the impression of a man of such boundless imagination and endless power of arrangement as yourself – Also I am encouraged a little to go on and send this to you by my remembering that one day you came to me and told me that it was your intention to paint a certain bathing subject and that you were uncertain whether a former sketch of mine did not treat of the same subject – and thereupon told me that it would annoy you greatly to find yourself at work upon anything that might be in the same strain as that of another –

Now what I would propose is that you should go with Billy Nesfield down to my place and together look at the sketch in question (it is hanging up on the wall in the studio, where you will be at once admitted without the necessity of mentioning your purpose) – The one I mean is one in blue green and flesh color of four girls careering along the sea shore, one with a parasol the whole very unfinished and incomplete – But [what] I want you two to see is whether it may be dodged by any suggestion of yours that we may each paint our picture without harming each other in the opinion of those who do not understand us and might be our natural ennemies – Or more clearly if after you have painted yours I might still paint mine without suffering from any of the arrangement either of the sea and shore or the mouvement of the figures –

If however Nesfield and you find that I am unnecessarily anxious and that I am altogether mistaken I will be more than satisfied and acknowledging my error still hope that you will consider all that I have written unsaid –

Again in every case begging you to excuse anything that may appear to you 'inconvenant' in this letter believe me my dear Moore ever yours affectionately – JMW

13. Anna Whistler to her sister, Kate Palmer.
The painting of her portrait.

2 Lindsey Houses, Chelsea
3 November 1871

My own dear Sister, [...]

I can [now] avail of opportunities for sending proofs of Aunt Anna's loving remembrance to your sons and daughters, especially to dear Julia a bridal gift, by Mrs Hoopes, and more recently by Mrs Julius Adams who offered, as few do nowadays, but she I suppose had not been shopping to the extent most do, for the cot was sent by a Co. to Europe, for information his only remaining son had alarmed his apprehensions that he too would be a victim to consumption, so he brought him and could not leave the only girl, she and her Mother needed change of scene, after the last few years of sickness and death they had been so saddened by. I never thought Lizzie or her husband so interesting, but the chastening tho grievous yielded the refinement – which made both Debo and I say how much Julius reminded us of George! and that Cousin Lizzie so warm-hearty it was a comfort to talk to.

Jemie had always been a favorite with them both. I wish they could have gone to Speke Hall as they intended, the old Hall would have interested the Col., and he not only desired to see Jemie but his recent paintings. My portrait you would all like, as Debo says it reminds her of her Grandmother and Uncle William MacNeill. When it is photographed I hope to send one to you and another to MGH. Meanwhile my love to the dear Scarsdale home circle "house and cottage" or send Margaret this letter to read, tho she must not blush for the vanity of her old Chum, in praise of my own likeness! but thankfulness to God is my emotion and it was a Mothers unceasing prayer while being the painters model

gave the expression which makes the attractive charm. If you could hear Mrs Hoopes describe the struggle Jemie has gone thru in his persevering work to *finish* pictures, you would understand the transition from "hope deferred which maketh the heart sick" to the cheering present and future work.

But I must tell you first of another divine lesson taught me in my intense sympathy for dearest Jemie. A lovely study ordered two years ago by a wealthy M.P. was promised in August, a beautiful young girl of 15 had posed first, she was a novice and soon wearied standing, and pleaded illness, then her brother in play with her as she was at home hurt her seriously, and she had convulsions. Poor Jemie does not relieve his trouble by talking of it, but I saw his misery, but he is never idle, his talent is too eager, if he fails in an attempt, he tries another, so I was not surprised at his setting about preparing a large canvass late tho it was in the evening, but I was surprised when the next day he said to me "Mother I want you to stand for me! it is what I have long intended and desired to do, to take your Portrait."

I was not as well then as I am now, but never distress Jemie by complaints, so I stood bravely, two or three days, whenever he was in the mood for studying me, his pictures are *studies*, and *I so interested* stood as a statue! but realized it to be too great an effort, so my dear *patient* Artist (for he is gently patient as he is never wearying in his perseverance) concluding to paint me sitting perfectly at my ease, but I must introduce the lesson experience taught us, that disappointments are often the Lords means of blessing.

If the youthful Maggie had not failed Jemie as a model for "The girl in blue on the sea shore", which I trust he may yet finish for Mr Grahame, he would have had no time for my Portrait. If I had not felt too feeble to sit one bright afternoon, he would not have given up work to take me down the river for air, we went to Westminster to call on Eliza Stevenson Smith. Jemie so seldom

goes out in the day, he was charmed with the life on the Thames, he took out his pencil and tablets as we side by side on the little steamer were a half hour or more benefitting by the sun[shin]e and breezes.

The Smiths were not in town! so we left our Cards and the dear fellow to prolong my inhaling the fresh air sauntered with me thro St James Park, and there we took a Hansom Cab as it is an open carriage, and for a shilling drive we were soon at our own gate, the river in a glow of rare transparency an hour before sunset, he was inspired to begin a picture and rushed upstairs to his Studio, carrying an Easel and brushes, soon I was helping by bringing the several tubes of paint he pointed out that he should use and I so fascinated I hung over his magic brushes til the bright moon faced us from his window and I exclaimed Oh Jemie dear it is yet light enough for you to see to make this a moonlight picture of the Thames.

I never in London saw such a clear atmosphere as this that August Moon, and Jemie went out two or three nights in a barge with two youths who own boats close to us and who delight to do any service to Mr Whistler who has always noticed them in a neighbourly spirit. So now Kate I send you by this mail steamer an "Athenaeum," a weekly Paper with a criticism on these two pictures exhibited now in "The Dudley Gallery". It is so true. The Moonlight is not more lovely than the Sunset, tho the Critique gives it only the mede of praise "Almost as beautiful tho quite different", these and two others (one before sunrise) took Jemie out often, work in the open air was like the renewal of Etching and gave zest to [the] Studio at intervals.

Jemie had no nervous fears in painting his Mothers portrait for it was to please himself and not to be paid for in other coin! only at one or two difficult points when I heard him ejaculate "No! I can't get it right! it is impossible to do it as it ought to be done perfectly!" I silently lifted my heart, that it might be as the

Net cast down in the Lake at the Lords will, as I observed him trying again, and oh my grateful rejoicing in spirit as suddenly my dear Son would exclaim, "Oh Mother it is mastered, it is beautiful!" and he would kiss me for it!

Some few of his most intimate friends came, Mr Rose who seems to have given me his own Mothers place since she died, was charmed and came four times, he says when it is exhibited next Spring he shall go every day to see it. Mr Rosetti the Poet and Artist in a note to Jemie after he had been here, said "Such a picture as you have now finished of your Mother, must make you happy for life, and ought to do good to the time we are now living in."

And now that dear Jemie is at Speke Hall it is there! I will just extract from Mrs Leylands letter to me what her little daughter said in her surprise, "I think you ought Mr W to write Peace on your Mothers picture for that is what it is!" and another remarked "Isn't it the very way Mrs Whistler sits with her hands folded on her handkerchief! oh it is exactly like her!" Fanny the eldest who was so ill last winter and I watched at her bedside, writes me often, I gave her a riddle to guess, and when she saw the Portrait, she wrote, she knew what Mr W was at work upon, tho' she could not guess the riddle til her astonishment upon his taking them in to see hung up what had come in the huge box. Mrs Leyland writes me that she thinks the full length Portrait he has begun of herself will be as lifelike as she is sure mine is! Jemie sent me a sketch of mine as the centre, Mr Leylands Portrait and a painting of Velasquez the two on either side of mine, covering the wall one whole side of the great dining room called the banquetting hall, and [said] that the two Portraits bore the comparison with the painting of the famous Spanish Artist to his satisfaction!

I must begin on a less blotted page. I had to send off a scrap of what I meant to have been a long letter last Saturday in my answer to Mrs Hoopes, she had not delayed writing us immediately on her welcome to her Phila. home and I was sorry to have

been prevented writing her for a fortnight, fearing she would think me indifferent.

Saturday afternoon 4th. [...] When you have read the criticism on Jemie's pictures of the river, send the Athenaeum to Julia. I think if she or Mr Boardman would write it out and offer it to the Herald, any N. York paper might gladly publish it without charge, for we see that Whistler's works as an American Artist are claimed and they seem proud to publish notices of them [...]

Ever your fond sympathising Sister Anna

14. To Frederick R. Leyland.
Adoption of the title 'Nocturne'.

2 Lindsey Houses – Chelsea –
[November 1872]

Dear Leyland – I know you dont see the Athenaeum and so send the enclosed –

The Princess is at Queens Gate and hanging in the "Velasquez Room" by the fireplace opposite the door so that you can see her from the hall as you go in – She looks charming –

You will I hope be pleased to hear that among other things I am well at work at your large picture of the three girls and that it is going on with ease and pleasure to myself –

I want much to borrow Mrs Leyland's little "Nocturne"! She says that she has no objection – so if you would kindly let John pack it in the case I took it to Speke in and send it to me I should be very much obliged – with apologies for the trouble –

I say I can't thank you too much for the name "Nocturne" as a title for my moonlights! You have no idea what an irritation it proves to the Critics and consequent pleasure to me – besides it is really so charming and does so poetically say all I want to say

and *no more* than I wish! The pictures at the Dudley are a great success – The Nocturne in blue and Silver is one you dont know at all.

Tell Tom that two of his works are on exhibition in London and catalogued and priced – and there he is lancé! – We all went in triumph to see them, and Mrs Tom carries back the catalogue – I have had the Princess photographed but have not yet seen the proofs – When they come [I] shall of course send one down – I do not think I shall come myself to Speke until about Christmas when I may come down with Freddie.

Ever yours
J A McN. Whistler

15. To George Lucas.
The innovation of painting his frames.

2 Lindsey Houses –
Chelsea, London –
[*postmark:* 18 January 1873]

Dear Lucas – I have heard of you from time to time through Avery and listened with great pleasure to his description of your new house you have lately built – The Studio in it naturally interested me immensely – He tells me that you invite me to come and paint in it! – This is a princely offer which I hope to remind you of and thank you for one of these days when I also intend to accept it – Meanwhile I write to tell you of an exhibition of several works of mine now to be opened by Mons. Durand Ruel – Rue Lafitte – Go and see them and do like a good fellow write me a letter and tell me how you like them – They are not merely canvasses having interest in themselves alone, but are intended to indicate slightly to "those whom it may concern" something of my

theory in art – The science of color and *"picture pattern"* as I have worked it out for myself during these years –

There! – I will not bore you with an article – Go and see and also fight any battles for me about them with the painter fellows you may find opposed to them – of whom by the way there will doubtless be many – Write me what you may hear and in short as I am not there to see, tell me what effect my work produces, if any –

You will notice and perhaps meet with opposition that my frames I have designed as carefully as my pictures – and thus they form as important a part as any of the rest of the work – carrying on the particular harmony throughout – This is of course entirely original with me and has never been done – Though many have painted on their frames but never with real purpose – or knowledge – in short never in this way or anything at all like it – This I have so thoroughly established here that no one would dare to put any colour whatever (excepting the old black and white and that quite out of place probably) on their frames without feeling that they would at once be pointed out as forgers or imitators; and I wish this to be also clearly stated in Paris that I am the inventor of all this kind of decoration in color in the frames; that I may not have a lot of clever little Frenchmen trespassing on my ground –

By the names of the pictures also I point out something of what I mean in my theory of painting –

I hope my dear Lucas you are quite well – and that you may perhaps run over this summer and give me a look up –

With best wishes for the New Year, believe me,

Ever Yours affectionately,

J A McN Whistler

You will see my mark on pictures and frames – It is a butterfly and does as a monogram for J.W. *[butterfly]*

Characteristic I dare say you will say in more ways than one! –

This exhibition of mine you will see clearly is especially intended to assert myself to the *painters* – in short in a manner to register among them in Paris as I have done here, my work – Therefore I have not waited for the Salon – where I could only send two things – This is an "overture!" –

16. *Harmony in Blue and Gold.*
The Peacock Room. 1877.

"HARMONY IN BLUE AND GOLD.
THE PEACOCK ROOM."

The Peacock is taken as a means of carrying out this arrangement.

A pattern, invented from the Eye of the Peacock, is seen in the ceiling spreading from the lamps. Between them is a pattern devised from the breast-feathers.

These two patterns are repeated throughout the room.

In the cove, the Eye will be seen running along beneath the small breast-work or throat-feathers.

On the lowest shelf the Eye is again seen, and on the shelf above – these patterns are combined: the Eye, the Breast-feathers, and the Throat.

Beginning again from the blue floor, on the dado is the breast-work, BLUE ON GOLD, while above, on the Blue wall, the pattern is reversed, GOLD ON BLUE.

Above the breast-work on the dado the Eye is again found, also reversed, that is GOLD ON BLUE, as hitherto BLUE ON GOLD.

The arrangement is completed by the Blue Peacocks on the Gold shutters, and finally the Gold Peacocks on the Blue wall.

17. To Theodore Watts-Dunton.
The rights of a patron in a commission.

96 Cheyne Walk
Saturday, 2 February [1878]

My dear Watts – This is my position. – It is far from my wish to rob Leyland of any real right – whatever may be my opinion of his conduct – The portraits of himself and Mrs Leyland I have witheld because of certain remarks in one of his letters impugning their artistic value, and whereas I do not acknowledge that a picture once bought merely belongs to the man who pays the money, but that it is the property of the whole world, I consider that I have a right to exhibit such picture that its character may be guaranteed by brother artists – therefore it was my intention to show, in a public exposition these two paintings this spring – and thereupon restore them to their chance purchaser –

With reference to the portrait of Miss Florence Leyland I have to say that it is incomplete simply because the young lady has not sufficiently sat for it – and as she is not likely to sit for it again, I must do what I can to make it as worthy of me and of herself as possible – When this is all accomplished, Leyland shall have it – for my "stock in trade" is my reputation, and it is not represented by Leyland's money.

In short I propose to hand him over these three pictures very shortly –

As to the fourth, he has made it impossible for me to pay him back the money at present – I am too poor to do so – but directly I am able, I will return him the 400 gns – either in a lump – or by instalments –

Forgive the weariness of all this my dear Watts
Ever yours
J A McN Whistler

P.S. After your rather curt letter, I should really like you to see a certain correspondence between me and Messrs Verity about Leyland gas matters! – *[butterfly]*

18. In conversation: *The Red Rag*, in the *World*, 22 May 1878. *His use of the term 'symphony' etc., in his titles.*

Why should not I call my works "symphonies," "arrangements," "harmonies," and "nocturnes"? I know that many good people think my nomenclature funny and myself "eccentric." Yes, "eccentric" is the adjective they find for me.

The vast majority of English folk cannot and will not consider a picture as a picture, apart from any story which it may be supposed to tell.

My picture of a "Harmony in Grey and Gold" is an illustration of my meaning – a snow scene with a single black figure and a lighted tavern. I care nothing for the past, present, or future of the black figure, placed there because the black was wanted at that spot. All that I know is that my combination of grey and gold is the basis of the picture. Now this is precisely what my friends cannot grasp.

They say, "Why not call it 'Trotty Veck,' and sell it for a round harmony of golden guineas?" – naïvely acknowledging that, without baptism, there is no ... market!

But even commercially this stocking of your shop with the goods of another would be indecent – custom alone has made it dignified. Not even the popularity of Dickens should be invoked to lend an adventitious aid to art of another kind from his. I should hold it a vulgar and meretricious trick to excite people about Trotty Veck when, if they really could care for pictorial art at all, they would know that the picture should have its own merit, and not depend upon dramatic, or legendary, or local interest.

As music is the poetry of sound, so is painting the poetry of sight, and the subject-matter has nothing to do with harmony of sound or of colour.

The great musicians knew this. Beethoven and the rest wrote music – simply music: symphony in this key, concerto or sonata in that.

On F or G they constructed celestial harmonies – as harmonies – as combinations, evolved from the chords of F or G and their minor correlatives.

This is pure music as distinguished from airs – commonplace and vulgar in themselves, but interesting from their associations, as, for instance, "Yankee Doodle," or "Partant pour la Syrie."

Art should be independent of all clap-trap – should stand alone, and appeal to the artistic sense of eye or ear, without confounding this with emotions entirely foreign to it, as devotion, pity, love, patriotism, and the like. All these have no kind of concern with it, and that is why I insist on calling my works "arrangements" and "harmonies."

Take the picture of my mother, exhibited at the Royal Academy as an "Arrangement in Grey and Black." Now that is what it is. To me it is interesting as a picture of my mother; but what can or ought the public to care about the identity of the portrait?

The imitator is a poor kind of creature. If the man who paints only the tree, or flower, or other surface he sees before him were an artist, the king of artists would be the photographer. It is for the artist to do something beyond this: in portrait painting to put on canvas something more than the face the model wears for that one day; to paint the man, in short, as well as his features; in arrangement of colours to treat a flower as his key, not as his model.

This is now understood indifferently well – at least by dressmakers. In every costume you see attention is paid to the key-note of colour which runs through the composition, as the

chant of the Anabaptists through the *Prophète*, or the Hugue-
nots' hymn in the opera of that name.

19. To the Metropolitan Board of Works.
Work on the White House.

96 Cheyne Walk, Chelsea
23 May 1878

Gentlemen, I am, I must say, astonished at getting from you a reply
such as that of your letter of the 20th. inst. – to my most rightful
request. –

I tell you that I have complied with all your requisitions not only
as far as custom requires, but absolutely as far as lies in my power. –

The panels and mouldings are in their places – the façade in
every detail coincides with the amended façade approved by the
Board – the builder's work is terminated, and it is monstrous that
I should be kept out of my house until some chosen sculptor shall
in his turn, have filled these panels with the bas reliefs the Board
insist upon – their wishes I have already undertaken to fully carry
out so soon as is practicable in matters so entirely artistic as these
decorations –

The question between me and the fate of being turned into
the street is one of hours almost –

The question of completing works of Art like the decorations
proposed, may be one of weeks or even months – during which
time I shall (if I am to be really subjected to the tyranny threat-
ened in your letter,) be without a house or studio in which to
carry on my work –

In proportion as you estimate the importance and beauty of
the decorations you insist upon, so must you recognise the neces-
sity of these being executed by a sculptor of distinction –

One must of course wait the time of such men as Mr Böehm Mr Leighton or Mr Watts, unless indeed the Board elects after all to stultify itself by accepting any kind of work that could be done by the nearest stone-cutter in a couple of hours –

And now I have to tell you reluctantly, but finally, that I am advised that your with[h]olding the lease, inflicting upon me, as it does, a damage for which no amount of money can ever compensate, is a proceeding whose wanton cruelty and unexampled vexatiousness no court of law would contenance – and I hold you from this date answerable for all the injury you are inflicting upon me. –

Unless I get the lease in the course of tomorrow, I shall instruct my solicitor to communicate with you –

The bearer waits your answer –

I have the honour to be, Gentlemen,

Your obedient Servant

J A McNeill Whistler

20. To his solicitor, James Anderson Rose.
Views on the Ruskin case.

[Chelsea]
[*received* 21 November 1878]

Dear Rose, – Another view of the case and a further note for Serj. Parry – First I am *known* and *always have been known* to hold an independent position in Art, and to have had the Academy opposed to me – That *is* my position, and this would explain away the appearance of Academicians against me – and offering to paint my pictures in five minutes! and I fancy it would be a good thing for Parry to take the initiative and say this, – and prepare the Jury for all Academic demonstration – Again I don't stand in

the position of the *popular* picture maker with herds of admirers
– my art is quite apart from the usual stuff furnished to the mass
and *therefor[e]* I necessarily have *not* the *large number of wit-
nesses!* – In defending me it would be bad policy to try and make
me out a different person than the well known Whistler – besides
I think more is to be gained by sticking to that character –

However, here are one or two more men to be subpœnaed –

Richard Holmes – Queens Librarian – Windsor –

Reid, The print room – British Museum –

Charles Keen , 11 Queen's Road West – Chelsea.

James Tissot, 17 Grove End Road, St. Johns Wood.

Though I don't think that Whistler ought to have many more
than Böehm and Albert Moore –

What would you think of the Revd Haweis? You know he
preached about the beauty of the Peacock Room – and I have his
printed sermon – it is a perfect poem of praise – he could be
subpœnaed to swear to what he had preached! –

Could you subpœna Prince Teck? to swear that he thought the
Peacock Room a great piece of art? –

Good–night –

J A McN Whistler

Another thing I have just heard – The other side is not at all so
cock sure as they pretend to be! It's a game of bluff my dear Rose
– and we mustn't be bounced out!

21. *Whistler vs. Ruskin.*
Art & Art Critics. December 1878.
Pamphlet on art critics.

Dedicated to
ALBERT MOORE

The *fin mot* and spirit of this matter seems to have been utterly missed, or perhaps willingly winked at, by the journals in their comments. Their correspondents have persistently, and not unnaturally as writers, seen nothing beyond the immediate case in law – viz., the difference between Mr. Ruskin and myself, culminating in the libel with a verdict for the plaintiff.

Now the war, of which the opening skirmish was fought the other day in Westminster, is really one between the brush and the pen; and involves literally, as the Attorney-General himself hinted, the absolute "raison d'être" of the critic. The cry, on their part, of "Il faut vivre," I most certainly meet, in this case, with the appropriate answer, "Je n'en vois pas la nécessité."

Far from me, at that stage of things, to go further into this discussion than I did, when, cross-examined by Sir John Holker, I contented myself with the general answer, "that one might admit criticism when emanating from a man who had passed his whole life in the science which he attacks." The position of Mr. Ruskin as an art authority we left quite unassailed during the trial. To have said that Mr. Ruskin's prose among intelligent men, as other than a *littérateur*, is false and ridiculous, would have been an invitation to the stake; and to be burnt alive, or stoned before the verdict, was not what I came into court for.

Over and over again did the Attorney-General cry out aloud, in the agony of his cause, "What is to become of painting if the critics withhold their lash?"

As well might he ask what is to become of mathematics under

similar circumstances, were they possible. I maintain that two
and two the mathematician would continue to make four, in spite
of of the whine of the amateur for three, or the cry of the critic for
five. We are told that Mr. Ruskin has devoted his long life to art,
and as a result – is "Slade Professor" at Oxford. In the same sen-
tence, we have thus his position and its worth. It suffices not,
Messieurs! a life passed among pictures makes not a painter –
else the policeman in the National Gallery might assert himself.
As well allege that he who lives in a library must needs die a poet.
Let not Mr. Ruskin flatter himself that more education makes the
difference between himself and the policeman when both stand
gazing in the Gallery.

There they might remain till the end of time, the one decently
silent, the other saying, in good English, many high–sounding
empty things, like the cracking of thorns under a pot – undis-
mayed by the presence of the Masters with whose names he is
sacrilegiously familiar; whose intentions he interprets, whose
vices he discovers with the facility of the incapable, and whose
virtues he descants upon with a verbosity and flow of language
that would, could he hear it, give Titian the same shock of sur-
prise that was Balaam's, when the first great critic proffered his
opinion.

This one instance apart, where collapse was immediate, the
creature Critic is of comparatively modern growth – and cer-
tainly, in perfect condition, of recent date. To his completeness
go qualities evolved from the latest lightnesses of to-day – indeed
the *fine fleur* of his type is brought forth in Paris, and beside him
the Englishman is but rough-hewn and blundering after all;
though not unkindly should one say it, as reproaching him with
inferiority resulting from chances neglected.

The truth is, as compared with his brother of the Boulevards,
the Briton was badly begun by nature.

To take himself seriously is the fate of the humbug at home,

and destruction to the jaunty career of the art critic, whose
essence of success lies in his strong sense of his ephemeral exist-
ence, and his consequent horror of *ennuyer*ing his world – in
short, to perceive the joke of life is rarely given to our people,
whilst it forms the mainspring of the Parisian's *savoir plaire*. The
finesse of the Frenchman, acquired in long loafing and clever
café cackle – the glib go and easy assurance of the *petit crevé*,
combined with the *chic* of great habit – the brilliant *blague* of the
ateliers – the aptitude of their *argot* – the fling of the *Figaro*, and
the knack of short paragraphs, which allows him to print of a pic-
ture "C'est bien écrit!" and of a subject, "C'est bien dit!" – these
are elements of an *ensemble* impossible in this island.

Still, we are "various" in our specimens, and a sense of
progress is noticeable when we look about among them.

Indications of their period are perceptible, and curiously
enough a similarity is suggested, by their work, between them-
selves and the vehicles we might fancy carrying them about to
their livelihood.

Tough old Tom, the busy City 'Bus, with its heavy jolting and
many halts; its steady, sturdy, stodgy continuance on the same old
much-worn way, every turning known, and freshness unhoped
for; its patient dreary dulness of daily duty to its cheap company –
struggling on to its end, nevertheless, and pulling up at the Bank!
with a flourish from the driver, and a joke from the cad at the door.

Then the contributors to the daily papers: so many hansoms
bowling along that the moment may not be lost, and the *à propos*
gone for ever. The one or two broughams solemnly rolling for
reviews, while the lighter bicycle zigzags irresponsibly in among
them for the happy Halfpennies.

What a commerce it all is, to be sure!

No sham in it either! – no "bigod nonsense!" they are all "doing
good" – yes, they all do good to Art. Poor Art! what a sad state the
slut is in, an these gentlemen shall help her. The artist alone, by

the way, is to no purpose, and remains unconsulted: his work is explained and rectified without him, by the one who was never in it – but upon whom God, always good, though sometimes careless, has thrown away the knowledge refused to the author – poor devil!

The Attorney-General said, "There are some people who would do away with critics altogether."

I agree with him, and am of the irrationals he points at – but let me be clearly understood – the *art* critic alone would I extinguish. That writers should destroy writings to the benefit of writing is reasonable. Who but they shall insist upon beauties of literature, and discard the demerits of their brother *littérateurs*? In their turn they will be destroyed by other writers, and the merry game goes on till truth prevail. Shall the painter then – I foresee the question – decide upon painting? Shall *he* be the critic and sole authority? Aggressive as is this supposition, I fear that, in the length of time, his assertion alone has established what even the gentlemen of the quill accept as the canons of art, and recognise as the masterpieces of work.

Let work, then, be received in silence, as it was in the days to which the penmen still point as an era when art was at its apogee. And here we come upon the oft-repeated apology of the critic for existing at all, and find how complete is his stultification. He brands himself as the necessary blister for the health of the painter, and writes that he may do good to his art. In the same ink he bemoans the decadence about him, and declares that the best work was done when he was not there to help it. No! let there be no critics! they are not a "necessary evil," but an evil quite unnecessary, though an evil certainly.

Harm they do, and not good.

Furnished as they are with the means of furthering their foolishness, they spread prejudice abroad; and through the papers, at their service, thousands are warned against the work they have yet to look upon.

And here one is tempted to go further, and show the crass idiocy and impertinence of those whose dicta are printed as law.

How he of the *Times* has found Velasquez "slovenly in execution, poor in colour – being little but a combination of neutral greys and ugly in its forms" – how he grovelled in happiness over a Turner – that was no Turner at all, as Mr. Ruskin wrote to show – Ruskin! whom he has since defended. Ah! Messieurs, what our neighbours call "la malice des choses" was unthought of, and the sarcasm of fate was against you. How Gerard Dow's broom was an example for the young; and Canaletti and Paul Veronese are to be swept aside – doubtless with it. How Rembrandt is coarse, and Carlo Dolci noble – with more of this kind. But what does it matter?

"What does anything matter!" The farce will go on, and its solemnity adds to the fun.

Mediocrity flattered at acknowledging mediocrity, and mistaking mystification for mastery, enters the fog of dilettantism, and, graduating connoisseur, ends its days in a bewilderment of bric-à-brac and Brummagem!

"Taste" has long been confounded with capacity, and accepted as sufficient qualification for the utterance of judgment in music, poetry, and painting. Art is joyously received as a matter of opinion; and that it should be based upon laws as rigid and defined as those of the known sciences, is a supposition no longer to be tolerated by modern cultivation. For whereas no polished member of society is at all affected at admitting himself neither engineer, mathematician, nor astronomer, and therefore remains willingly discreet and taciturn upon these subjects, still would he be highly offended were he supposed to have no voice in what is clearly to him a matter of "Taste"; and so he becomes of necessity the backer of the critic – the cause and result of his own ignorance and vanity! The fascination of this pose is too much for him, and he hails with delight its justification. Modesty and good sense are revolted at nothing, and the millenium of "Taste" sets in.

The whole scheme is simple: the galleries are to be thrown open on Sundays, and the public, dragged from their beer to the British Museum, are to delight in the Elgin Marbles, and appreciate what the early Italians have done to elevate their thirsty souls! An inroad into the laboratory would be looked upon as an intrusion: but before the triumphs of Art, the expounder is at his ease, and points out the doctrine that Raphael's results are within the reach of any beholder, provided he enrol himself with Ruskin or hearken to Colvin in the provinces. The people are to be educated upon the broad basis of "Taste," forsooth, and it matters but little what "gentleman and scholar" undertake the task.

Eloquence alone shall guide them – and the readiest writer or wordiest talker is perforce their professor.

The Observatory at Greenwich under the direction of an Apothecary! The College of Physicians with Tennyson as President! and we know that madness is about. But a school of art with an accomplished *littérateur* at its head disturbs no one! and is actually what the world receives as rational, while Ruskin writes for pupils, and Colvin holds forth at Cambridge.

Still, quite alone stands Ruskin, whose writing is art, and whose art is unworthy his writing. To him and his example do we owe the outrage of proffered assistance from the unscientific – the meddling of the immodest – the intrusion of the garrulous. Art, that for ages has hewn its own history in marble, and written its own comments on canvas, shall it suddenly stand still, and stammer, and wait for wisdom from the passer-by? – for guidance from the hand that holds neither brush nor chisel? Out upon the shallow conceit! What greater sarcasm can Mr. Ruskin pass upon himself than that he preaches to young men what he cannot perform! Why, unsatisfied with his own conscious power, should he choose to become the type of incompetence by talking for forty years of what he has never done!

Let him resign his present professorship, to fill the chair of

Ethics at the university. As master of English literature, he has a right to his laurels, while, as the populariser of pictures he remains the Peter Parley of painting.

22. To Marcus Huish, The Fine Art Society.
On proportions and technique in etching.

[Venice]
[c. 26 January 1880]

My dear Mr. Huish – I am shocked out of all my usual impassiveness by the suggestion I have this instant read with horror in your letter, that I could be neglecting the work, for which I had exiled myself, in order to trifle with plates, whose exaggerated size, not only partook of the character so generally accorded to all Howellian assertion, but would have been proof enough in itself – were any needed – of the unlikelihood of the story! –

Little Mr. Brown would have told you how Mr. Whistler holds in contempt and derision the 'big plate' – the advertisement of the ignorant – the inevitable pitfall of the amateur –

I am even astonished that Howell himself – in his desire to make statements – should have missed this tip – as he has often heard me scoff at the vulgarity of the pretence – and point out the gross condition of brain that could tolerate the offensive disproportion between the delicate needle of the etcher and the monster plate to be covered! – Perceive how inartistic is the undertaking – based as it is on the dulness which distinguishes not between mastery of manner, and "muchness" of matter! – From this *pente ridicule* the painter's science saves him – he *knows* that the dimensions of work *must* be always in relation to the means

used – and reaching the limit, unerringly lays aside the needle for
the brush, that he may not find himself worming his weary way
across a waste of copper – all quality lost – all joy of execution
gone – nothing remaining but the doleful task for the dreary
industry of the foolish – the virtue of the duffer! –

Behold now the hardy though unconscious Amateur! – He
hesitates not! – and so we have heads the size of soup plates – and
landscapes like luncheon trays – while lines are bitten furiously
until in the impression they stand out like the knotted veins on
his own unthinking brow –

Poor meek Rembrandt! – with his mild miniatures – besides
such colossal deeds how dwarfed he becomes! how uninteresting
his puny portraits of diminutive Burgomaster Sieymund Clem-
ent de Young – how weak his little windmill – – – – – Ah well!
nous avons changé tout celà! – ... But this is not a letter! – I shall
find myself in the midst of another pamphlet so by the way you
had better carefully keep this – for who knows – I may borrow it
for an extract – Meanwhile I am not sorry that in this moment of
your anxiety you should find me enunciating theories and offering
doctrines as a means of reference – for I wish you to see in this very
preoccupation and certainty in what concerns my work a reason
for rejecting doubtful suggestions from outsiders – The "Venice"
my dear Mr. Huish will be superb – and you may double your
bets all round – only I can't fight against the Gods – with whom I
am generally a favorite – and not come to grief – so that now – at
this very moment – I am an invalid and a prisoner – because I
rashly thought I might hasten matters by standing in the snow with a
plate in my hand and an icicle at the end of my nose. – I was
ridiculous – the Gods saw it and sent me to my room in disgrace.
– For two weeks, with an ulcerated throat and a native doctor,
have I been fought over by an attached friend with a faith in
homoeopathy – though an architect by profession – perhaps
because an architect. – Sly doses of Aconite have counteracted

gargles until at length refusing further experiments, I have as-
serted my right as a wreck – and now comes your letter of re-
proach. – I have not written to you for I hate writing – and
couldn't tell you anything that you didn't already well know –
Have you not read how the people in Monté Carlo fled before
the snow – shrieking with fear at the unknown miracle? How·
Mount Vesuvius is frozen inside – and nothing but icicles come
out? – How here in Venice there has been a steady hardening of
every faculty belonging to the painter for the last two months and
a half at least – during which time you might as well have proposed
to etch on a block of Wenham Lake as to have done anything with a
copper plate that involves holding it! –

Nevertheless be comfortable Huish – and put on an air of ease
when you appear among the questioning philistines and unbe-
lievers generally – for it is a good thing you have gone in for and
will pay splendidly in the end – and after all it is even "for the
best" that this inclemency should have interfered – for had there
been nothing but ordinary weather to deal with, your twelve
plates would have been finished and I should have been back in
London before I had at all known the mine of wealth for both you
and me in this place –

You see when I promised to come here and complete a set of
etchings within a given time, I undertook a Herculean task with-
out knowing it – but as far as the mere plates went doubtless I
should have carried out my contract had not Providence inter-
fered greatly to the advantage of us both – and now I have
learned to know a Venice in Venice that the others never seem to
have perceived, and which, if I bring back with me as I propose,
will far more than compensate for all annoyances delays and
vexation of spirit – Of course I should have found you something
new in any case – but it would not have been so complete – and
the trouvaille would not have been such a mine of wealth as I
shall manage to make it – I have not been idle you may be sure –

The etchings themselves are far more delicate in execution, more beautiful in subject and more important in interest than any of the old set – Then I shall bring fifty or sixty if not more pastels totaly new and of a brilliancy very different from the customary watercolor – and will sell – I don't see how they can help it –

But then my dear Huish the revers de la medaille! – I am frozen – and have been for months – and you cant hold a needle with numbed fingers – and beautiful work cannot be finished in bodily agony – also I am starving – or shall be soon – for it must be amazing even to you that I should have made my money last this long –

You had better send me fifty pounds at once and trust to a thaw which will put us all right – If I come back with pictures drawings and etchings the expedition will have succeeded beyond all hope and each item will go to increase the value of the other –

Please write and address Café Florian Place St. Marc. Venice –

Very sincerely Yours

J A McN Whistler

The 57th day of hard unrelenting frost! Venetian method of counting – Send for Howell and read him my letter! – –

23. To his mother, Anna Matilda Whistler.
His new work in pastels.

[Venice]
[Spring 1880]

My own dearest Mother – I have been so grieved to hear of your being ill again – and now I am delighted to hear better news of you – Do not let any anxiety for me at all interfere with your rapidly getting quite well – for I am happy to tell you that my own

health is capital and the weather alone in all its uncertainties retards my work – which however is now very nearly complete – so that I look forward to being with you soon.

It has been woefully cold here – The bitterest winter I fancy that I ever experienced – and the people of Venice say that nothing of the kind has been known for quite a century – Mrs Bronson was telling me – by the way you will be pleased to hear that they have returned from their wanderings and are now settled in their palace on the Grand Canal – well she has told me that since it was known that she was here, her many pensioners have called to welcome her back and all said to her the same thing – "Look Signora they said, pointing to their white hair, look – I am old – and yet I have never seen such a winter! – and I only wonder that I have lived through it to tell the Signora!" –

At last the ice and snow have left us and now the rain is pouring down upon us! Today reminds me of our stay long ago at Black Gang Chyne! – After all though this evening the weather softened slightly and perhaps tomorrow may be fine – and then Venice will be simply glorious, as now and then I have seen it – After the wet, the colors upon the walls and their reflections in the canals are more gorgeous than ever – and with sun shining upon the polished marble mingled with rich toned bricks and plaster, this amazing city of palaces becomes really a fairyland – created one would think especially for the painter – The people with their gay gowns and handkerchiefs – and the many tinted buildings for them to lounge against or pose before, seem to exist especially for one's pictures – and to have no other reason for being! – One could certainly spend years here and never lose the freshness that pervades the place! But I must come back to you all now though – even if I return afterwards – Yes I hope now in a couple of weeks or so to pack all my works and see how the long hoped for etchings will look in London –

Also you know, for I daresay Nellie has told you, – that I have

fifty pastels! So you see Mother dear that I have not been idle –
though I have found my labors terribly trying – It will be pleasant
to talk them all over with you when I come back – I shall have
plenty to tell you of all the beautiful things I have seen – and I
hope you will like some of the pastels I have done – Nellie must
tell you about them – They are much admired here – and I think
rather well of them myself – though sometimes I get a little
despondent –

My kind friend Mr Graham whom you remember my writing
to you about, has been away for some weeks in Rome – returning
only the other day – I was glad to see him for he had been most
courteous and persistent in his good services to me – He brought
Mr Bronson with him a couple of mornings ago, and very jolly
was our meeting – for I always like him – he is most original and
amusing – I have dined with the Bronsons since – and they are
most amiable and nice – Mrs Bronson who is the most generous
woman possible has been so kind to a poor Gondolier I was paint-
ing, and who fell ill with dreadful cough and fever – I told her all
about him – and she at once had all sorts of nice things made for
him – and Miss Chapman who is staying with the Bronsons has
been herself to call on poor Giovanni – He is getting well now I
hope and will soon be able again to pose for his picture – Mrs
Harris the wife of the American Consul has been very charming –
always asking me to her house and presenting me to all her best
acquaintances – She is a dear old lady and I know you would like
her –

So you see I have not been without friends Mother, and not-
withstanding the fearful climate, not absolutely forlorn and
cheerless – I am so glad to hear that everything is happily ar-
ranged for Annie's future – Give my love and congratulations to
her when you see her, or send them through Sis –

And now Goodbye my darling Mother – I do hope you will be
quite well and strong again directly now – for I have accounts

from England saying that the sun is shining upon all there and
that everything is warm and delightful! You asked once about
Susie Livermore's etchings – doubtless she has had them all
before now – for they were left out purposely for her – ready in
their frames – I received your nice Christmas card Mama dear –
and meant to have written at once to tell you how gratified I was
– but it is the same old story my dear Mother I am at my work the
first thing at dawn and the last thing at night, and loving you all
the while though not writing to tell you – Remember me to Mrs
Mutrie and give my love to all –

Your fond son

J A McN Whistler

24. In conversation with Mortimer Menpes.
The secret of drawing.

[Venice] [1880]

He described how in Venice once he was drawing a bridge, and
suddenly, as though in a revelation, the secret of drawing came to
him. He felt that he wanted to keep it to himself, lest someone
should use it, – it was so sure, so marvellous. This is roughly how
he described it:

"I began first of all by seizing upon the chief point of interest.
Perhaps it might have been the extreme distance, – the little pal-
aces and the shipping beneath the bridge. If so, I would begin
drawing that distance in elaborately, and then would expand
from it until I came to the bridge, which I would draw in one
broad sweep. If by chance I did not see the whole of the bridge, I
would not put it in. In this way the picture must necessarily be a
perfect thing from start to finish. Even if one were to be arrested
in the middle of it, it would still be a fine and complete picture."

25. To Thomas S. Chapman.
How to paint flesh, shadows, etc.

[Spring 1881]

My Dear Old Tom I am sorry to see from your letter that you
think so badly of yourself – if the wind that blows and blows un-
ceasingly here is blowing as I suppose it is all over the world, and
is at this moment saddening your life as it is ours, I can under-
stand your depression – However I do hope you will be stronger
and brighter when this reaches you – and if you are wishing to
paint upon any principal of mine, I must say my dear Tom you
give proof of pluck that I wish you were here to show 'mine en
emies'! – A propos of enemies, I enclose a copy of some corre-
spondence that I think will interest and amuse you – There has as
yet been no termination to the little row but at least you will ap-
preciate the villainy and foolishness of that nice couple of black-
guards Haden and Legros! –

And now about the painting – I don't know Tom that at this
distance I can make myself understood – however I will try –

1st Indicate the head with charcoal – that is find its place on
the canvass – and then draw it lightly with a brush – you might
use a little grey for this purpose made of Ivory black – white –
Venetian red and a little yellow ochre.

2 – Rub this, as you draw, with a hog hair brush, into the
shadow – and in short draw or model lightly your whole head
with this warm grey or brown – *If tired* then let this *dry com-
pletely* – that is put it away for 3 or 4 days – Put your canvass out
in the open air – with its face to the wall and its back to the sun –
You do not, you see, paint over the surface enclosed in your draw-
ing with white or other preparation. When you take it up again,
you may work over the same places again with the same material
only that now as your head is already found you will have less

trouble – and in short this will to all intents and purposes be a *first* painting.

Continue now with your flesh color painting *from the light* into the shadow while the shadow is wet – so that you will really be covering the whole head in one sitting and indeed with one painting –

This Tom is the simplest and best way out of it all – You will mix your flesh tints of course with white, and as you get towards the shadow you will see how much darker the grey or brown looks than nature, and then you will perceive the *color* that there is in the shadow and you will be enabled to reach that by a mixture of your grey with some of the flesh tone on your palette – and so my dear Tom you will proceed and finish – If you are not quite satisfied the next day, don't be disheartened – *put away* your canvass again for some few days and only take it up when completely dry –

3rd Use if you like linseed oil and turpentine mixed – *not* meguilp –

4th dont be afraid of your shadows having white in them – You see I tell you the flesh colors will mix themselves with your shadows – And Tom old chap I hope I have not fatigued you – Willie sends his love – he is laid up for the moment with a cold.

Ever yours affectionately

J A McN Whistler.

26. To his sister-in-law, Helen Whistler.
Struggles with nature in Jersey.

[Hôtel de l'Europe,
St Helier, Jersey]
Monday [Autumn 1881]

I suppose you have all given me up – and well you may – for I have almost given myself up – and a poor time I have had of it – Nothing but sheer obstinacy my dear Nellie, makes me stay away from the only place that is meant to live in – The fact is I am more than ever convinced that all fables about warm climates and gulf streams are of the meanest invention – and I am continually their victim!–

I only got here on Saturday morning – after a trip – if you can call it a trip – of the wildest – thirteen and a half hours of pitch and toss until it was a mere chance how I turned up – heads or tails! – At Guernsey then I chucked up the game and went ashore – There I stayed and struggled with wind and weather – and paintboxes with that perseverence that is the peculiarity of this family, as you will know – But what will you – quite hopeless – After being whisked about on the tops of very grand rocks and nearly blown into the sea canvas and all and dragging myself each evening back to the inn a dishevelled wreck of fright and disappointment I ceased a career only fit for an accrobat and came over to Jersey remembering that you had said it was comparatively flatter! –

Well it's flat – or a bit of it is – and besides I run no more risks on pinacles – but the weathercocks in the place have played me another trick and gone round, the lot of them, to the East – North East by East! – and awful it is – cold as Venice in winter – and everything hard as nails – What shall I do! not a single picture have I managed yet – though I have tried ever so hard – but that you know is no

comfort for – have I not written it! – 'mere industry is the virtue of the duffer'! – and poor as I am – well you know – how is my journey to be payed for! – It is true that I partly discovered a little game in watercolors that may possibly be worked into an pound or so – but alas – what is that – However I shall still try – for a few days longer and then I must try the "Ella" for my home passage – The 'Fannie' thank you I am utterly indifferent to –

Meanwhile if you write at once you may tell me whether Madame Dominique of Guernsey is to send you the parrot – I understood her to say that after all you may have it for 3 French Louis – that is 60 francs – tho' she had meant 3 Guernsey Louis – that is 72 francs – I really couldn't take charge of the cage myself Nellie – I dont really think I could do it – as I have the folly to bring with me lots of boxes and traps enough to produce a *gallery* of chef d'oeuvres! As to Mme. Coronio's pot and pans – *impossible!* – I mean I can't bring them – tho' I would give any message to the man in St. Heliers if you send it with the address – I am staying at the Hotel de l'Europe – which I must say is certainly most capital – but you had better write to me Poste Restante – for who knows! – Love to both – always affectionately

Tell me *all the* news

27. To his sister–in–law, Helen Whistler. *The decoration of a room for his brother William and her.*

[Hogarth Club]
postmark: 16 December 1881]

My dear Nellie – It all comes of not doing *exactly* as I understood it should be –

If the first coat had been as I *directed* grey brown – This too

crude and glaring condition of the yellow would not have occured –

It is just because of the horrid white ground – Also why on earth should the workmen think for themselves that after all *two* coats of the yellow upon *white* would do just as well as *one* coat of yellow on grey! – This was so ordered by me because in my experience the result would have been fair and at the same time soft and sweet –

However it is not for the purpose of boring you my dear Nellie that I write all this, only I am just a little disappointed because I thought I had done nicely the matter you wished me to manage – and now it is most impossible for me to get up today or tomorrow – for I have the old boy and Mrs Forster without intermission upon my hands –

Now listen –

See that the man gets a tube of "Ivory black" from any colorman's and a tube of "raw Sienna." Let him put first about a saltspoon full of the Ivory black into his pot of yellow paint, 'mix well – and stir' this will lower the moral tone of that yellow! – but you must not be alarmed if to your over anxious eyes it even looks a little green – all the better –

Then mix and stir in say half the tube of raw Sienna and I should think you would bring things to their natural harmony – If not quite satisfied – try then another salt spoon of black – and the other half of the tube of Raw Sienna – 'mix to taste' – Don't be afraid – you are well started – and dont be shocked if the *first little daub* of this new mixture looks dirty on the bright yellow coat already on the wall – Of course it will – but remember that brightness is what you wish to be rid of – also remember that when the second coat is all over the wall you will *only see the second coat!* – You can't make any mistake – it is not like the distemper business, because here you see exactly what you are about in the pot! – Que Dieu vous garde! –

[butterfly]

28. To Waldo Story. *'Arrangement in White and Yellow': his exhibition at the Fine Art Society.*

13 Tite Street
Chelsea. London
[*postmark*: 5 February 1883]

Now listen to me! – I am always waiting to talk to you my dear old Waldino – and I am always meaning to write – so that things go on – go on – until how to say it all and where to begin!! – Well – *Games* you know! of course – Amazing! – Really I do believe "I am a devil" like Barnaby Rudge's raven! – Oscar too always says 'Jimmie you are a devil'! – Anyhow I have had inspiration after inspiration and I am free to acknowledge that they partake greatly of the dainty collecting and wickedness of our friend the original 'Amazer'! – Waldino it is simply superb, the game! – Only *now* is the moment for a rally – and so I am waiting for you – you *must* just pack your bag and turn up in Tite Street on Wednesday the 14th at about 2 o'clock – or Thursday morning by 10 – A.M. – but that is already late – No say Wednesday – in time for dinner if you like – but "don't be late"! – Write at once and say you are coming – that it is all right – and that I may rely on you – I mean you would never forgive yourself if you were absent –

Besides are you not my most intimate chum – a very Pal – and the *only* one who besides myself really *knows!* So Waldo put aside the work which I know must be lovely – and run up to London for a week – and then you shall go back – But don't let anything prevent your coming – It will do us both such a lot of good to meet again just now – we have such a lot to say to each other – And with this all I haven't told you what it is about –

Well great Shebang on Saturday 17 Feb – Opening of Show and Private View – "Arrangement in White and Yellow". I do the

Gallery in Bond Street – where I have won my battle and am on good terms with the Fine Art Society – having it all my own way of course – hurrah! – All the World there – Lady Archie – the Prince – and Various! – especially Various! – great glorification – and the Butterfly rampant and all over the place! I can't tell you how perfect – though you would instinctively know that there isn't a detail forgotten – Sparkling and dainty – dainty to a degree my dear Waldino – and all so sharp – White walls – of different whites – with yellow *painted* mouldings – not *gilded!* – yellow velvet curtains – pale yellow matting – yellow sofas and little chairs – lovely little table yellow – own design – with yellow pot and *Tiger* lilly! Forty odd *superb* etchings round the white walls in their exquisite white frames – with the little butterflies – large white butterfly on yellow curtain – and yellow butterfly on white wall – and finally servant in yellow livery (!) handing catalogue in brown paper cover same size as Ruskin pamphlet!!! And *such* a catalogue! – The last inspiration! – Sublime simply – Never such a thing thought of – I take my dear Waldo, all this I have collected of the silly drivel of the wise fools who write, and I pepper and salt it about the Catalogue under the different etchings I exhibit! – in short I put their nose to the grindstone and turn the wheel with a whirr! – I just let it spin! – stopping at nothing – marginal notes like in the Paddon Papers – I give 'em Hell! – quoting old Solomon about the fool to my heart's content –

The whole thing is a joy – and indeed a masterpiece of Mischief! –

For instance –

"This is not the Venice of a Maiden's fancies"

"Arry" – in the Spectator – –

Then I have got two or three etchings by Hammerton – and Arry's Doorway – and I am thinking of exhibiting them as the "Works of those who judge our Work" – and then as the final tip I am having a lot of lovely little butterflies made in yellow satin

and velvet with their little sting in silver wire which will be worn as badges by the women Amazers!!! –

You must come of course – so now rouse up Waldo and rush over here at once – It would be so nice if you could be here some few days beforehand – that we might shove on the Show together –

Can't you come at once – as well one day as another – Eldoni at present is hopeless – domesticity and whisky having proved too much –

It was awful about the lovely figurines being broken! we were all dreadfully disappointed –

Many kind things to Miss Broadwood – and come at once – always

29. To his sister-in-law, Helen Whistler.
Painting at St Ives: nature is a poor creature.

14 Barnoon Terrace,
St. Ives, Cornwall.
[20 January 1884]

You are quite right my dear Nellie – I have been shabby enough in not writing to you – and unwise too for I might have had more of your own nice letters in reply – But I am as you have divined in a very bad way indeed! –

The country wearies me – I have exhausted the Ocean! – come now this is charming! the grasshopper is indeed a burden – wherever he is! –

Dear me Nellie when I am talking to you I find I am quite brilliant again! –

Dont you think Atlas ought to have those two things – about the Ocean – and the grasshopper?

Well – for dullness, this place is simply amazing! – nothing but Nature about – and Nature is but a poor creature after all – as I have told you – poor company certainly – and, artistically, often offensive –

Upon this subject I shall be quite eloquent when you see me again – Indeed it must be made much of in my next brown paper pamphlet – when shall I write that masterpiece? –

I wish enough I could run up to town again at once – but I don't know. The work I am doing may make this exile worth while – I have such inspirations too! in the way of 'games' for other shows – indeed I am sometimes quite bewildered with my own sparkling invention –

Thank Willie for sending me the ten pounds at once as I begged him to – Enclosed is my check for that sum – but do you know I *really am* on the verge of destitution again – Lots of wealth I suppose in the way of material – but like pastels worth much if able to keep – what I want now is a portrait, that would pay me – I wrote to Jack Chapman the other day and told him that if he would send me £200, *at once*, (a sum I happen to require) I would paint him a full length of his wife when they come to town – I haven't heard as yet – but surely that is a good offer considering the value the picture will be to him – Don't you know anyone? – but it requires great diplomacy to make it all right – Of course the Ross Winans would be a good business by and by when they come back – etchings and pictures and portrait – But I want somebody now – Also could you and Willie think of anyone I might borrow from for the while – You see I don't want to go to the Fine Art Society.

Get the World again this week – not quite sure – but *may* have another shot –

If you write me a line tomorrow it would be delightful
Always affectionately,

[butterfly]

30. *Propositions – No. 2.* May 1884.
What constitutes a finished picture.

A picture is finished when all trace of the means used to bring about the end has disappeared.

To say of a picture, as is often said in its praise, that it shows great and earnest labour, is to say that it is incomplete and unfit for view.

Industry in Art is a necessity – not a virtue – and any evidence of the same, in the production, is a blemish, not a quality; a proof, not of achievement, but of absolutely insufficient work, for work alone will efface the footsteps of work.

The work of the master reeks not of the sweat of the brow – suggests no effort – and is finished from its beginning.

The completed task of perseverance only has never been begun, and will remain unfinished to eternity – a monument of goodwill and foolishness.

"There is one that laboureth, and taketh pains, and maketh haste, and is so much the more behind."

The masterpiece should appear as the flower to the painter – perfect in its bud as in its bloom – with no reason to explain its presence – no mission to fulfill – a joy to the artist – a delusion to the philanthropist – a puzzle to the botanist – an accident of sentiment and alliteration to the literary man.

[butterfly]

31. To Walter Dowdeswell.
His wish to pick his own prey for skirmishes in the press.

Beaufort Grill Club,
32 Dover Street, W.
[18 July 1884]

Dear Mr. Dowdeswell – I rather fancy, from what you hinted at the other day, that it may be the intention of either yourself or your brother to answer the foolish little article you showed me in "The Artist." –

Let me, while thanking you for your warm feeling, beseech you to do nothing of the kind –

Among sportsmen there is a certain sense of the ridiculous that prevents them firing at a skunk – and I who count my trophies of the chase, could not possibly pin upon my wall the poor pecked feathers of the twittering tomtit, who struggles in the street with the stray straw from beneath the scavenger's cart, that his starving family may feed on the filth and thrive –

They say that I am cruel, and that I cannot forgive the fool – but I pick my prey, dear Mr. Dowdeswell, and do not indiscriminately pursue "even unto him that pisseth against the wall"!

[butterfly]

32. *Mr Whistler's "Ten O'Clock."* 20 February 1885.

Ladies and Gentlemen! –
It is with great hesitation and much misgiving that I appear before you, in the character of – The Preacher –

If timidity be at all allied to the virtue modesty, and can find favor in your eyes, I pray you, for the sake of that virtue, accord me your utmost indulgence –

I would plead for my want of habit, did it not seem preposterous, judging from precedent, that aught save the most efficient effrontery, could be ever expected in connection with my subject – for I will not conceal from you, that I mean to talk about Art! Yes, Art – that has, of late become, as far as much discussion and writing can make it, a sort of common topic for the Tea table. –

Art is upon the Town! – to be chucked under the chin, by the passing gallant! – to be enticed within the gates of the householder – to be coaxed into company, as a proof of culture and refinement! –

If familliarity can breed contempt, certainly Art, or what is currently taken for it, has been brought to its lowest stage of intimacy! –

The people have been harrassed with Art in every guise – and vexed with many methods, as to its endurance – They have been told how they shall love Art! and live with it – Their homes have been invaded – their walls covered with paper – their very dress taken to task, – until roused at last, bewildered and filled with the doubts and discomforts of senseless suggestion, they resent such intrusion, and cast forth the false prophets, who have brought the very name of the beautiful into disrepute, – and derision upon themselves. –

Alas! ladies and gentlemen – Art has been maligned – she has nought in common with such practices – She is a goddess of dainty thought – reticent of habit – abjuring all obtrusiveness – proposing in no way to better others –

She is withal selfishly occupied with her own perfection only – having no desire to teach – seeking and finding the beautiful in all conditions, and in all times – As did her high priest Rembrandt, when he saw picturesque grandeur and noble dignity in the Jews' quarter of Amsterdam – and lamented not that its inhabitants were not Greeks. –

As did Tintoret and Paul Veronese, among the Venetians – while not halting to change the brocaded silks for the classic draperies of Athens. – –

As did, at the Court of Philip, Velasquez, whose Infantas clad
in inaesthetic hoops, are, as works of Art, of the same quality as
the Elgin marbles –

No reformers were these great men – no improvers of the
ways of others! – Their productions, alone, were their occupa-
tion, and, filled with the poetry of their science, they required not
to alter their surroundings – for as the laws of their Art were re-
vealed to them, they saw, in the developement of their *work*, that
real beauty, which, to them, was as much a matter of certainty
and triumph, as is to the astronomer, the verification of the re-
sult, foreseen, with the light given to him alone. – In all this, their
world was completely severed from that of their fellow creatures,
with whom, sentiment is mistaken for poetry, and for whom,
there is no perfect work, that shall not be explained by the benefit
conferred upon themselves – Humanity takes the place of Art –
and God's creations are excused by their usefulness –

Beauty is confounded with Virtue, and, before a work of Art, it
is asked: "What good shall it do?" –

Hence it is that nobility of action, in this life, is hopelessly
linked with the merit of the work that portrays it – and thus the
people have acquired the habit of looking, as who should say, not
at a picture, but *through* it, at some human fact, that shall, or
shall not, from a social point of view, better their mental, or moral
state – So we have come to hear of the painting that elevates, –
and of the duty of the painter – of the picture that is full of
thought – and of the panel that merely decorates. –

A favorite faith, dear to those who teach, is that certain periods
were especially artistic, and that nations, readily named, were
notably lovers of Art. –

So we are told that the Greeks were, as a people, worshippers
of the beautiful, and that in the fifteenth century, Art was
engrained in the multitude –

That the great masters lived, in common understanding with their patrons – that the early Italians were artists – all! – and that the demand for the lovely thing, produced it. –

That we of today, in gross contrast to this Arcadian purity, call for the ungainly, and obtain the ugly –

That could we but change our habits and climate – were we willing to wander in groves – could we be roasted out of broad-cloth, were we to do without haste, and journey without speed, we should again *require* the spoon of Queen Anne, and pick at our peas with the fork of two prongs! And so, for the flock, little hamlets grow, near Hammersmith, and the steam horse is scorned. –

Useless! quite hopeless and false is the effort! – built upon fable, and all because "a wise man has uttered a vain thing and filled his belly with the East wind". –

Listen! – there *never* was an artistic period! –

There *never was* an art loving nation –

In the beginning, man went forth each day – some to do battle – some to the chase – others again to dig and to delve in the field – all that they might gain, and live – or lose and die – until there was found among them, one, differing from the rest – whose pursuits attracted him not – and so he staid by the tents, with the women, and traced strange devices, with a burnt stick, upon a gourd. –

This man, who took no joy in the ways of his brethren, who cared not for conquest, and fretted in the field – this designer of quaint patterns – this deviser of the beautiful, who perceived in nature about him, curious curvings, – as faces are seen in the fire – This dreamer apart – was the *first* artist. –

And when, from the field and from afar, there came back the people, they took the gourd and drank from out of it. –

And presently there came to this man another – and, in time others – of like nature – chosen by the Gods – and so they worked together – and soon they fashioned, from the moistened earth,

forms resembling the gourd – and, with the power of creation, the heirloom of the artist, presently they went beyond the slovenly suggestion of Nature – and the first vase was born, in beautiful proportion –

And the toilers tilled, and were athirst, – and the heroes returned from fresh victories, to rejoice and to feast – and all drank alike from the Artists goblets, fashioned cunningly – taking no note the while of the craftsman's pride and understanding not his glory in his work – drinking, at the cup, not from choice, not from a consciousness that it was beautiful – but because, forsooth, there was none other! –

And time, with more state, brought more capacity for luxury, and it became well that men should dwell in large houses and rest upon couches, and eat at tables – whereupon the artist, with his artificers, built palaces, and filled them with furniture, beautiful in proportion, and lovely to look upon –

And the people lived in marvels of Art – and eat and drank out of Masterpieces – for there was nothing else to eat and to drink out of – and no bad building to live in – no article of daily life – of luxury, or of necessity that had not been handed down from the design of the Master, and made by his workmen –

And the people questioned not – and had nothing to say in the matter –

So Greece was in its splendour – and Art reigned supreme – by force of fact – not by election – and there was no meddling from the outsider – The mighty warrior would no more have ventured to offer a design for the temple of Pallas Athene, than would the 'sacred' poet have proffered a plan for constructing the catapult –

And the Amateur was unknown – and the Dilettante un-dreamed of –

And history wrote on – and conquest accompanied civilisation – and Art spread – or rather its products were carried by the

victors among the vanquished from one country to another – And the customs of cultivation covered the face of the earth – so that all peoples continued to use what *the artist alone produced* –

And centuries passed in this using, and the world was flooded with all that was beautiful – until there arose a new class who discovered the cheap –

and foresaw fortune in the facture of the sham –

Then sprang into existence, the tawdry – the common – the gewgaw –

The *taste* of the tradesman, supplanted the *science* of the artist – and what was born of the million, went back to them – and charmed them – for it was after their own heart – and the great and the small, the statesman and the slave, took to themselves the abomination that was tendered, and preferred it, and have lived with it ever since –

And the Artists occupation was gone – and the manufacurer and the huckster took his place –

And now the heroes filled from the jugs, and drank from the bowls, with understanding – noting the glare of their new bravery, and taking pride in its worth.

And the people, this time, had much to say in the matter – and all were satisfied – and Birmingham and Manchester arose in their might, and Art was relegated to the curiosity shop –

Nature contains the elements of color and form of all pictures – as the keyboard contains the notes of all music –

but the artist is born to pick, and choose, and group with science, these elements, that the result may be beautiful – as the musician gathers his notes, and forms his chords, until he brings forth from chaos, glorious harmony. –

To say to the painter, that nature is to be taken, as she is, is to say to the player, that he may sit on the piano! –

That Nature is always right, is an assertion, artistically, as

untrue, as it is one whose truth is universally taken for granted –
Nature is very rarely right, to such an extent even, that it might
almost be said that Nature is usually wrong – that is to say – the
condition of things that shall bring about the perfection of
harmony worthy a picture, is rare, and not common at all –

This would seem, to even the most intelligent, a doctrine almost
blasphemous – So incorporated with our education has the
supposed aphorism become, that its belief is held to be part of
our moral being – and the words themselves have, in our ear, the
ring of religion! – Still, seldom does nature succeed in producing a
picture – –

The sun blares – and the wind blows from the East – the sky is
bereft of cloud – and without all is made of iron The windows
of the Crystal Palace are seen from all points of London – the
holiday maker rejoices in the glorious day – and the painter turns
aside to shut his eyes –

How little this is understood, and how dutifully the casual in
Nature, is accepted as sublime, may be gathered from the unlim-
ited admiration, daily produced, by a very foolish sunset –

The dignity of the snowcapped mountain is lost in distinctness
– but the joy of the tourist is to recognise the traveller on the top
– The desire to see, for the sake of seeing, is, with the mass, alone
the one to be gratified – hence the delight in detail – and when
the evening mist clothes the riverside with poetry, as with a veil –
and the poor buildings lose themselves in the dim sky – and the
tall chimneys become campanile – and the warehouses are
palaces in the night – and the whole city hangs in the heavens,
and faireyland is before us – then the wayfarer hastens home –
the working man and the cultured one – the wise man and the
one of pleasure – cease to understand, as they have ceased to see
– and Nature, who for once, has sung in tune, sings her exquisite
song to the Artist alone, her son and her master – her son in that
he loves her, her master in that he knows her –

To him her secrets are unfolded – to him her lessons have become gradually clear – He looks at her flower, not with the enlarging lens, that he may gather facts for the botanist, but, with the light of the one, who sees, in her choice selection of brilliant tones and delicate tints, suggestions of future harmonies –

He does not confine himself to purposeless copying, without thought, each blade of grass, as commended by the inconsequent – but, in the long curve of the narrow leaf, corrected by the straight tall stem, he learns how grace is wedded to dignity, how strength enhances sweetness, that elegance shall be the result. –

In the citron wing of the pale butterfly with its dainty spots of orange – he sees before him the stately halls of fair gold, with their slender safron pillars – and is taught how the delicate drawing, high upon the walls, shall be traced in tender tones of orpiment, and repeated by the base, in notes of graver hue –

In all that is dainty, and loveable, he finds hints for his own combinations, and *thus* is Nature ever his resource – and always at his service – and to him is naught refused –

Through his brain, as through the last alembic, is distilled the refined escence of that thought which began with the Gods, and which they left him to carry out –

Set apart by them to complete their works, he produces that wondrous thing called the masterpiece, which surpasses in perfection, all that they have contrived in what is called Nature, and the Gods stand by, and marvel – and perceive how far away more beautiful is the Venus of Melos, than was their own Eve. –

For some time past the unattached writer has become the middleman in this matter of Art – and his influence, while it has widened the gulf between the people and the painter, has brought about the most complete misunderstanding as to the aim of the picture –

For him, a picture is more or less a hieroglyph or symbol of story

– Apart from a few technical terms, for the display of which he finds an occasion, the work is considered absolutely from a literary point of view – indeed from what other can he consider it – and in his essays he deals with it, as with a novel, a history or an anecdote. –

He fails entirely, and most naturally to see its excellencies, or demerits, artistic, and so degrades Art – as supposing it a method of bringing about a literary climax –

It thus, in his hands, becomes mainly a method of perpetrating something further, and its mission is made a secondary one, even as a means is second to an end –

The thoughts emphasized, noble or other, are inevitably attached to the incident – and become more or less noble, according to the eloquence or mental quality of the writer, who looks, the while, with disdain, upon what he holds as "mere execution" – a matter belonging, he believes, to the training of the schools, and the reward of assiduity – So that as he goes on, with his translation, from canvas to paper, the work becomes his own – He finds poetry, where he would feel it, were he himself transcribing the event – invention, in the intricacy of the mise en scène – and noble philosophy in some detail of philanthropy – courage, modesty, or virtue sugested to him by the occurrence –

All this might be brought before him and appeal to his imagination, by a very poor picture – indeed I might safely say that it generally is –

Meanwhile, the *painter's* poetry, is quite lost to him – The amazing invention that shall have put form and color into such perfect harmony that exquisiteness is the result, is without understanding – the nobility of thought that shall have given the artist's dignity to the whole, says to him absolutely nothing. –

So that his praises are published, for virtues we would blush to possess – while the great qualities that distinguish the one work from the thousand, that make of the masterpiece the thing of beauty that it is, – have never been seen at all – –

That this is so, we can make sure of by looking back at old Reviews upon past Exhibitions, and reading the flatteries lavished upon men who have since been forgotten altogether, – but upon whose works the language has been exhausted in rhapsodies that left nothing for the National Gallery! –

A curious matter in its effect upon the judgement of these gentlemen, is the accepted vocabulary of poetic symbolism that helps them by habit in dealing with nature – A mountain to them, is synonymous with height – a lake, with depth – the ocean with vastness – the sun with glory –

So that a picture with a mountain, a lake and an Ocean, however poor in paint, is inevitably lofty – vast – 'infinite' and 'glorious' on paper –

There are those also, sombre of mien, and wise with the wisdom of books, who frequent museums and burrow in crypts – Collecting – comparing – compiling – classifying – contradicting. – Experts these – for whom a date is an accomplishment – a hallmark, success – Careful in scrutiny, are they, and conscientious of judgement – Establishing, with due weight, ... unimportant reputations – discovering the picture, by the stain on the back – testing the Torso, by the leg that is missing – filling folios with doubts on the way of that limb – disputatious and dictatorial, concerning the birthplace ... of inferior persons – speculating ... in much writing, upon the great worth of bad work – ... True clerks of the collection, they mix memoranda with ambition – and reducing Art to Statistics, they 'file' the Fifteenth Century and pigeonhole the Antique! –

Then the 'Preacher' – appointed! – He stands in high places – harangues and holds forth – Sage of the Universities – learned in many matters, and of much experience in all save his subject –

Exhorting – denouncing – directing –

Filled with worth and Earnestness –

Bringing powers of persuasion and polish of language to prove – nothing! –

Torn with much teaching – having naught to impart –

Impressive – important – shallow

Defiant – distressed – desperate –

crying out, and cutting himself while the Gods hear not –

gentle-priest of the Philistine, withal, again he ambles pleasantly from all point, and, through many volumes, escaping scientific assertion, "babbles of green fields" –

So Art has become foolishly confounded with education – that all should be equally qualified

Whereas, while polish, refinement, culture and breeding, are, in no way, arguements for artistic result, it is also no reproach to the most finished scholar or greatest gentleman in the land that he be absolutely without eye for painting, or ear for music – that in his heart he prefer the popular print to the scratch of Rembrandts needle – or the songs of the Hall to Beethovens 'C minor Symphony' –

if he have but the wit to say so – and do not feel the admission a proof of inferiority –

Art happens – no hovel is safe from it – no Prince may depend upon it – the vastest intelligence cannot bring it about – and puny efforts to make it universal end in quaint comedy – and coarse farce –

This is as it should be – and all attempts to make it otherwise are due to the eloquence of the ignorant – the zeal of the conceited – The boundary line is clear – Far from me to propose to bridge it over, that the pestered people be pushed across –

No! I would save them from further fatigue – I would come to their relief, and would lift from their shoulders this incubus of Art! –

Why, after centuries of freedom from it, and indifference to it, should it now be thrust upon them by the blind! – until wearied and puzzled they know no longer how they shall eat or drink – how they shall sit or stand – or wherewithal they shall clothe themselves – without afflicting Art! –

But lo! there is much talk without! –

Triumphantly they cry 'Beware'! – This matter does indeed concern art! – We also have our part in all true Art! – for remember the "one touch of Nature", that "makes the whole world kin!" –

True indeed – but let not the unwary jauntily suppose that Shakespeare herewith hands him, his passport to Paradise – and thus permits *him* speech among the chosen – Rather learn that, in this very sentence, he is condemned to remain without – to continue with the common –

This one chord that vibrates with all – this "one touch of nature" that calls aloud to the response of each – that explains the popularity of the Bull of Paul Potter –

that excuses the price of Murillo's Conception – this one unspoken sympathy that pervades humanity – is Vulgarity! –

Vulgarity – under whose fa[s]cinating influence 'the many' have elbowed 'the few' – and the gentle circle of Art swarms with the intoxicated mob of mediocrity, whose leaders prate and council, and call aloud, where the Gods once spoke in whisper! –

And *now* from their midst the Dilettante stalks abroad! – The Amateur is loosed – the voice of the Aesthete is heard in the land – and catastrophe is upon us! –

The medler beckons the vengeance of the Gods – and ridicule threatens the fair daughters of the land . –

For there are curious converts to a weird Culte, in which, all instinct for attractiveness – all freshness and sparkle – all woman's winsomeness, is to give way to a strange vocation for the

unlovely! – and this desecration, in the name of the Graces! –

Shall this gaunt, ill at ease – distressed – abashed mixture of mauvaise honte and desperate assertion, call itself artistic – and claim cousinship with the artist? – who delights in the dainty – the sharp bright gaiety of beauty! –

No! a thousand times no! – Here are no connections of ours! – We will have nothing to do with them –

Forced to seriousness, that emptiness may be hidden – they dare not smile –

While the artist, in fulness of heart and head, is glad and laughs aloud – and is happy in his strength – and is merry at the pompous pretention – the solemn silliness that surrounds him! –

For Art and Joy go together with bold open[n]ess – and high head and ready hand – fearing naught – and dreading no exposure –

Know then all beautiful women, that we are with you – pay no heed we pray you to this outcry of the unbecoming – this last plea for the plain! –

It concerns you not –

Your own instinct is near the truth – your own wit far surer guide than the untaught ventures of these thick headed Apollos! –

What! will you come up and follow the first piper that leads you down Petticoat Lane, there, on a Sabbath, to gather, for the week, from the dull rags of Ages, wherewith to bedeck yourselves! – that beneath your travestied awkwardness, we have trouble to find your own dainty selves! Oh fi! – Is the world then exhausted! – and must we go back, because the thumb of the mountebank jerks the other way? –

Costume is not dress –

and the wearers of wardrobes may not be doctors of 'taste'! – For by what authority shall these be pretty masters! – Look well, and nothing have they invented! – nothing put together for comeliness' sake –

Haphazard from their shoulders hang the garments of the Hawker – combining in their person, the motley of manny manners, with the medley of the mummers' closet –

Set up as a warning, and a fingerpost of danger – they point to the disastrous effect of Art upon the Middle Classes –

Why this lifting of the brow in deprecation of the present? – this pathos in reference to the past! –

If Art be rare today, it was seldom heretofore –

It is false this teaching of decay –

The Master stands in no relation to the moment at which he occurs – a monument of isolation – hinting at sadness – having no part in the progress of his fellow men –

He is also no more the product of civilisation than is the scientific truth asserted, dependent upon the wisdom of a period. – The assertion itself requires the *man* to make it – the truth was from the beginning. –

So Art is limited to the infinite, and beginning there cannot progress –

A silent indication of its wayward independence from all extraneous advance, is the absolutely unchanged condition and form of implement, since the beginning of things –

The painter has but the same pencil – the sculptor the chisel of centuries –

Colours are not more since the heavy hangings of night were first drawn aside, and the loveliness of light revealed! –

Neither Chemist nor Engineer can offer new elements of the Masterpiece –

False again is the fabled link between the grandeur of Art, and the glories and virtues of the State – for Art feeds not upon Nations – and peoples may be wiped from the face of the Earth, but Art *is* –

It is indeed high time that we cast aside the weary weight of

responsability and copartnership – and know that, in no way, do our virtues minister to its worth – in no way, do our vices impede its triumph! –

How irksome! how hopeless! how superhuman the self imposed task of the Nation! – how sublimely vain the belief that it shall live nobly – or Art perish! –

Let us reassure ourselves – at our own option, is our virtue – Art, we in no way affect –

A whimsical Goddess – and a capricious – her strong sense of joy tolerates no dul[l]ness – and live we never so spotlessly, still may she turn her back upon us –

As, from time immemorial, has she done upon the Swiss in their mountains –

What more worthy People! – whose every Alpine gap yawns with tradition, and is stocked with noble story – and yet the perverse and scornful one will none of it – and the sons of Patriots are left with the clock that turns the mill, or the sudden Cookoo, with difficulty restrained in its box –

For this was Tell a hero! – for this did Gessler die! –

Art, the cruel jade cares not – and hardens her heart, and hies her off to the East – to find, among the opium eaters of Nankin, a favorite with whom she lingers fondly – carressing his blue porcelain, and painting his coy maidens – and marking his plates with her six marks of choice – indifferent, in her companionship with him, to all save the virtue of his refinement! –

He it is who calls her – *he* who holds her –

And again to the West that her next lover may bring together the gallery at Madrid – and show the World how the Master towers above all – and in their intimacy they revel, he and she, in this knowledge – and he knows the happiness untasted by other mortel –

She is proud of her comrade – and promises that in after years others shall pass that way and understand –

So in all time does this superb one cast about for the man

worthy her love – and Art seeks the Artist alone –

Where h*e* is, there *she* appears – and remains with him – loving and fruitful – turning never aside in moments of hope deferred – of insult and of ribald misunderstanding –

and when he dies, she sadly takes her flight – though loitering yet in the land – from fond association – but refusing to be consoled. –

And so have we the ephemeral influence of the Master's memory – the afterglow, in which are warmed, for a while, the worker and disciple –

With the *man*, then, and not with the multitude are her intimacies – and in the book of her life, the names inscribed are few – scant indeed the list of those who have helped to write her story of love and beauty –

From the sunny morning, when, with her glorious Greek, relenting, she yielded up the secret of repeated line, as, with his hand in hers, together they marked, in marble, the measured rhyme of lovely limb, and draperies flowing in unison,

to the day, when she dipped the Spaniard's brush in light and air, and made his people *live* within their frames, and *stand upon their legs* – that all nobility, and sweetness, and tenderness, and magnificence should be theirs by right, –

ages had gone by, and *few* had been her choice! –

Countless, indeed, the horde of pretenders! –

but she knew them not! – a teeming, seething, busy mass! – whose virtue was Industry – and whose Industry was vice –

Their names go to fill the catalogue of the Collection at home – of the Gallery Abroad – for the delectation of the bagman, and the Critic! –

Therefore have we cause to be merry! – and to cast away all care – resolved that all is well, as it ever was – and that it is not meet that we should be cried at, and urged to take measures –

Enough have we endured of dullness! – Surely are we weary of weeping – and our tears have been cozened from us falsely – for they have called out 'woe'! when there was no grief – and alas! where all is fair –

We have then but to wait – until, with the mark of the Gods upon him, there comes among us, again, the chosen, who shall continue what has gone before – satisfied that even, were he never to appear, the story of the beautiful is already complete – hewn in the marbles of the Parthenon, and broidered, with the birds, upon the fan of Hokusai – at the foot of Fusihama –

33. *Mr Whistler's "Ten O'Clock." Opinions of the Press. 1885. Extracts from press reviews.*

"The lecture will certainly attract every one in town, and is sure to be worthy of an attentive hearing. Those who have met Mr. Whistler in society know that he is one of the most amusing of companions, and that his bons mots are unique. The artistic event of the opening season will, of course, be Mr. Whistler's 'Ten o'Clock.'" – WORLD, Feb. 14.

"Mr. Whistler's lecture is distinctly a surprise. We expected, as a matter of course, wit, humour, and neat epigram. We got these and a great deal more." – DAILY NEWS.

"During his brilliant harangue, Mr Whistler was frequently interrupted by a ripple of laughter or a hearty round of applause from the crowded audience, whose interest and amusement never slackened for an instant." – DAILY NEWS.

"There was a large and brilliant audience, at whose hands the lecturer experienced a very favourable reception." – MORNING POST.

"The carefully and well-kept secret of Mr Whistler's purpose

in asking the public to meet him last night at the hour of 10 o'clock, in Prince's Hall, was revealed in the first sentence which he addressed to the fashionable and brilliant audience who had assembled in the expectation that the eccentric genius of the artist would find them amusement for an hour. Their faith was not misplaced." – THE TIMES.

"Punctually at 10 o'clock, as fashionable, as literary, and as artistic an audience as London could muster, arrived at the doors of the Prince's Hall, Piccadilly." – DAILY TELEGRAPH.

"Few, if any, of the audience who crowded Prince's Hall last night, to listen to the message, with the delivery of which Mr. Whistler had mysteriously announced himself to be commissioned, credited the lecturer beforehand with the remarkable powers of oratory which he showed that he possessed." – ST. JAMES'S GAZETTE.

"In presence of one of the most brilliant, fashionable, and representative audiences of the season, Mr. Whistler gave yesterday, at ten o'clock, at the Prince's Hall, an hour's address upon Art and Criticism ... Flashes of amusing paradox and outbursts of characteristic cynicism elicited much mirth from the audience – and the whole was a great success ... Not difficult was it sometimes to individualise the unnamed writers against whom the lecturer fulminated." – THE GLOBE.

"For some little time past that eccentric person, Mr. James M'Neill Whistler, has kept the intellects of London in suspense by the announcement that on a Friday evening he would give a 'Ten o'Clock' at Prince's Hall, Piccadilly. Mr. Whistler's lecture will, of course, be published. It will be more than curious to note if Mr. Ruskin will condescend to notice it; and if he does, in what fashion he will treat the artist." – LIVERPOOL DAILY POST.

"A very large and fashionable audience filled the Prince's Hall, Piccadilly, on Friday evening, little expecting to hear a closely-reasoned and lucid exposition of the relations between the artist,

his work, and the people in general ... The success of Mr. Whistler's 'Ten o'Clock' was indeed unquestionable, not only as a rare entertainment; but as a most unexpected revelation of serious and scientific work, from a man who previously has been popularly regarded as eccentric and incomprehensible." – MANCHESTER GUARDIAN.

"Last night, at Prince's Hall, Mr. Whistler made his first appearance as a lecturer on Art, and spoke for more than an hour with really marvellous eloquence." – PALL MALL GAZETTE.

"Mr. Whistler excelled himself last night. He asked people to come to a mysterious meeting, which he called his 'Ten o'Clock.' When he got them there in full evening dress after dinner he gave them a lesson on Art. It was the most amusingly amazing performance ever witnessed." – LIVERPOOL MERCURY.

"OUR 'TEN O'CLOCK' TEACHER. – Mr Whistler's latest enterprise has scored a great success. Those who came to scoff remained to listen meekly. Before long, it is to be hoped that this sermon will have been heard again in the land, and subsequently, perchance, it will also be given to the world in the brown-paper covers which have in times past contained so much to drive critics to despair. Even then, when the homily is read in its completeness, there will be wanting the inimitable manner in which each point was made, and every paragraph ended with an epigram, which oftentimes tickled from its unexpectedness." – THE WORLD.

"Mr. Whistler's 'Ten o'Clock' was a great success on Friday night. All that was pretty, witty, artistic, aesthetic, dramatic and poetic, turned up to listen to the utterances of the master." – WHITEHALL REVIEW.

"Mr. Whistler is certainly a universal favourite. Last Friday night the Prince's Hall was crowded with literature and fashion. There were lords and ladies, beauties and their attendant 'beasts,' painters and poets, all who know about Art, and all who thought that they did. 'What is Jimmy going to say?' At last

'Jimmy' appeared on the stage. There was none of the mincing affectation of the lecturers who prate of an Art they know nothing about. His lecture was a genuine success, and all seemed delighted with 'Jimmy.'" – TRUTH.

"Mr. Whistler's 'Ten o'Clock' was not even a good practical joke. In a metropolis seething with irreverence, Mr. Whistler is permitted to mount a platform and spout artistic sedition. But the Art work of this country will thrive, and men like Ruskin will be remembered after Mr. James Whistler and his 'Ten o'Clock' are buried in oblivion." – DRAMATIC REVIEW.

"Mr. Whistler's very clever and brilliant 'Ten o'Clock' was repeated by him before a company of invited guests at the galleries of the Society of British Artists. It is a coruscation of epigrams. The epigrams are of the finest and most rapier-like kind, and such as nobody but Mr. Whistler could put together. The lecture is a very marvellous literary achievement. It is like nothing else of the kind – and superior to most things of the kind – ever done, and is a very welcome contrast to the commonplace efforts of common speakers and writers. It is very, very fine." – VANITY FAIR.

"Mr. Whistler's views on Art are not such as would find acceptance with the million." – YORKSHIRE POST.

"'Everybody' was there, and nearly everybody knew everybody else. It was rather the thing to go. Whistler is undoubtedly a witty man." – LEICESTER CHRONICLE.

"Mr. Whistler's 'Ten o'Clock' attracted, as, of course, everybody knew it would, most of the beauty and the talent that one is accustomed to see on 'first nights' at the most fashionable theatres." – THEATRICAL PROGRAMME.

"Mr. Whistler's 'Ten-and-Sixpenny o'Clock.' Our Jemmy's 'Ten o'Clock' promises to go like one o'clock. He is never for a moment a 'Dismal Jemmy.'" He certainly 'scored' at the Prince's Hall – and as Mr. Whistler hates being indebted to anyone, he paid off several old scores at the same time. A certain proportion

of the crowded audience had evidently come in the expectation of seeing the McNeill stand upon his head, but they were disappointed; the historic white lock remained uppermost, and James firmly planted on his feet, delivered many well-aimed thrusts with the keen rapier of epigrammatic satire. In this lecturing Mr. James Whistler is 'Real James' and not the Pretender. His theories on Art and Nature may be debatable, but his power of epigram is undoubted." – PUNCH.

"All eight o'clock dining London – social, artistic, literary – assembled on Friday, the 20th inst., at the Prince's Hall, to hear Mr. Whistler's 'Ten o'Clock' lecture. Ladies appeared 'en grande tenue.' Diamonds flashed, satins gleamed. There was a subdued air of excited and pleased anticipation. It was 'so like Whistler' to have chosen such an hour for his lecture. At last the painter of 'Symphonies' and 'Harmonies' stepped upon the platform, and was received with the welcome a jaded generation gives to the provider of a new sensation discourse fraught with cynicism and paradoxes, suggestive, occasionally serious, and at times truly eloquent. Many of the ladies present were superbly dressed." – THE QUEEN.

"Everybody was there – lords and ladies of high degree, and persons of more than qualitee. Whistler, with the historical White Lock well to the forefront, began his lecture at 10.15. Pierced through and through with paradox and epigram, the talk came to an end at 11.20. In one way the ten-and-sixpence per seat function was wonderfully successful. It has rehabilitated and made fashionable the ancient lecture, and added a new amusement to a world by no means full of fun after dinner." – SPORTSMAN.

"It was a brave audience of quality and high degree that waited for the coming of Mr. Whistler on the Prince's Hall platform, even as the Israelites awaited the descent of Moses from Sinai. Like unto Moses in one respect, Mr. Whistler decidedly was when he appeared – for he brought with him assorted

epigrammatic commandments – still he differed in appearance from the great law-giver of the desert, inasmuch as Moses is habitually represented with two horns, and Mr. Whistler had only one rising from the ever-arching brow that poured defiance on the Philistines. It was a striking scene – the British Lion and this agile Unicorn fighting for the crown of criticism. The lecturer gradually warmed himself and his audience into enthusiasm as he scattered his pretty paradoxes and glittering conceits by handfuls through the hall. His pose as a pearl-caster before a fashionable and critical audience was sometimes that of a gallant game-cock; sometimes, especially when he presented to us his 'featheredge,' that of a practised duellist." – VANITY FAIR.

"We have had a 'Ten o'Clock' at the Prince's Hall; but that was Mr. Whistler's, and no one knew when it would begin, and it was so bright that no one cared when it ended. Mr. Whistler had cleared every table and chair from the perch where speakers appear, so that no figure but himself could be seen. With his light, graceful, black figure, in an American dress suit, he appeared a remote silhouette, making graceful motions. His manner was marvellously self-possessed. Had he been on a stage all his life he could not with more coolness meet a great audience, not one of which knew what was to be done or said. He assailed his enemies – the critics; he speared like a Soudanese, and so brilliant arrows of scorn and satire flashed through the white hall till after eleven o'clock; and without pause or hesitation, the quaint, luminous, and eloquent harmogue was delivered. The audience consisted of the curious of all nations under the sun in London, and the beauty and variety of the dresses were worthy of the 'dainty goddess' of whom the lecturer spoke. It was itself a triumph that Mr. Whistler's name and his nameless subject should have drawn such an audience together." – BIRMINGHAM WEEKLY POST.

"Mr. Whistler's Art Lecture last evening at 'Ten o'Clock' attracted a large and fashionable audience. The discourse abounded in

sparkling paradoxes, polished epigrams, and novel views on Art. It was a serious protest against mediocrity and vulgarity arising out of recent attempts to popularise Art. The success of the lecture was brilliant." – CABLEGRAM IN NEW YORK TRIBUNE.

"Mr. Whistler's much talked of 'Ten o'Clock,' which people attended with some doubtful expectation of what was coming, proved to be a lecture on Art. I had almost said a serious lecture, and if the word may be taken to express sincerity of purpose, it may stand. Mr. Whistler is nothing if not original. He is the first to hit upon the plan of an entertainment at an hour which will allow his audience to dine comfortably, and no earlier than usual. He emphasised his discovery by the name he gave his lecture. Everybody arrived in good humour, and 'everybody' included numbers of those fashionable women and men whose presence stamps an occasion as 'smart.' Gladys, Countess of Lonsdale, Lady Randolph Churchill, Lady Ribblesdale, Mr. Henry Calcraft, Mr. Mitford, Lord Rowton and Mrs. Cornwallis West were but a few of the many celebrities. To them may be added others equally well known: Lord Dunraven, Lord Wharncliffe, Sir Arthur Sullivan, Mr. Archibald Forbes, Sir Julius Benedict, Mr. Pellegrini, and Mr. George Lewis. There were artists, too, like Mr. Poynter, Mr. Boehm, the sculptor, Mr. Boughton, and Mr. Horkomer, critics who had come to hear themselves mocked with airy ridicule; and persons of distinction in other walks of life. Prince's Hall in Piccadilly holds perhaps 800 people, and was well filled."

"There is a story that a very distinguished writer and personal friend to Mr. Whistler offered to look over the manuscript of his lecture, revise it for him, and put it into shape. The manuscript was duly committed to the hands of this good friend, who found it – he says so himself – so much superior to anything he could have written, that he returned it to Mr. Whistler untouched and with many apologies for his offer. In truth, nothing was more admirable in this performance than its perfection of literary form. The

lecture abounded in polished epigram, in sparkling paradox, in picturesque and poetic passages. It had, moreover, a definite aim, and every arrow shot from that platform went straight to its mark. To Mr. Whistler, art is a religion. His discourse is in the devout strain of a worshipper, but enlivened throughout by wit, and by raillery as subtle as it was good-humoured. Its success was never a moment in doubt. Laughter and applause accompanied the speaker throughout, and congratulations flowed in upon him at its close. Nor was the cordiality of the audience in any wise diminished by its perception of the fact that some flashes of brilliant impertinence which lighted up the lecture scorched and dazzled certain well-known members of the company there present." – NEW YORK TRIBUNE.

34. To Walter Dowdeswell. *On exhibition design.*

[Chelsea]
[April 1886]

Walter –

It is nonsense them telling you that in the papers there would be no room in the papers for our show if the Academy or Grosvenor are going on – Why the arrangement in Brown Paper and Gold is all over the place already – even in the English and American papers in Paris! – I have just had one sent to me – And the papers here will be mad about it – Instead of their being *asked* to write their articles for us, we really ought to charge the Critics something for letting them have the chance! – In any case you may be sure it will be *the* Artistic event of the season, if we dont break our necks and spoil things by undue haste – coming upon the Public without the usual *complete perfection of finish* which is the great characteristic of the Whistler shows –

You know that I am the *last* one to suggest delays, preferring far away swiftness in action – but I wish this of all shows to be an absolute triumph of perfection–

However come down to me this afternoon at 5. to 5.30 without fail and you will understand many things and we will work it all out once *for all* and settle so that matters be put into the calm condition that is necessary to

Success!!

[butterfly]

35. *Propositions.* April 1886
On proportion and the practice of etching.

I. That in Art, it is criminal to go beyond the means used in its excrcise.

II. That the space to be covered should always be in proper relation to the means used for covering it.

III. That in etching, the means used, or instrument employed, being the finest possible point, the space to be covered should be small in proportion.

IV. That all attempts to overstep the limits insisted upon by such proportion, are inartistic thoroughly, and tend to reveal the paucity of the means used, instead of concealing the same, as required by Art in its refinement.

V. That the huge plate, therefore, is an offence – its undertaking an unbecoming display of determination and ignorance – its accomplishment a triumph of unthinking earnestness and uncontrolled energy – endowments of the "duffer."

VI. That the custom of "Remarque" emanates from the amateur, and reflects his foolish facility beyond the border of his picture, thus testifying to his unscientific sense of its dignity.

VII. That it is odious.

VIII. That, indeed, there should be no margin on the proof to receive such "Remarque."

IX. That the habit of margin, again, dates from the outsider, and continues with the collector in his unreasoning connoisseurship – taking curious pleasure in the quantity of paper.

X. That the picture ending where the frame begins, and, in the case of the etching, the white mount, being inevitably, because of its colour, the frame, the picture thus extends itself irrelevantly through the margin to the mount.

XI. That wit of this kind would leave six inches of raw canvas between the painting and its gold frame, to delight the purchaser with the quality of the cloth.

[butterfly]

36. In conversation: *A Further Proposition*, in *Court and Society Review*, 1 July 1886. *On flesh tone.*

The notion that I paint flesh lower in tone than it is in nature, is entirely based upon the popular superstition as to what flesh really is – when seen on canvas; for the people never look at nature with any sense of its pictorial appearance – for which reason, by the way, they also never look at a picture with any sense of nature, but, unconsciously from habit, with reference to what they have seen in other pictures.

Now, in the usual "pictures of the year" there is but one flesh,

that shall do service under all circumstances, whether the person painted be in the soft light of the room or out in the glare of the open. The one aim of the unsuspecting painter is to make his man "stand out" from the frame – never doubting that, on the contrary, he should really, and in truth absolutely does, stand *within* the frame – and at a depth behind it equal to the distance at which the painter sees his model. The frame is, indeed, the window through which the painter looks at his model, and nothing could be more offensively inartistic than this brutal attempt to thrust the model on the hitherside of this window!

Yet this is the false condition of things to which all have become accustomed, and in the stupendous effort to bring it about, exaggeration has been exhausted – and the traditional means of the incompetent can no further go.

Lights have been heightened until the white of the tube alone remains – shadows have been deepened until black alone is left. Scarcely a feature stays in its place, so fierce is its intention of "firmly" coming forth; and in the midst of this unseemly struggle for prominence, the gentle truth has but a sorry chance, falling flat and flavourless, and without force.

The Master from Madrid, himself, beside this monster success of mediocrity, would be looked upon as mild, *beau bien sure, mais pas "dans le mouvement"!*

Whereas, could the people be induced to turn their eyes but for a moment, with the fresh power of comparison, upon their fellow-creatures as they pass in the gallery, they might be made dimly to perceive (though I doubt it, so blind is their belief in the bad) how little they resemble the impudent images on the walls! how "quiet" in colour they are! how "grey!" how "low in tone." And then it might be explained to their riveted intelligence how they had mistaken meretriciousness for mastery, and by what mean methods the imposture had been practised upon them.

[butterfly]

37. To Henry Labouchère. *The universality of art.*

<div align="right">

Paris

21 August [1886]

</div>

Hoity-toity! my dear Henry! – What is all this? How can you startle the "Constant Reader," of this cold world, by these sudden dashes into the unexpected?

Perceive also what happens.

Sweet in the security of my own sense of things, and looking upon you surely as the typical "Sapeur" of modern progress and civilisation, here do I, in full Paris, *à l'heure de l'absinthe,* upon mischievous discussion intent, call aloud for *"Truth."*

"Vous allez voir," I say to the brilliant brethren gathered about my table, "you shall hear the latest beautiful thing and bold, said by our great Henry – *'capable de tout,'* beside whom *'ce coquin d'Habacuc'* was mild indeed and usual!" And straightway to my stultification, I find myself translating paragraphs of pathos and indignation, in which a colourless old gentleman of the Academy is sympathized with, and made a doddering hero of, for no better reason than that he *is* old – and those who would point out the wisdom and comfort of his withdrawal into the wigwam of private life, sternly reproved and anathematized and threatened with shame – until they might well expect to find themselves come upon by the bears of the aged and irascible, though bold-headed, Prophet, whom the children had thoughtfully urged to "go up."

Fancy the Frenchmen's astonishment as I read, and their placid amusement as I attempted to point out that it was "meant drolly – that *enfin* you were a *mystificateur!*"

Henry, why should I be thus mortified? Also, why this new *pose*, this cheap championship of senility?

How in the name of all that is incompetent, do you find much

virtue in work spreading over more time! What means this affectation of *naïveté*.

We all know that work excuses itself only by reason of its quality.

If the work be foolish, it surely is not less foolish because an honest and misspent lifetime has been passed in producing it.

What matters it that the offending worker has grown old among us, and has endeared himself to many by his caprices as ratepayer and neighbour?

Personally, he may have claims upon his surroundings; but, as the painter of poor pictures, he is damned for ever.

You see, my Henry, that it is not sufficient to be, as you are in wit and wisdom, among us, amazing and astute; a very Daniel in your judgment of many vexed questions; of a frankness and loyalty withal in your crusade against abuses, that makes of the keen litigator a most dangerous Quixote.

This peculiar temperament gives you that superb sense of right, *outside the realms of art,* that amounts to genius, and carries with it continued success and triumph in the warfare you wage.

But here it helps you not. And so you find yourself, for instance, pleasantly prattling in print of "English Art."

Learn, then, O! Henry, that there is no such thing as English Art. You might as well talk of English Mathematics. Art is Art, and Mathematics is Mathematics.

What you call English Art, is not Art at all, but produce, of which there is, and always has been, and always will be, a plenty, whether the men producing it are dead and called ——, or (I refer you to your own selection, far be it from me to choose) – or alive and called ——, whosoever you like as you turn over the Academy catalogue.

The great truth, you have to understand, is that it matters not at all whom you prefer in this long list. They all belong to the excellent army of mediocrity; the differences between them

being infinitely small – merely microscopic – as compared to the vast distance between any one of them and the Great.

They are the commercial travellers of Art, whose works are their wares – and whose exchange is the Academy. –

They pass and are forgotten – or remain for a while in the memory of the worthies who knew them, and who cling to their faith in them, as it flatters their own place in history – famous themselves – the friends of the famous! –

Speak of them, if it please you, with uncovered head – even as in France, you would remove your hat as there passes by the hearse – but remember, it is from the conventional habit of awe alone this show of respect, and called forth generally by the corpse of the commonest kind.

J. McNeill Whistler

38. To Queen Victoria. *Etchings of the Naval Review.*

[454 Fulham Road, London]
[Autumn 1887]

To – The Queen's most excellent Majesty

Madam,

By Your Majesty's signal kindness, and condescension, in the matter of a Memorial, submitted by me, in behalf of the Society of British Artists, now, by Your Majesty's Sovereign will and pleasure, signified through me to them, become the Royal Society of British Artists, I am encouraged to hope that Your Majesty will graciously deign to accept, as an expression of loyal reverence, and respect, a Portfolio of Etchings, in which I have attempted to recall some salient features of the memorable and magnificent Review held by Your Majesty of Your Fleet, assembled at

Spithead, on the 23rd day of July 1887, in honour of Your Majesty's glorious year of Jubilee.

To have looked upon that august and stately scene will be cherished as an inspiring privilege in the lifelong recollection of thousands of Your Majesty's loyal and devoted subjects –

To be permitted by Your Majesty's approbation, to believe that I have not entirely failed in my efforts to convey to those who may not share this privilege, some sense and perception of the splendour and grandeur of this historical event, is the most fervent wish and hope, Madam, of

Your Majesty's
Most obedient humble servant
James McNeill Whistler

39. Agenda for the Committee Meeting of the Royal Society of British Artists.

[December 1887]

To receive the Balance Sheet.

To receive a proposition from the President to alter the staircase.

To receive also from the President the following propositions:

1.

That this Society of British Artists having been constituted and appointed by her Most Gracious Majesty, in this Her year of Jubilee, a Royal Society, with all the rights, powers, privileges, and advantages to such a Royal Society appertaining, it is proper and necessary that the indulgence, heretofore extended to persons resigning their membership, should cease and determine.

Be it therefore resolved that any resignation of membership offered to this Royal Society, shall take effect instantly upon its presentation and acceptance at any General Meeting.

2.

That this Society having been recognised and constituted by the personal Act and Will of Her Most Gracious Majesty, as Her Royal Society of British Artists, it is obviously unbecoming and improper that any person being, or desiring to become a member of this Royal Society, should affiliate himself, or remain affiliated, with any other association of Artists established in London.

Be it therefore resolved that any person, now a member of this Royal Society, who, before bestowal upon it, by Her Most Gracious Majesty, of the rights and privileges involved in the assumption of the Royal Title, may have allowed himself to become connected with any of the associations above referred to is hereby required immediately to elect whether he will sever such, henceforth, improper and unbecoming connection, or tender his resignation as a member of this Royal Society.

And that any member, falling under the force of this resolution, who shall fail, at or before the next General Meeting of this Royal Society, to notify this Royal Society of his election, as aforesaid, shall be thereby held to have tendered his resignation, and that the said resignation shall be taken and held as accepted and final, without further proceedings.

3.

That Bye-laws 46, 47, and the portion of Bye-law 43 relating to Peers of the Realm, and Members of Parliament, are, in their spirit and tone, foolish and unworthy, tending to bring upon this, Her Majesty's Royal Society of British Artists, derision and contempt.

That they be therefore expunged from the book of Bye-laws, as offensive and incompatible with the dignity of this Royal Society.

———

To elect a member to serve on the Hanging Committee in place of Mr. Caffieri (resigned).

NOTE. The private view list having been carefully revised, members are requested to send to the Secretary, as soon as possible, the names they wish to be retained on the list.

40. To Henry S. Theobald.
The owner's role in the possession of works of art.

The Tower House
Tite Street, Chelsea
25 April [18]88

Dear Mr. Theobald, It cannot be that you really mean to withhold pictures of mine from the recognition that the occasion of exhibition offers them, for the mere accidental reason that you happen to possess them.

Surely dear Mr. Theobald this view is absolutely unworthy the keen sense of things that you showed in buying them.

You were on the former occasion charming to me, immediately lending the pictures, but this is the privilege of the man, who, like yourself acquires a work of art and knows that he has the care of what really belongs to the world and to posterity.

Dont you see, dear Mr. Theobald that when a picture is purchased by the Louvre or the National Gallery, all can come and see it on the walls, but when a painting is bought by a private gentleman, it is, so to speak, withdrawn from circulation, and for public fame is missing from the story of the painter's reputation.

Your role herein, as the "patron," certainly is that of the man who, owning some of the works of the Master, takes every occasion of spreading his fame by showing them, and is pleased and proud to do so – thereby achieving also for himself, the esteem and affection of history.

Do let me send those lovely things to Munich. I dont believe that they will be absent much more than a month or two, (they will be insured until returned to you) – and next year when the great International Exhibition takes place, do not the cruelty to me, and to yourself the injustice of proposing to hold back these dainty pictures that should take their part before my confrères in the chapter of my work.

After all you have these beautiful things always with you – like the poor! – and seldom indeed shall I have troubled you for their loan!

> With many thanks
> Dear Mr. Theobald
> Very faithfully yours,
> J. McNeill Whistler

41. In conversation: 'An interview with an ex-President.' *Pall Mall Gazette*, 11 June 1888. *On his departure from the Royal Society of British Artists.*

The adverse vote by which the Royal Society of British Artists transferred its oath of allegiance from Mr. Whistler is for the time the chief topic of conversation in artistic circles. Whether the British Artists' taste has tired of light comedy and yearns for the "serious drama" once more, or whether, as the side that is "in" declared the other day, wounded pride and an empty exchequer are responsible for the phenomonal blizzard that has for some time been raging in Suffolk Street, we do not intend for the moment to inquire. But inasmuch as we have already laid before our readers a report emanating in the first instance from the "Conquering Hero" faction, we instructed our representative to visit Mr. Whistler to obtain his explanation of the affair.

"The state of affairs?" said Mr. Whistler, in his light and airy

way, raising his eyebrows and twinkling his eyes, as if it were all the best possible fun in the world; "why, my dear sir, there's positively *no* state of affairs at all. Contrary to public declaration there's actually nothing chaotic in the whole business; on the contrary, everything is in order, just as it should be, and as is always the case after a downfall of any kind. The survival of the fittest as regards the presidency, don't you see, and, well – Suffolk Street is itself again! A new Government has come in, and, as I told the members the other night, I congratulate the society on the result of their vote, for no longer can it be said that the right man is in the wrong place. No doubt their pristine sense of undisturbed somnolence will again settle upon them after the exasperated mental condition arising from the unnatural strain recently put upon the old ship. Eh? what? Ha! ha!"

"You do not then consider the society as out of date? You don't think, as is sometimes said, that the establishment of the Grosvenor took away the *raison d'être* and original intention of the Society – that of being a foil to the Royal Academy?"

"I can hardly say what was originally intended, but I do know that it was originally full of hope and determination, and that is proved, don't you see, by getting a Royal Charter – the only art society in London I believe that has one.

"But by degrees it lapsed into a condition of incapacity – a sort of secondary state, do you see, till it acknowledged itself a species of crèche for the Royal Academy. Certain it is that when I came into it the prevalent feeling among all the men was that their best work should go to 'another place.'

"I felt that this sense of inferiority was fatal to the well-being of the place, don't you see – very well.

"For that reason I attempted to bring about a sense of *esprit de corps* and ambition, which culminated in what might be called my 'first offence' – by my proposition that members belonging to other societies should hold no official position in ours. I wanted

to make it an art centre," continued Mr. Whistler, with a sudden vigour and an earnestness for which the public would hardly give credit to this Master of Badinage and Apostle of Persiflage; "they wanted it to remain a shop, although I said to them, 'Gentlemen, don't you perceive that as shopmen you have already failed, don't you see, eh?' But they were under the impression that the sales decreased under my methods and my *régime*, and ignored the fact that sales had declined all over the country from all sorts of causes, commercial, and so on, don't you know – very well. Their only chance lay in the art tone of the place, for the old-fashioned pictures had ceased to become saleable wares – buyers simply wouldn't buy them. But members' work I *couldn't*, by the rules, eliminate – only the bad outsiders were choked off."

"Then how do you explain the bitterness of all the opposition?"

"A question of 'pull devil, pull baker,' don't you see – and the devil has gone, and the bakers remain in Suffolk Street! Ha! ha! Here is a list of the fiendish party, who protested against the thrusting forth of their president in such an unceremonious way – Alfred Stevens, Waldo Story, Nelson Maclean, Theodore Roussel, Macnab, Ludovici, jun., Starr, Francis James, Rixon, Aubrey Hunt, Lindner, Girardot, Ludby, Arthur Hill, Llewellyn, Symons, C. Wyllie, A. Grace, J.E. Grace, J.D. Watson, Mortimer Menpes, Jacomb Hood, Thornley, J.J. Shannon, and Charles Keene. Why, the very flower of the society! And whom have they left – *bon Dieu!* whom have they left?"

"It was a hard fight then?"

"My dear sir, they brought up the maimed, the halt, the lame, and the blind – literally – like in Hogarth's 'Election;' they brought up everything but corpses, don't you know! – very well."

"But all this hardly explains the bitterness of the feud and personal enmity to you."

"What? Don't you see? My presidential career had in a manner been a busy one. When I took charge of the ship I found

her more or less waterlogged. Well, I put men to the pumps, don't you understand, and thoroughly shook up, you know, the old vessel; had her re-rigged, re-cleaned, and painted, don't you see – and finally I was graciously permitted to run up the Royal Standard at the masthead, and brought her fully to the fore, ready for action – as became a Royal flagship, don't you see. And as a natural result mutiny at once set in!

"Don't you see," he continued, with one of his strident laughs, "what might be considered, by the thoughtless, as benefits, were resented, by the older and wiser of the crew, as innovations and intrusions of an impertinent and offensive nature. But the immediate result was that interest in the Society was undeniably developed, not only at home, but certainly abroad – don't you know. Notably in Paris all the art circle was keenly alive to what was taking place in Suffolk Street; and, although their interest in other institutions in this country had previously flagged, there was the strong willingness, you know, to take part in its exhibitions, do you see?

"For example, there was M. Alfred Stevens, who showed his own sympathy with the progressive efforts by becoming a member. And look at the throngs of people that crowded our private views – eh? – ha! ha! – don't you see – what! But what will you! – the question is, after all, purely a parochial one – and here I would stop to wonder, if I do not seem pathetic and out of character, why the Artist is naturally an object of vituperation to the Vestryman?– Why am *I* – who, of course, as you know, am charming – why am I the pariah of my parish?

"Why should these people do other than delight in me? – Why should they perish rather than forgive the one who had thrust upon them honour and success!"

"And the moral of it all?"

Mr Whistler became impressive – almost imposing – as he stroked his moustaches, and tried to hide a smile behind his hand.

"The organization of this 'Royal Society of British Artists,' as shown by its very name, tended perforce to this final convulsion, resulting in the separation of the elements of which it was composed. They could not remain together, and so you see the 'Artists' have come out, and the 'British' remain – and peace and sweet obscurity are restored to Suffolk Street! – Eh? eh? Ha! ha!"

42. To Marcus Huish, The Fine Art Society. *A proposal for new Amsterdam etchings.*

Brack's Doelen Hotel
Amsterdam
[3 September 1889]

My dear Huish –

I have a proposition to make to the Fine Art Society – of its seriousness you shall judge – and if you think it well to place it before the Directors kindly do so *at once* – for I wish to take my own course without loss of time –

I find myself doing far finer work than any that I have hitherto produced – and the subjects appeal to me most sympathetically – which is all important –

I make my offer first to yourselves, because of the recent entente cordiale which you have brought about –

Without further prelude, this is the business in a few words – I will however premiss that what I now propose is officially private – i.e., if you do not find in it good business for yourselves, you will be silent about my proceedings –

Now: – I have begun etchings here – that already give me great satisfaction – I shall therefore go on, and I will produce new plates – of various sizes – The beauty and importance of these plates you can only estimate from your knowledge of my care for my own

reputation – and from your experience of myself in the Venice transaction – Meanwhile I may say that what I have already begun is of far finer quality than all that has gone before – combining a minuteness of detail, always referred to with sadness by the Critics who hark back to the Thames etchings (forgetting that they wrote foolishly about those also when they first appeared!) with greater freedom and more beauty of execution than even the Venice set, or the last Renaissance lot can pretend to –

I will if you chose *sell* you a set of ten plates outright, on the following terms –

1. Thirty proofs of each plate to be printed for your stock –

2. One proof of each for the British Museum –

3. Five proofs of each plate for myself none of which latter to be parted with for the period of one year from the date of delivery of stock to the Fine Art Society –

4. If there are different states of the plates, two of each state to be printed for yourselves, and two for me.

5. The price for plates to be two thousand guineas –

6. The price of each proof for the public to be from ten guineas up – i.e. the quality will be the "preciousness" that will class proofs among those for which I habitually ask 12 – or more –

7. After the above conditions are complied with – the plates to be destroyed, in such a manner as shall prevent the possibility of further printing, but shall leave the surface undefaced – in which condition they shall be exhibited – the method, chemical, or other, producing such result, to be determined between us –

8. The printing to be done by myself without further payment

9. If the Fine Arts Society agree to these terms, they are to pay at once 500 guineas to my account at Messrs. Drummond – 500 guineas more upon the delivery of the first set of proofs – and the remaining 1000 guineas upon delivery of the entire stock of proofs as per above –

The work will probably be completed by the beginning of next

month – so that what with printing etc etc, you would be enabled to make your arrangements for a unique and choice little exhibition this coming Winter – a very new feature of which would be the show upon the walls opposite the framed etchings, of the destroyed plates, with the pictures still looking like enamel upon them –

Kindly let me hear from you – this week –

Very sincerely yours –

J. McN Whistler

43. In conversation: 'Mr Whistler's new etchings: a chat with the Master.' *Pall Mall Gazette*, 4 March 1890. *His three phases of etching.*

Mr. Whistler was in extra good form the other day when I ventured to call upon him at his studio in the Tower House, Tite Street. This many-sided man presented first one facet and then another – the farcical facet, the serious facet, the ironical facet, the pugnacious facet, the emotional facet. The studio rang with strident peals of laughter, the mirror reflected the mocking smile, and every hair of the white lock bristled with contending emotions. Need I say that the Knight of the Needle was discussing his friends and his enemies, and the whirlpool of controversy in which he loves to disport himself. Mr. Whistler is sometimes likened to the Indian brave, who, when war is declared, sallies forth to the enemies' lodges and returns laden with scalps which he has won by the keenness of his blade and the deftness of his arm. For myself I always like to think of him as the Mephistopheles of Tite–street. On the other hand, Mr. Whistler says he has recently had occasion to compare himself to a ship, in that after a long voyage or passage of arms he is compelled to scrape the barnacles off his sides. The fierce rolling or the "r" in the word "barnacle" made me shiver when Mr. Whistler made

use of this simile. However, these are matters which need not be discussed now, for Mr. Whistler is much too busy to think about such growths as barnacles. He is busy printing the most exquisite series of etchings that he has ever produced.

Mr. Whistler is not given to paying compliments to himself. He reserves *"mes compliments"* to others; but in a chat I had with him over a cup of tea he admitted that his etchings of Amsterdam were, in his opinion, the best work he had ever given to the public. Last November Mr. Whistler looked about him for new worlds to conquer, and elected to visit Amsterdam, which he thinks one of the most picturesque cities in Europe. He packed up his copper plates, and his wax candles, his acids, his etching needles and various tools of the etcher, and proceeded to the quaint old capital of the Low Countries. The result will be given to the world in a series of ten etchings, which are practically completed. Proofs of these, enclosed in their dainty frames of white with black bars, reposed on the studio floor with their faces to the wall, and one after the other they were placed on the easel. Picture to yourself delightful representations of stagnant Dutch canals, reflecting on their surface every detail of the quaintly grotesque architecture. One of Mr. Whistler's difficulties when working in these picturesque but tortuous byways of the Dutch capital was the attitude of the Amsterdam Arab, who was thunderstruck at the apparition of a gentleman sitting in a boat doing nothing but scratch a bit of copper plate with a needle. Sometimes the Arab thought that the figure which was so still was a dummy, and threw stones at it. In consequence of this Mr. Whistler invoked the intervention of the police, and was left in peace to pursue his lonely studies.

The man who only knows Mr. Whistler as the gay, versatile *farceur* thinks that he leads a butterfly existence. But – excepting the famous emblem – Mr. Whistler is not one of the *Lepidoptera*. In Amsterdam he began early and worked into the night, defying

the searching blasts and the withering weather. Here, for instance, is the *nocturne* of the series, a wonderful representation of night on one of the canals, the weird and ghostlike gloom being shown by a brilliant flash of light from a lantern placed in one of the mullioned windows above. Mr. Whistler has often been joked about his *nocturnes*, in private and in a court of law. But his retort is true enough. Night has no form – gloom no length or breadth. This particular nocturne, however, is full of the most delicate and elaborate detail when your eyes have accustomed themselves to the lantern flash. You see the shadows of the people through the blinds and curtains, and the glow of the oil lamps softened by the gloom of night. Here, again, is a proof which Mr. Whistler calls "the embroidered curtain." It hangs in a window overlooking one of the canals, and the delicate tracery of the pattern has been worked out to the minutest detail. But Mr. Whistler did not spend all his time in these sombre and narrow water byways, in which the houses rise on either side like precipitous and frowning walls of a Texan cañon. We find him emerging now and then into the sun on expeditions which result in bits of real lowland scenery, dotted with windmills and alive with traffic.

In this series of etchings the master has avowedly shown himself to the public in all his powers. "I divide myself into three periods," he says, being in his most serious and sensible mood. "First, you see me at work on the Thames," producing one of the famous series. "Now, there you see the crude and hard detail of the beginner. So far, so good. There, you see, all is sacrificed to exactitude of outline. Presently, and almost unconsciously, I began to criticise myself, and to feel the craving of the artist for form and colour. The result was the second stage, which my enemies call inchoate, and I call Impressionism. The third stage I have shown you. In that I have endeavoured to combine stages one and two. You have the elaboration of the first stage and the quality of the second." For some reason or another, Mr. Whistler

has decided not to hold an exhibition, but his etchings will be on view at one or two of the galleries.

The conversation then turned on the number of proofs which he prints from his plates. It is well known that Mr. Whistler's early etchings are rare and extremely valuable. Instances can be given in which a half-guinea proof is now worth seventy guineas, or even more. The collector hates the common crowd, and will only have etchings that are scarce. It is easy to gratify him by keeping the supply down. From his early plates Mr. Whistler told me he had taken about a hundred proofs, and then destroyed the plate. But the numbers vary according to his judgment. Sometimes there might be a hundred, but ofttimes a dozen or twenty proofs, each having the sign of the butterfly, and the little note which shows that he also printed the proof. Mr. Whistler's studio is more like a workshop than a famous artist's retreat. Sumptous draperies, luxurious couches, thick carpets and bric-à-brac are conspicous by their absence; and in their place are the presses and inking rollers with which he is now at work.

44. To his wife, Beatrix Whistler.
His response to the Paris Salon

Hotel du Helder
Rue du Helder [Paris]
[11 June 1891]

Chinckie – my own dear sweet Chinckie – I am talking to you Chinckie – at breakfast – ! – by myself – I think I must get a little black book and talk to you on the leaves from time to time during the day as I go on – so that you will hear from me at different places and so to speak be with me – When I arrived this morning I sent off to Stevens. But after my bath – yes I knew that bath

would at last happen – and of course the Coiffeur's – I came away from the Coiffeurs completely wonderful! – after all this I found a note from poor old Stevens regretting that he could not breakfast with me – of all things he would have wished to be in my company for he has l'âme bien triste! and so I combined the solitude of the occasion with the always latent sense of saxpence, and instead of the Boulevards came down to our little Marchand de vin in the Place Gaillon – you remember – where I have done "extremely well" – Indeed as I look in the glass, I fancy that you would say that I have rather 'silly eyes'! –

On my way I could not resist walking through Durand Ruel's – and then I saw again that horrible "lampoon" of Chase's – Shocking – I told them so – The place for the first time seems to be full of people! – The young son tells me that all Americans go there – I shall see what I shall say to him about my possible exhibition – but I shall be careful – Oh! but Renoir! – There is a little room full of Renoirs – You have no idea! – I *dont* know what has happened to the eyes of everybody – The things are simply *childish* – and a Degas absolutely shameful!! – If you were with me the two wams would hold each others hands as they thought of the beautiful Rosies and Nellies in the little drawer on the sofa!! – Take care of them Trixie – take the two drawers, just as they are, and carry them up stairs – dont let them be shaken, and cover them over with a little drapery and wait till I come back – We have no idea how precious they are! –

I don't seem to be in any hurry to bother about Montesquiou – but doubtless I shall go out to him tomorrow or the day after – I shan't stay many days – but I shall try and get at Mallarmé and settle about the Lemercier people for the lithograph business – William must send the framed etching all right to the Hotel du Helder – and by post parcel also send me two copies of the Gentle Art – and two large copies – probably making two parcels of them – The journey across was like a mill pond – and the stewart furnished

me with ruggs – The wicked Bunnie – to whom many amiable things – of course gave me no silk socks! – perhaps a pair might be put over the glass of the etching – Rosie had better be told to give *Monday* to some one else – after that I shall be back before *Wednesday*. Paris is lovely – !! – We must come here directly – and the Wam shall get garments for the seaside – I am off now – the rest later –

My dear Chinkie I have just come back from the Exhibition! – Oh! Chincks!!!! – Well you cannot imagine it. – Bad – so jolly bad! – it is really stupendous how everything is not only bad, but *going on to the bad!* baddest without stopping for breath – just *galloping* down – I don't believe that in London we would notice it so much, simply because there, nothing is of *any* quality whatever – there everything is absolutely beneath notice and cannot even excite your contempt – *There* is the quiet trade of painting Parish[i]oners, beadles and workers boys – and one year is what all years have been and will be – but here the painters you are forced to look at and they seem to be gone stark staring mad after the Bad!! – The Impressionist analines (I can't even spell it) seem to have been spilled over all the palettes – Even the man Dannat, who by the way is right *next* to the really *holy* Valparaiso has mauve and ultramarine running into the huge legs of his Spaniard – and, by the same token there is no B to be found anywhere – They must have got through with her! – But beyond this, the *drawing* is marvellous in its blatant badness! – The men seem to [have] thrown all tradition and discipline to the winds, in the crazy hope that something else shall take its place – Sargent's "Boy" that was supposed to be a masterpiece is *horrible!* – Boldini has some bad paintings and some hysterically *clever* pastels – but wildly out of drawing – My imitator Gandarini, of course I fancy I see something in – but I hope you wouldn't! – The Rosa Corder naturally is very austere and grand among these strange strugglings – but – we have better – and Oh horrors it struck me suddenly that she looked short! I wonder? – Well well my dear luck more tomorrow –

I shant stay long – I want to be at work with luck in my pocket again! – We must never stop, for we have much farther to go – my own Trixie –

Love to Bunnie and do get Truth, Labby is splendid about Baccarat – His argument is of course word for word that of the solicitor gent. which makes you feel that logically Sir E. Clarke won the battle –

45. To the *Pall Mall Gazette*.
His wish always to destroy unworthy works.

Chelsea
1 August [1891]

Sir, – My letter should have met with no reply at all – It was a statement – authoritative and unanswerable, if ever there were one.

Because of the attention drawn to it, in the press, I felt called upon to advise the public that one of *my own works* is condemned *by myself*.

Final this, one would fancy! –

That the accidental owners of the Gallery should introduce themselves to the situation, is of a most marked irrelevancy. They come in *"comme un cheveu sur la soupe!"* to be removed at once.

The dealer's business is to buy and sell – and in the course of such traffic, these same busy picture bodies, without consulting me, put upon the market a painting that I, the author, intended to efface – and, thanks to your courtesy, I have been enabled to say so effectually in your journal.

All along have I carefully destroyed plates, torn up proofs, and burned canvases, that the truth of the word quoted shall prevail,

and that the future collector shall be spared the mortification of cataloging his pet mistakes.

To destroy is to remain.

What is commercial irritation beside a clean canvas! – What is a gentlemanly firm in Bond Street beside Eternity.

I am sir,

Your Obedient Servant,

J McN. Whistler.

46. To his wife, Beatrix Whistler.
His execration of Academy painting.
[*fragment only remains*]

[Liverpool]

[c. 15 August 1891]

[] One of the largest of the rooms I have devoted to the Academy – and while really achieving wonderful harmony upon the walls, by using the individual pictures however execrable, as elements of a huge mosaic, I have in the most ruthless way *exposed* the whole bag of tricks! –

To begin with I mark "the line" so low that the work of these absurd imposters, in all its revolting details of ignorance, pretension and incapacity may be leisurely examined with the utmost ease. In this way the absolute childishness of execution, the hopelessness of exploded technique, the poor doddering drawing, the ghastly colour, the total absence of all sense of "picture", and the grotesque cheapness of the shocking befuddlement that takes its place, stand at last revealed to even the blind – but the British Public may as well be told –

Now then – and this is amazing! – Putting Fildes' "Doctor" in the place of honour, centre of line, I have plastered the place ... [...]

47. To his wife, Beatrix Whistler. *His success in Paris.*

[Paris]
[January 1892]

Well Trixie! – No letters again! and after my telegram too – what can it all be? Chinkie dear I hope there is nothing wrong! – My own darling Wam is not ill – I hope to Heaven that there is nothing really the matter – and that only in her own beautiful smooth round sunny southern way she has let the post run off from her without being absolutely ready! – But this will make me now three long days without a line from you Chinkie – for yesterday you contented yourself with popping the Fine Arts note into an envelope, and tomorrow nothing comes from London! – Too bad of you Chinkie – You know how I miss you – you know how each morning I look forward to your talk with me – I doubt not you are very busy! – The dear "busy" Wam I can see from here, with paints and canvasses and boxes and furs and Bunnie and the keys! – but you might write *something*! – If you only knew the love I have for the little notes –

Well what is it all about? – Of course things here are endless – and the complications without termination! – Each day something – perhaps all to the good – but meanwhile most tantalizing – So that the work itself is not really properly got at –

In the first I was only installed in the Studio of Gandara's friend on Tuesday night – The next day, *Wednesday* I had an afternoon with Montesquiou – very *quiet* – and doing I believe a great deal of good to the *head* – well then as I told you he announced that the Friday had to be given up to the "World" – whereupon I made up my mind that I would not touch the background and figure until *afterwards* – for I was determined to go through with the whole picture in *one perfect* final coating – for which I had been enabled to prepare the canvass with one last

scraping, and pommice stoning and washing and the terrible bag of tricks that we know only too well! – Therefore I would only commence when I could be assured that we would be quite safe from further intrusion – Bon! – That was agreed to –

Thursday consequently went for nothing – a little tinkering at the hand which only proved to me that I was right – Then Friday – and the beau monde – of which I am longing to tell you! – only let me get through my griefs first – for I must put all my troubles into the lap of my dear beautiful Luck – that she may do her great Obi always all so bold – that all may be well – Well then it is arranged that the proper owner of this most fascinating studio shall know who is his guest – Whereupon on the *Saturday* (yesterday) there comes in the morning, his answer – to say that he is charmed to be of any service to Monsieur Whistler – for whom his admiration is very great – and he begs him to consider the place his own – for as long as he likes – This is all delightful – and looked upon upon as most becoming – and "respectucux" – and all the rest of it – but then – he the unknown host, – must come to Paris on the *Sunday*, and stay through until, at least the *Tuesday!* – So that again no chance of beginning – again the unfortunate black work toiled with and struggled back into its box – to be kept in hiding until this newcomer shall have got himself away into the Country again! – Isn't it terrible! – So that after all these journies and mysteries I have only one little sitting that at all is to the good – I try to think it all for the best – and propose to captivate this painter landlord – or rather host – by asking him to dinner – and then I may be permitted at last to *begin* on this next Wednesday, or even Tuesday and perhaps then carry it right through – dont you think so Chinkie? – I ought really to manage it in 3 or 4 days if I dont get to[o] demoralised! so you must do great Obis – and the "Blanche with the hump" had better put up a candle –

Now then – Drouet the little man came there the other night just as I was finishing my letter to you – and he it was who

brought me the little old photograph – and while I was longing to ask him for it, he said of his own accord – take it and send it to your wife – and tell her that it [is] one that you have just sat for – "Car, mon cher, vous n'avez pas du tout changé"! Wasn't it nice of him – And you didn't care for it Chinkie! – I thought it would have given you such pleasure – and not a word!! –

Well we went off and dined together at the old "Perouse' – you know on the quai – and afterwards back to the students ball – the "Closerie des Lilacs" – to see what it would all look like again! – for he also it appears had not been inside it "for years – and years – and years"! – Well Chinkie – it was probably not much changed – in character – if that be a way of looking at it – but any impression of the picturesque that I might have remembered had gone – The students themselves were much more like common place mashers or clerks – The Gavarni kind of wonderful people in great hats and amazing trousers were gone – and the Grisettes with or without caps were no longer there – supplanted by the sort of appearances we both saw together that night at the other place – Still there were one or two "types" – I did see an amazingly tall hat or so with marvellous broad brim – and there were some costumes – it being about Carnaval time – but poor – and rather shamefaced and shabby – and then there was some dancing – two couples certainly amazing! – I should have liked you to see it – but still – upon the whole I was rather bored – and we came away – and "so to bed" like Mr. Pepys – Drouet back to his damp Joan of Arc! and I to my big red room – all in scarlet chinz – to think of his dear old absent Wam – and to long for her – and to believe that the little souvenir of the early "Jim" would give her pleasure when she opened the envelope and found the surprise – and now she has said to him never a word – and he is woefully disappointed! –

Chinkie I am having a nice long talk with you – this Sunday afternoon – and yet I shall have scarcely time to tell you half – not that so much has happpened – but I miss you so continually –

without you I am forlorn – and you know it – and you are my own
dear sweet bad Wam! – How can you leave me like this without
your daily little lettters! – They are delightful when they come –
the last so charming – so dear to me – and so encouraging to the
poor grinder – exiled with his big black mangle! – We are much to
be envied though I know – for I look round and I see no others so
happy as we two are in each other – I suppose we are even a little
spoilt in the luxury of this knowedge – and so the Wam bullies her
man and says he is cross and beats him! –

On Friday then, le grand monde! – Breakfast with "the Count"
– and the "respectueux" business started for the day – Bignons on
the Boulevards – and the old want of appetite! – These dejeuners
in Paris are really terrible – you and Bunnie must never be with-
out your pepsine! – Enfin! We cross the street to the Vaudeville –
carriages and "good people" without end – and at last we are seated
– I am placed behind the "ra–vi–sante" Grefhule – who is queen of
the groupe – with Madame de Montebello on the one side and a
Russian Princesse, who speaks to me in English, on the other! –
The Prince de Polignac in front turns round and says most
aimable things – I am introduced to the Prince de — famous Ital-
ian – always in debt and always charming – I am fêted and made
much of – and all the "respectueux" jiggery goes entirely to the
winds!! The Comtesse asks if I stay long in Paris and I tell her that
I am waiting for my own beautiful Wam – and I look well at them
all and I know, as I always did know, that among them, there
would be no one more "belle" as Drouet says, and no one more
attractive from their own point of view than his own gypsie Trix! –
and I am quite settled and superior in this matter and only wish
she could have a peep at him in this "hoight of fine company" –

In the midst of it all there appears "Monsieur le Ministre de
l'Instruction Publique et des Beaux-Arts" – and I am presented
between two bars of the music – which after all turns out to be
Bach and not Wagner – I dont see Chinkie how you will ever read

all this long epistle! – I ought to stop – But I must tell you of the final triumph – An improvised party! Directly the Concert finished, Madame Gréfhüle, the Count of course, and a whole banquet of Princes go over to Goupils! – and sit for *two hours* in Joyants little entresol, and stare at the B. who goes up in price – and up in chance of being gobbled up by the fish! They look at the pastels and the little landscape and admire the lithographs and altogether the whole thing amazing! un succes colossale! to be spread all over Paris in the next few hours as Montesquiou said – who was enchanted! – He has quite settled that when the picture is finished we are to have a "five o'clock" in the studio "pour feter l'arrivé de Madame Trixie et votre belle soeur" and then he will read his great piece!! – So there! –

Now Chinkie your nice large envelope with your delightful little letter has just come – and we must I suppose give up scolding each other – it is only the time that is always ahead of us because of the clocks and things with which we have no connection – You and I are all right – and the post is in too great a hurry! – You ask me if I have seen Heinemann? – I should think so! – I have dined with him and he has dined with me – and I went with him to the Moulin Rouge – which is big noisy and rowdy – and we also heard the famous Yvette Guilbert – and she was not to compare with Chaumont though I daresay Walter Sickert might have at once proposed to paint her – Tomorrow morning I am to meet Heinemann again and go to Belfond's – and I am afraid that the dear blind Bunnie has lost the contract she promised to pack off to Webb, for H. has never seen it yet – He is to leave tomorow – and it is a mercy that he could not make out the name of my hotel until it was too late or he would have come there to stay with me –

And now Goodnight my own darling dear Chinkie Wam –
Do plenty of Obi and bless your own fond
Love to Bunnie

48. To David Croal Thomson.
The selection of photographs of his work for publication.

33 Rue de Tournon, Paris
[April 1892]

Dear Sir – I am afraid that my letter of yesterday will not have reached you this morning – so that it will come with this one –

Album. I am glad to find you of my opinion that simple photographs are the best – They certainly seem to me much pleasanter to look at –

Price, etc. All will depend upon the get up of the volume or Portfolio or whatever it may be – You know that whatever I design is happily of the simplest character and *not expensive* –

This work must be perfect of its kind – and thoroughly characteristic –

However *first* I must see the photographs themselves

Visitors – Painters etc. who now come, as did Mr. Watts (R.A.) and as might come others from all sorts of head quarters – for the purpose of spying out the nakedness of the land – Well as they can no longer see the Exhibition in its impressive entirety, they had much better not see a mere portion in a haphazard way – So I would say that it is *now all over* –

Only show as a matter of business to business intending people the one or two things for sale –

Lithographs – I forget whether I mentioned that I sent one more than your list contained – *"The Reading Girl"* –

Have they arrived yet?

Very truly yours

J McN. Whistler

49. To Stephen Richards. *On the care of paintings.*

33 Rue de Tournon – Paris
12 June 1892

Dear Sir – I have just recieved the five small paintings on mill-board – (sketches of figures and sea) – that you have cleaned and varnished for me – They look pure and brilliant – as on the day they were painted! –

But while you were about it, I wish enough you had seen to the condition of their backs – They were put down upon other cardboards some time ago, and they are all loose and bent about now –

In short they had been badly done –

Also how is it that they come back to me without their frames?!! –

How *could* you let them leave your place, clean and freshly varnished as they were, unframed!

This is so unlike your usual thoughtfulness and great care! I was horrified! However happily they are unharmed. –

About the large Nocturne of Cremorne that comes with them – What did you do to this? –

I wanted you to clean it and take off whatever varnish there may have been upon it – and send *unvarnished*, that I might paint upon it – I have not examined it closely – but at first sight it doesn't seem as if you had done anything to it at all? –

[dictated to Beatrix Whistler] Now I understand that you will have brought to you, almost directly, four more pictures by me; I have said that you are the only man fit to touch my work, therefore you must prove again how right I am, in having this full confidence in you. You will clean and take off the varnish with the utmost care and tenderness – Two of the pictures have not been cleaned since they were first painted. They ought all to come out in the most brilliant condition. One, "The Balcony," you can use

your own judgment about. The little Thames picture and the seapiece are painted as well as I remember, in one go and consequently are not so much impasted, therefore will require your utmost care –

Let me have a line from you, telling me how you get on with them, and above all, no one is to know that you are occupied with them, and not a soul is to see them.

Very truly yours,
J. McN. Whistler To Mr. Richards, Berners Street

50. To Alexander Reid. *Negotiations over commission.*

Restaurant et Hôtel Foyot
33 Rue de Tournon
[2 August 1892]

Dear Mr Reid –

There are many things I should have liked to talk to you about, and especially about the Brodequin Jaune, and thinking that you were coming to Paris I haven't written hitherto – However, I will not put off longer –

My idea is, that these things of mine are becoming more and more worth while – and it is rather rough on me that I should (from my willingness to take a sum down) get so little out of the work by which the reputation – which is money – to others – has been made –

Since my exhibition, already eight or nine of my pictures have changed hands, at, at least, an average of ten times what I got for them!

Now, this picture is one of the most in repute, and is continually referred to in the press – There are many who look upon it as much more important (than, for instance, the "Furred Jacket",

which is more of an artist's picture) besides being the portrait of a well-known lady – instead of an obscure nobody –

The public take such a time learning things – that it may take them years to see that my present work is always the best, and that I improve – This is what happened with my etchings, for ten years the Thames Set alone would be looked at, and it has taken me that time, to get my present price for the work I am now doing –

This "Brodequin Jaune" then, is one of the last of my possessions – of what the people are pleased to call that period – Wherefore, it seems to me, that you ought to stand me a better chance –

I think you ought to give me either more down – or – the £600 – and then divide the profits – Whatever is finally done, I hope, if you do have the picture, that you will see that it goes to Chicago – next year – with the "Furred Jacket" and the "Princess". I ought to carry everything before me over there – and am trying to get together a collection – This would be not only for my good, but your own – as they seem to be very strong on Whistler –

With kindest regards from us both to yourself and Mrs Reid
Very sincerely yours
J McN Whistler

51. To his sister-in-law, Helen Whistler.
Owners profiting by selling his paintings.

33 Rue de Tournon, Paris
[*postmark:* 7 August 1892]

My dear Nellie – Of course I thank you – and I must have shown how pleased I was in the letters I have written – If I have [not] said so in so many words, it was partly because I was always waiting to tell you the long story in full detail – and partly because I never

propose to acknowledge to anyone that *you* had anything whatever to do with it – This is what you want – and I had begun to get into the way of it by not referring to your share even to yourself! –

The story I think I must still reserve in its entirety until we see you – it is too pretty to struggle with on paper – But I had lately waited until *with the beautiful pictures before us*, I could tell you that John who in his rabid greed for money *sold even the present* I made him has been beaten completely! – for in his indecent haste he has parted with the works for only one quarter of what they will *at once* fetch! – So that he might have had about twenty two or twenty three times what they ever *gave me for them!* – That is counting in of course *my present!* –

You will say that he got £650 – after all that is no more than seven times what I got – as well as I remember – Yes but to have disgraced himself – (for I shall tell the story of the sale of the present everywhere, now that the pictures are safe! –) – and from a criminal point of view, for *so little!!* Why the Westminster Bridge is being asked a thousand for by itself – And the Balcony – what do you think will be the price of that? – and my Courbet on the shore! – and the little evening on the Battersea Reach – a most gorgeous bit of colour – greatly admired here – The idea of Johns peddling these beautiful things away! Why they were possessions! – They are all going to America except my Courbet – And Aleco has sold the *"Three Yachts"* for £200! to a man in Paris! – What do you suppose I got for it? Twenty do you think? – Ask him – and tell him what I think of their "trading" and "bettering themselves" with my work – It is the dealer's business to sell – it is the gentleman's privilege to preserve and care for and take pride in works of art he has acquired – Aleco, you know I suppose, has sold the Valparaiso Nocturne – for "cash" – in both cases! – pretty business isn't it? –

Of course I shall pay the other twenty pounds and get back the Southampton – but you may well imagine that I have not at this

moment much ready money – Did you tell Madame Coronio that I was pleased that I could have been of any service? – what does she think of John's sale of my present? – I suppose she thinks he was lucky in having it to sell ! –

Mrs. Sickert is charming always – and I must see to everything – This must go off *at once* – so Goodbye for this time –

Is Willie going to the Moffat dinner? I doubt if I shall get across after all – Though I have taken a ticket, and subscribed to the testimonial –

I see by Galignani that the Century Club has gone to pieces! – *[butterfly]*

52. To David Croal Thomson.
His work in photographs.

110 Rue du Bac, Paris
[*received* 13 May 1893]

Dear Mr Thomson – Well – in the first place thanks for your letter this morning which I read with great interest –

Then about the portfolio – For Heavens sake never send any parcel by this route again! There are endless formalities – and I had to go myself all across Paris and sign endless papers that took up a whole morning – This was my fault I know – for I hurried you – However it will always be better to send everything through your house –

Now. I am afraid I am rather disappointed. The Album was unfortunately badly packed and was all creased and even torn by a nail in the case! –

As to the cover – I think it a little flimsy – in any case I would have a yellow ribbon on the two end flaps so that they at least may tie together *[sketch of flaps secured by a bow]*. That may do something towards strengthening the whole –

Then the title and contents ought not to be on o*ne folded* sheet – Each should be *separate* – I would cut the present sheet in two – *[sketch of two separate pages]*

In signing the proofs I find considerable difference in their condition – There is no doubt that the negatives have given *most remarkably* beautiful proofs – If you only sift them out and insist upon it you *can* have perfect collections – At present some of the Carlyles are *too pale* – and some of the Valparaiso Crepuscules are too black –

Otherwise seriously I think when they are seen they will be a success –

Very sincerely yours

J McN Whistler

53. To Ernest Brown, The Fine Art Society.
One proof from a plate is enough.

10 Rue du Bac, Paris

[May 1893]

Dear Mr Brown – I cannot and I must not be made responsible for your Whitsuntide trip across the Channel. –

You will I trust come over – and have a "good time" in Paris – but certainly you can't have the proofs yet awhile –

I have work of the utmost importance – involving hundreds of golden guineas – (which is the clearest way of putting it to the Fine Art Society!) that *cannot* be put aside at this moment – in order that I should print for that Society what they might have had long ago, and in splendid condition, but for their own folly –

The next couple of weeks are absolutely filled with work –

Also the devil of it is that it will doubtless give me endless trouble to get these two plates into working order – You see, as I

have told you over and over again, when one *once* stops – it is the very devil to start again and all my precious time that goes – It is *too* bad that your people should have behaved so foolishly! – I can't tell you how angry it makes me every fresh time I think of it! –

Upon my word there is no use ever doing anything for you – you get on much more comfortably with common things and common place work – All this great over refinement and anxiety for the perfection of *quantity* is dead loss and vexation – for my own reputation, the complete beauty of *one* proof is enough – and the production of scores of the same plate is really a madness! – Than which nothing could be madder except your stopping me in the midst of it! or madder still just on the very eve of my absolutely getting through with all and handing it over to you – the whole lot – full up to the last destroyed proof! –

Your Japanese paper I got all right – and it will be just the thing – I wish you would let me know how I can get some *exactly* like it myself –

I suppose you will come over all right – in which case you will let me know –

Very faithfully J McN Whistler

54. To Stephen Richards. *On varnishing.*

110 Rue de Bac, Paris
[January 1894]

Dear Mr Richards – I was very pleased to hear from you and to find that everything is so brilliant with you – Write me a line to tell me how my two sea pieces took the varnish and how they looked when you had put them again in their frames –

Now I want you to go at once tomorow morning and bring away from the Grafton Gallery a smaller painting of mine that

they have placed upon an easel – It is called "Blue and Violet – Among the Rollers" – I have written to Mr Prange to tell him that you would take it – Bring it home and if you think it dry enough, give it a rapid and even coat of varnish – for I know it would be much more brilliant with it –

But this is what I want you to understand – I painted the panel out in the full sea – and some of the spray got upon it – and the salt made it a very long time in drying – and the last time I examined it – some two or three months ago, the surface seemed to me still sticky – so that I did not touch it, and it has never been varnished – Dont rub it in any way – Perhaps you might gently wash it with a little beer in a soft brush – and that might take off any salt – I would dry it over *hot* air – only I fear the panel would warp – However you know all these things and in your hands I know I am perfectly safe – Therefore I say, if possible, *varnish* it – Then put it nicely back in the frame with the little board at its back and paste it in – and take it to the Gallery all right – the same evening – so that it may be in time for the Press View –

Write me a line to tell me how you got on, and how it looks –
With my best wishes for your continued success,
Very truly,
J McN Whistler

55. To Thomas R. Way, Jr.
His acumen in business transactions.

110 Rue de Bac – Paris
11 January [1894]

My dear Tom – Many thanks for your letter – You may say to Mr. Gleeson White, with my compliments, that I am pleased at their liking the "Gants de Suede" – and that I am willing to let them

have the use of the stone, as understood by yourselves, for "The Studio" (for one number) for 10 gs. This *for the strict publication only* – The proprietor and editor are *not to have one single proof or print* beyond those you print in their publication "The Studio" – certainly not!! –

Such a proposition was surely never heard of! –

No one has hitherto certainly ever dreamed of making it *to me!* –

I believe that Mr. Gleeson White cannot have understood its astonishing audacity – and, on the part of Mr. Holmes himself, it could only have been thoughtless naïveté – and not the dazzling bit of "try on" it really looks like – and that amounts to genius!!

Tell them, from me, to reflect upon their sugestion – : deliberately that I should give them, at their own calculation, *fifty guineas*, for *ten pounds!!* over and above all the chances of profit or artistic interest that should accrue to their magazine because of the presence in it of the drawing itself. – Chances that Mr. Gleeson White, in his first letter to me, most assuredly thought good enough to induce him to write it, asking for a work, and proposing to pay for it – –

You don't suppose, do you, that Mr Thomson has bethought himself of such brilliant business as this? for his Art Journal? –

If Mr White and Mr Holmes are under such impression, you had better tell them, from me, that if Mr Thomson could ever, by any unwonted influence of his present Editorship upon his charming nature, have harboured, for a fleeting instant, in the uttermost parts of his journalistic mind, such a thought, he would, I know, have hastily thrust it from him, rather than run the risk of this utterance, in an unguarded moment, before me! –

However I daresay after all, with these gentlemen, it is as the doctor would say, "better out than in" – and now we can go on all right. –

If then they would like still to have the "Gants de Suède" for the one number of "The Studio" under these clearly made out condi-

tions, why then my dear Tom ask Mr Gleeson White kindly to write me a little letter of acceptance, and Mr Holmes can send me a cheque, and you can fire away and print the lithograph at once –

There is nothing as yet ready for the Art Journal – so that Mr Thomson will have to wait – at any rate he couldn't well have it for *next* month – so Mr. White need not be afraid if he were to put mine in "The Studio" for *February*

With kindest regards to your Father and yourself,

Always

Private

Now Tom do exactly as I tell you Take the enclosed letter, after reading it to your Father, round to Mr Gleeson White yourself and say to him: "I have had Mr. Whistler's answer to your proposal, and I think the best way is to give you his letter – to read yourself and to show to Mr. Holmes" –

Then let him have the letter – and see how he and his proprietor like it –

Make him give you back the letter afterwards Tom – you might like to keep it as a rare instance of business perception in an artist! – You ought to show it to the doctor

56. To Thomas R. Way, Jr. *The folly of trying to produce the same masterpiece twice.*

110 Rue du Bac, Paris
[*postmark:* 15 July 1894]

My dear Tom – The portrait is damnable! – I dont mean the printing which is even as good as the thing to be printed was bad! and that is saying a lot! – No, my drawing or sketch, or whatever

you choose, is damnable – and no more like the superb original than if it had been done by my worst and most competent enemy! –

I hope to heavens that no one has seen it – Now wipe off the stone *at once, at once!* – sending me one proof on the commonest of paper of its destroyed state – and also every other trial proof you may have taken – that I may myself burn all – There must be no record of this abomination! It is neither for catalogue nor posterity – and only proves what other people could never understand – that is the folly of proposing to produce the same masterpiece *twice* over!! Why should one – Ridiculous. Wait till you and your Father see the picture one of these days –!

Now on the other hand this last little draped figure is delightful and beautifully printed of course – Wherefore we are going then to have, in all, 25 proofs each of the two "Balconies" – and 25 of this new draped figure – and let us never remember this foolish business of the portrait – which by the way is to be reproduced later on by Hole, and I wish him joy! –

What did Mr. Thomson say about the draped figure? – I have written to him that if he prefers to it either of the two Balconies he can have his choice – only I must know by tomorrows post –

I am going to write to Mr. Gleeson White, from whom I had a letter a while ago about another lithograph for the Studio –

With kindest regards to you both,

J McN. Whistler

57. To David Croal Thomson. *His debt to Thomas Way.*

110 Rue du Bac – Paris –
[*received* 21 July 1894]

My dear Mr Thomson – You really are grieving me greatly about this unhappy business of the lithograph for the Art Journal! –

I have done every possible thing to please you – and we are no nearer to the result –

You of course must know yourself that I would not possibly allow my work to be treated by any one else but Mr Way –

These things are of great delicacy – and I could not dream of running risks in other hands –

Mr Way has for years not only acquired the experience that is beyond doubt – but he brings to this work of mine the appreciative and complete understanding of the connoisseur and artist that he is –

For ages he has made this matter of art printing his particular affair – and it is to him entirely that is due the revival of artistic lithography in England –

As far as I am concerned I certainly owe all the encouragement I may have received in my work to his exquisite interpretation –

Besides which personally he is one of my oldest and best friends – and I take it you know me well enough by this time to make it unlikely to suppose that I should mortify him by taking out of [his] hands the work to which he has given such tender care – –

If Messrs Virtue are not pleased that Mr Way should do for them the printing, absolutely as he did before, I am afraid that it all falls to the ground – and that is the end of *that!* – –

As to the possible portrait, of course, if I am here at that time I daresay that will be all right – And as soon as I can see my way I will let you know what are our plans – At present I am occupied with a large full length portrait –

As to the £1500 portrait you speak of, I will agree to the 15 per cent – Only if it is way off in the clouds what is the use considering it? Eh? –

Cheque all right – and many thanks –

Badoureau – I wrote to him the other day about it – and am writing again – Only meantime I had to commission him myself

for a *small* cliché which he did in a few days – I am to see the proofs tonight or tomorrow – This shows that he will not be long with yours –

The one I asked for I was obliged to get for the Gazette des Beaux Arts under these most embarrassing circumstances – They had asked me to let them reproduce the Count, and he also had been asked – I *had agreed* – The end of it was such an infamous etching by a man of distinction here that I went down in a fury and made them put it aside on the promise that I would *myself* do them an etching or lithograph – This I did my very impossible to execute – But I was so bored to death with it that I had to give it up after keeping them waiting – One *cannot* produce the same masterpiece twice over!! – I had no inspiration – and not working at a *new* thing from nature, I found it impossible to copy *myself!* I wish Mr Hole joy when he begins – (by the way you know he came here and was charming and has engaged to do the etching) – In despair therefore I sent the Gazette word that I would give them a cliché from London – and wrote off to Badoureau – I doubt not that he is well under way with yours of which I told him you had doubtless given him full instructions – Perhaps it is already done – In any case I write to him again today –

[butterfly]

58. To Thomas Way, Snr.
The radically new quality of his lithographs.

110 Rue du Bac – Paris
[*postmark:* 14 September 1894]

My dear Way – You see this rubbishy cold of mine and the present blowy weather have just prevented my finishing one or two out of door things that ought to be excellent – and that would help to show where we are with the new paper – Mind you, the

two forges are disappointments to us *now* – but you must remember that we have been making amazing *progress*! and some time ago, I daresay we should have thought, with a certain pleasant astonishment, that we were doing very wonderful things indeed had we produced these two failures *then!*

Now let us distinguish – The two proofs are on two different papers. The failure is really I believe more *my* fault, than yours – Take the stump fellow – My work here was not sharp enough and *bright* enough – It was too much nagged at – You *like* the paper – and I rather wore it out! Look at "La Belle Jardinière" – There the result is excellent – not too much stump – The perfection in employment of that paper is seen in "La Jolie New Yorkaise Louis Quinze" (The Visit, old title) – That is a fine drawing, short and sharp as it might to be – Now what I am aiming at in the deep effects *ought* to be brought about on the other paper, which you think as yet not so well made. Well – but I am in hopes that it can be prepared with greater care – The principle seems to me as I draw upon it to be right – and we must yet try the newer stuff I have just got – *though I am not sure* that Lemercier has done even this as well as he may be made to –

The second little Forge was an *old bit*, and even *it* had some beautiful results – All the *simple lines* were of a charming quality – shutters – top window, etc – much prettier than in the other – and devoid of any of the grittiness of the usual "lithograph" – Well the next time all the rest shall be more certain – and if put on the stone *at once*, I think we will find that we have made an immense stride – or if again failure then I must see Lemercier about the gum on the paper being better in strength – and more carefully spread.

Certainly I mean that the *newest* and most beautiful quality I have reached, is in "La Belle dame Paresseuse", and that was on a paper of the same kind, though I fancied of an inferior condition – Take a fine proof of this and put beside it any one of the old

lithographs out of your portfolio – and then see how this 'belle dame' looks fair and silvery, and beautiful in the *quality* of blacks! Indeed far and away more like the charcoal *drawing itself* of the painter – than anything that had ever been printed! – It is really also quite *velvety* – like, in effect, the burr in a dry point! – Now even the little Rue de Furstenburg has also this same "fusain" look – and no other paper has *ever* given it! –

If I can only get that paper put *quite* right, then we can do *anything* – and this is something, worth while – for "Lithography" shall develop into *very* strange matter indeed – and the fun and the mystery will begin in *earnest!*

Wait, till I get some more nude figures too! beside – well never mind just yet –

I suppose you will be sending me the "Furstenburg", and the "Belle Jardinière" and whatever else there is –

The "Duet" as I said, I dont think so highly of – but you might and see what you think is its best – and send a couple of proofs to judge of – The single figure Forge you might perhaps have one more trial at – but the other I would leave for the present –

That is all for *today!!* –

With best regards to both *[butterfly]*

59. To David Croal Thomson.
An artist's rights in relation to his dealer.

110 Rue du Bac, Paris
15 August [1895]

Dear Mr Thomson – Would you really like to find yourself quoted in the second volume of the Gentle Art?! – I had never thought of refering to you in any way – either in that noble work, or in my correspondence with the Art Gentlemen who are

turning my pictures into large monies – which according to you the poor innocents themselves never touch!! –

Let me undeceive you about one thing – I have no "gossip" with you "about the prices" at which these people are selling my pictures –

All facts concerning my work belong to history and are for publication *of course* – Nothing is to be done in a corner by these people – No shady transaction of theirs shall be hidden – no matter through what house it pass – Your very anxiety shows how furtive and questionable the whole business is felt to be –

But the facts themselves are *not yours* – They *must* come to me, whether you give them me or no – Directly a picture is sent to you to sell, its price must be revealed to the purchaser – Why do you tremble? – I ask you what pictures have you now of Mr Chapmans for sale, and what are their prices? – You must tell me in proper course of business – I may want to buy – I *have* bought before my own work from you – As to all the rest information always comes to me from the gentlemen who buy and who are delighted to tell me all I ask – Mr Pope told me about the 1000 gns for the Potter picture – and so with the "Little White Girl" – the Nocturne and the others –

You have no right to withold from me names and prices of what you actually have in your shop, any more than from any other purchaser – "Sea and Rain" which by the way the Gazette did not call a Nocturne by chance – is openly announced as for sale at 300 gns – Mr Ionides gave me £20 or £30 for it –

I have a perfect right to ask you, as director of Messrs Goupils business in London, any question about the sale of pictures of mine that are put into your hands – and *very curious* it would appear if Messrs Goupil's Director made any *mystery* about it! – Wherefore I ask you again for the name of the purchaser of my "Old Battersea Bridge" – and what he paid for it? – Why should Messrs Goupil try to hide from me the whereabouts of pictures

of mine they have sold – as though the transaction were a nefarious one!! – –

As you seem not to have delivered my message to Mr Ionides, I shall manage that myself – Indeed that was only casual in its intention – You may not meet again for years – if he have no more to sell! You have still the Tanagra I suppose though–

The Tadema lecture I thanked you for – and you saw the result in the Pall Mall of the 9th –

I hope you are now quite comfortable –

Very sincerely

J McN Whistler

Is Mr Prange in town?

I am pleased to know that my portrait after all belongs to a Scotchman – –

Oh! I quite forgot about Mrs Williamson – Have you seen her? –

60. To his sister-in-law, Helen Whistler
Selling one of his pictures for his brother and her.

The Royal Lion –
Lyme Regis – Dorset –
[*postmark:* 13 October 1895]

My dear Nellie – Enclosed I send cheque – £210, two hundred guineas, for the little picture of Devonshire cottages you have had hanging in desperate loneliness at the top of the house for all these years –

Not so bad is it – especially as it is bought by Thomson of Goupils – picture dealer! – instantly on sight and the cheque paid down on the nail – and this under rather stringent conditions – one of which was that they undertake that the picture shall *not* be sold to an Englishman! –

You see the little [picture] up in the bedroom had really no frame to it and you cant really know anything of a painting without a frame – Besides it was lost in dirt! I washed it –

What pleased me is that this is only as who should say a feeler – for the "Studio" picture has got to come on! and *now* I think we can bide our time and get a niceish little sum –

I haven't written before because I wanted to have the pleasure of telling you something worth while – and I *do* hope this comes in well so that you need not be entertaining painful intentions of accepting the Winans or others as boarders and vexing yourselves! –

If Willie can spare it for the moment I wish he would send for Mr Hanson and lend him the ten pounds off the guineas, for me! –

Not a *penny more* must he advance – This must be understood – But I do wish he would do this *tomorrow* – and explain that if I haven't written it is because I have been too much troubled to do so –

Write me a line tomorrow to say this is all right – Indeed you might wire in the morning to say it had arrived safely –

With love to both
Always
J McN Whistler

61. To his wife, Beatrix Whistler.
Canvases to be saved.

[The Royal Hotel
Lyme Regis, Dorset]
[*postmark:* 19 November 1895]

What I mean you Chinkie Wink, is by no means the upshot in these here weeks that I am floundering through – The Lamp you see means not only the future, which you would think one might

be contented with – but if we like, all the past! – or such of it as we can lay our hands upon –

Wait a bit and you will see – Come a little nearer to the windy and I'll tell you!

Well you know how you used to grieve when you would see me sitting dazed before the unhappy little picture begging hard to become a masterpiece, and on the eve of destruction, which the miserable Grinder in abject fright remained pitifully painting in the air! – You remember the little Woakes! – and the poor Boston girl – and the others – Well Chinks all those badly treated pretty things remain on his mind – and make him sit up in the dark night – for the Goddess forgives nothing –

The King of Spain it appears had by him a lot of old pictures – why he didn't burn them I don't know – But he turned them over to the great Don Diego – and perhaps in fun, or wondering may be, asked him just to "put a few touches upon them"! –

And Velasquez went the round with his palette, and put those touches in!

Julian Story – by the way I have never written about his father – Julian told me he saw those paintings in the Gallery – at Madrid – It was wonderful he said – how at once they had answered to the Master's call! – Well I understand *that* now! – Do you see Winkie? – and when we can be a little more at ease – there *are* canvases that may be saved – The Grinder's labour may be played with by the Luck's own Painter! and poor old Duret for instance – made really to live! – and even Sarasate – by and bye – don't fear – yet! and perhaps one day the little Woakes – and when we go to America – which we will – for no! I wont go alone – even the Bosting girl need not bring us to shame! – But, to come down from the clouds and I fear the Goddess dont like these flights – but the Wink [will] make it right – Well again what I mean is that the trouble and agonies I have had – even with or especially with these present things – you can quite understand was owing to the

doubtful beginnings of the old uncertainty – and that trouble – and loss of time – for time is taken by Doubt – I am to have no more! – There *that* is what I mean – and *that* is the outcoming of the exile to which the grand Lady condemned the wretched Grinder in order that he might become her Painter and be worthy of his office – and then she will cover him with ribbons and gold medals and take pleasure in him and laugh at him for the vexation he has been to her –

Her little letter this morning was beautiful!

So dont expect too much in these grubs of the future Butterfly – but *"the principle remains the same"!* – And Goodnight! my own Winks! and beautiful sleep! and the little prayers!

The jaunty Boy tomorrow!

62. To Louise Kinsella. *His pleasure with her portrait.*

St Jude's Cottage –
Heath End – Hampstead –
[*postmark*: 4 July 1896]

Dear Miss Kinsella – We had better say Tuesday then at the morning hour –

Voici l'affaire – or rather no – I think I will keep it until I see you – so if you stay away I shall think you not very much interested! –

Tomorrow wont do – for I could not be ready with what I want for the picture yet – though I hope to manage by Tuesday –

For this much I will say – the change is not at all in you – Indeed I am so very much pleased with yourself in the picture that today I showed the portrait to Sargent! – He came to see me – and you know I dont show my things – but I couldn't resist it! – He was I really believe very much struck – He said it is very beautiful – and I must say I admired it myself quite recklessly for

once – Certainly the pink lady stood up magnificently and looked back at us with the utmost calm and assurance – No – *You* are apparently going on to the finish with the greatest possible ease – very nearly approaching that finish as it is – and if I can only get what I want the painting promises to be remarkable –

In short the combination, as I now have thought it out, is one that I doubt [not] has never been made at all –

I certainly have never seen anything of the kind in any large work – I mean that perhaps in some of the tiny pastels I may have hinted at something like the crispness and sparkle I have now in my mind but a full length portrait is a very different matter –

You must excuse all this long and rather wild thinking aloud as who should say – Besides it is perhaps premature!

We have to do it first!!

With kindest regards

Very sincerely

J McNeill Whistler

63. To Charles L. Freer.
His devotion to his wife through his art.

[Chelsea]
[c. 24 March 1897]

Shall I begin by saying to you, my dear Mr Freer, that your little "Blue and Gold Girl" is doing her very best to look lovely for you? – Perhaps it were well – and so you shall be assured that though steamer after steamer leaves me in apparently ungracious silence, it is that only of the pen! –

I write to you many letters on your canvas! – and one of these days, you will, by degrees, read them all, as you sit before your picture –

And in them, you will find, I hope, dimly conveyed, my warm feeling of affectionate appreciation for the friendship that has shown itself to me, in my forlorn destruction – as it had done before, in our happiness, to both of us –

And in the work, perhaps, will you, of your refined sympathy and perception, discover the pleasure and interest taken in the perfecting of it, by the other one who, with me, liked you, and delighted in the kind and courteous attention paid, on your travels, to her pretty fancy and expressed wish –

She loved the wonderful bird you sent with such happy care from the distant land! –

And when she went – alone, because I was unfit to go too – the strange wild dainty creature stood uplifted on the topmost perch, and sang and sang, as it had never sung before! – A song of the Sun – and of joy – and of my despair! – Loud and ringing clear from the skies! – and louder! Peal after peal – until it became a marvel the tiny beast, torn by such glorious voice, should live!

And suddenly it was made known to me that, in this mysterious magpie waif, from beyond the temples of India, the spirit of my beautiful Lady had lingered on its way – and the song was *her* song of love – and courage – and command that the work in which she had taken her part, should be complete – and so was her farewell! – –

I have kept her house – in its freshness, and beauty – as she had made it – and, from time to time, I go to miss her in it –

And, in my wanderings, I may come – who knows? to you – as we both had meant to do!

J McNeill Whistler

64. *Eden versus Whistler.* 2 December 1897
The artist's right to determine when a work is complete.

JUDGMENT

THE COURT,

Having heard the counsels for plaintiff and defendant, and the summing-up of the Avocat-Général, and being called upon to pronounce judgment in the appeal made by the defendant, Whistler, against the decision of the Civil Tribunal of the Seine, given 20 March, 1895

Inasmuch as the agreement described in the judgment against which the defendant appeals consisted merely of a contract to execute, making the defendant liable, in case of non-execution, for damages

And inasmuch as William Eden *was never, at any moment, the owner of the picture for which his wife sat,* and merely asserts that the painter, actuated by caprice or *amour propre*, refused to give up the portrait in question as required

Inasmuch as Whistler, having failed to keep his engagement, as above stated, has to return the 2625 francs (100 guineas) he accepted from Eden, with five per cent interest thereupon from the day of payment; and inasmuch as he has further to pay damages to the amount of 1000 francs (£40); –

But inasmuch as the Judges of the lower Court wrongfully ordered that the portrait mischievously altered by Whistler should be handed over to Eden, on the grounds that the picture was the exclusive property of Eden, and ought to be given up to him; and inasmuch as the agreement between the parties *was in no sense a contract to sell,* but merely an *obligation to execute,* so that the portrait *has never ceased to be the artist's property, and cannot be taken from him without his consent*

Inasmuch, on the other hand, as this portrait, though altered in some essentials, still retains the general harmony given to his

composition by the artist with the help of certain motives furnished by Lady Eden, and that, under these conditions, it seems evident that the artist's right to the picture is not absolute, without limitation or restriction, and that, on the contrary, so long as the transformation of the little picture is not complete, Whistler may not make any use of it, public or private

HEREBY

confirms the judgment against which appeal is made in so far as it set forth the material facts,

And confirms it in ordering the appellant to refund the 2625 francs (100 guineas) paid him by William Eden, with five per cent interest thereon from 14 February, 1894, and to pay 1000 francs (£40) damages, with interest

But rules that the judgment was at fault in declaring that William Eden became the owner of the picture as soon as the contracting parties had agreed as to the thing and the price

Amending this clause of the judgment, and pronouncing afresh, the Court declares the contract between the parties to have been merely an agreement to execute, resolving itself, in the event of non-execution, into a question of damages; it therefore *leaves the artist master and proprietor of his work till such time as it shall please him to deliver it, and give up the holding thereof*

It discharges Whistler from all obligation to give up the portrait to William Eden laid upon him by the lower Court, but declares, on the other hand, that so long as the work remains incomplete, and unfit to deliver, Whistler can make no sort of use of it, public or private.

It orders Whistler to pay the costs of the first suit, and William Eden to pay costs of appeal.

The fine to be refunded.

RÉSUMÉ

PRESTIGE OF THE WORK OF ART AND PRIVILEGE OF THE ARTIST –

*Established: The ABSOLUTE RIGHT of the Artist to control
the destiny of his handiwork – and, at all times, and in all circum-
stances, to refuse its delivery into unseemly and ridiculous keep-
ing –*

*The DIVINE RIGHT of the Artist to pay damages, and so rid
himself cleanly of the carelessly incurred, and pertinaciously un-
becoming company of the hereintofore completely discovered,
penetrating – persevering – planning – devising – Valentine
designing – pestilential, and entirely matagrabolising personage! –*

*Who forthwith empouches the gainings – unthinkingly,
unblushingly, inevitably! – and once more unwittingly and
prodigiously justifies the judgment! –*

65. To his sister, Lady Haden.
His triumph in the Eden case.

110 Rue du Bac, Paris
[January 1898]

My dear Sis – How are you! and my best wishes to you for this still
New Year –

Did you receive the Conclusions de l'Avocat Général? I sent
them to you that you might take pleasure and a not unseemly
pride, let us hope, in the consideration in which your brother is
held in France!

You might write me a line and tell me what you think of it all –
You must remember that this was not the plaidoirie of *my* lawyer,
but the official summing up of the representative of the Govern-
ment who had been watching the Trial on behalf of the

République – He was therefore quite unbiassed – and indeed as far as we knew might have been dead against me – So that at last I have had my pound of flesh handed to me as who should say in silver paper with the Government stamp upon it!!

If you could have heard him my dear Sis, holding forth, in the great hall in the Palais de Justice, before the High President and his assembled Judges, upon the acknowledged qualities and unlimited rights of this wicked person to do as he thought fit, I believe you would have shed tears, as did Aunt Alicia in the open station of Preston long ago when the Queen, "God bless her" passed through!! "*This* is the man whom France delighteth to honour!" And yet he has done these things – this mocker of Baronets!

Also did he not destroy and wipe out their picture, and does he not unblushingly admit it! and yet, Messieurs this deed is in effect a deed of sound logic, coming from *him!* Car il est *Monsieur Whistlère!!* Il se devait *à lui-même*, il devait aux *Whistleriens* et au *Whistlerisme* de ne pas se laisser *jouer* par Sir Eden! *et c'est pourquoi* il n'a pas voulu livrer le portrait!!! –

Did the like of this ever before happen to hardened offender? Sent to the stocks by belted Briton, that he may there be pelted with unclean egg by the Philistine of the market in his righteous wrath, and behold! They come out to meet him with Heralds and Banners and Trumpeters from fair France!

And the law of the land is altered, and *new Statutes* are made in his honour – And Hayman the Islander is shamed before the people, and is hanged as an offering to the distinguished one! to appease him, and for his hearty pleasure!

And there was great rejoicing! And it was commanded that a record of these things be kept in the Chronicles of the Court, and it was graven upon the tablets of the "Causes Célèbres" – and the new law was added to the Code Napoléon – and the name thereof is famous for ever!

"Whistlère"!

66. To William Heinemann.
His extraordinary progress.

[Paris]
Monday evening [31 January 1898]

The Financier – who is splendid – wires this afternoon that he has bought me a hundred Kalgourlies!!! –

Now what do you think of that?! – I hope it is all right at the bank – for of course not only is the thing itself in the hands of the financier of Napoleon, the very first tip and chance – A. 1. – copper bottomed – but it is such a proof of his care for me – that I wouldn't have a hitch of any kind for worlds! – Well now I put a thousand guineas into the Bank somewhere about Christmas or at the beginning of this month – and 5 or 6 hundred I think between my leaving London and being here – I won't be sure – but I think it is all right – don't you? – Though of course I have been pulling out a good deal – what with the Eden business and the rents of my various establishments – Now as I make this out it would be a pull of £600 or £620 – Still don't you think it is all right? Besides as it is paid into the Bank – I mean the scrip, it is all one to Drummond – I shall have a lot more to go in this Spring – for I am doing work that is far beyond anything I have done before –

Indeed the beautiful condition of work is at last quite laughable – I don't know any other word for it! – I mean I sit in the studio and could almost laugh at the extraordinary progress I am making and the lovely things I am *inventing!* – I have now in the studio a Phryne – a Dannae – an Eve – an Odalisque – and a Bathsheba – that carried out ou[gh]t to bring in two or three thousand apiece! – MacMonnies says he has never seen anything like the Phryne – which I am going to do large – after completing the little one – which by the way will make two – so that I see

excellent business if I can only hold on! I mean, don't you see that I must not allow small ordinary considerations of Exhibition or what not in the way of periods to interfere with work of this character which I always looked forward to and was sure would one of these days announce itself – bursting forth suddenly as the result of much preparation! All these inventions are *since you left me* the other day!

Now you see my dear Publisher and charming host, I have impulsively poured into your private ear – so you know "where I am at!" Voilà! Write us a line and say you think it is all right – (Of course I have just had your letter from Brighton) and tell the Financier how delighted I am with him.

I had a charming letter from your kind and handsome cousin Mrs Walter – Remember me to both. –

Always

What about "Tuesday"? [*butterfly*]

67. In conversation: 'The International Exhibition. Interview with Mr Whistler.' *Pall Mall Gazette*, 26 April 1898.

"First of all," said Mr. Whistler, "it must be thoroughly understood that the organizers of the International Exhibition are animated by the most serious artistic motives. I was approached, to begin with, by a number of young men – the vanguard of English art – who expressed the desire to see a really international collection of pictures brought together in London. We wanted to break through the wearisome routine of the annual shows – to mention only the Royal Academy, the New Art Gallery, the Grosvenor, and so forth. Mere annual output we have nothing to do with. What we want is to show artists and the public, too (if the public likes), the present point to which art has reached, and no

opportunity for this has yet occurred in England. The English, for instance, are very proud of their black and white artists. Well, we would like to show them that all they have done in black and white, in coloured lithography, and so forth, is the merest child's play as compared with what has been done on the Continent. The British public is kept completely in the dark as to the real nature of the Art movement throughout the world. It will be the task of the International Art Exhibition to enlighten that ignorance. Fortunately the position which I occupy here gives me the necessary authority to persuade the great continental painters to treat this scheme seriously. I have been able to point out the advantages of this exhibition to men of the highest eminence such as Puvis de Chavannes, Rodin, Forain, and others, all of whom have consented to contribute, and are much interested in the success of the show. And, believe me, the lesson will be great, the revelation enormous. For instance, there will be a fine show of drawings by Milcendeau and quite a big collection of Forains."

Mr. Whistler then unhooked from the wall a framed drawing by Milcendeau, representing a mediaeval personage in knightly guise. "Who draws like that in England at the present day?" he said. "There's a quality about that which is perfectly extraordinary – the air of something that comes out of a museum. And so with coloured lithography: the exhibition will show the English artists and the English public the giant strides that have been made abroad in this department of Art."

"And you prophesy success for this exhibition, Mr. Whistler?"

"It seems to me," he replied, "that the people who go down Bond-street and Piccadilly would hardly fail to come to our show. But we do not address ourselves so much to the general public, to the paying public, as to that section of the public that is seriously interested in Art. The International Art Exhibition will be an artistic congress held in London – with or without the public – for the purpose of enabling artists and the public, if it likes, to study

and comprehend the progress which Art is making.

"Of course," said Mr. Whistler, in conclusion, "we shall meet with a certain amount of opposition. We shall be looked on with a very wooden eye by the working men of the trade. That doesn't matter. We shall have brought together the most representative collection of international art that has ever been exhibited in London, and thus supplied a want that has long been felt. We have the serious men with us, and they take us seriously. Naturally the larger proportion are foreigners. It just happened that the best men are abroad. We have had to seek them and find them where we could. That London should have been chosen as the centre where this artistic congress is to meet is a fact of which London may be proud. "

68. To the Committee of the International Society. *His satisfaction with the Society's exhibition.*

110 Rue du Bac [Paris]
18 May 1898

[dictated:]

To

The Vice President and Gentlemen of the Committee –

Gentlemen – it was greatly to my regret that I was forced to return before calling you all together to express, to you, my satisfaction at the splendid way in which you have worked, in unison, to bring about the harmonious result I intended, and you have achieved!

I have barely had more than time to perceive the rare appreciation and sympathy with which the plan of the walls has been carried out! – The managing of the lighting, the placing of the "velum" as it is called here, about which I was anxious, is most perfect.

My compliments also to the hangers, whose labours must have been Herculean, and whose results show no trace of the terrible difficulties, overcome in such impossible time!

In short, Gentlemen, your President is proud of his Committee and begs them to accept his warmest congratulations upon the triumphant results of their endeavours – together with his conviction that this year's brilliant beginning has brought with it the assurance of next year's absolute success, and of an irresistible future –

And I have the honour to be, Gentlemen,

Your obedient servant

J. McNeill Whistler

69. To John Lavery.
Business of the International Society.

110 Rue du Bac [Paris]
18 May 1898

[dictated:]

Dear Mr Lavery – I enclose letter to the Committee which I beg you to read, with my compliments, at the first meeting Mr Howard will call at your earliest convenience.

The business of the Society will then come on in due course – I take it for granted that the correspondence with the Prince was read out to you all, as I desired – If overwhelming work prevented this at the moment, the letters can be read at this meeting – that you may see the kindly disposition of H.R.H., so that on a future occasion, with more time given him to dispose of his lesser engagements, it is evident that the Society may depend upon all that a distinguished body of Britons can ask from their Prince! –

I need not say how pleased I was to find among you, on the evening of my arrival, our staunch camarade, Shannon –

His presence was proof of his devotion to us – for however slight, from our own point of view, may have been his connection with another association, still it has been considered, before now, of importance, and the severence of such tie, painless as it may have been, is still a graceful offering of loyalty as well as evidence of wit.

The Committee will instruct Mr Secretary to enter the account of Mr Shannon's resignation from the Academy and formal adherence to ourselves in the minutes – and, with Mr Howard's facilities in the Press, I think it were well that the gallant episode be properly known.

Meanwhile I would point out to you that you have transmitted to me no statement, from Mr Shannon to yourself, in reply to my letter with which you made him acquainted.

The business of the Exhibition has necessarily hitherto retarded these considerations – Now Mr Shannon may give you his official answer, that the incident may be closed and the precedent established.

Catalogue: In future we shall do better – I trust that rectifications have been made, and I should like to see a new copy.

I have received a further communication from Marlborough House. The Prince reiterates his intention of visiting the Exhibition, but owing doubtless to late notice, is unable to fix as yet any date.

I beg that you will read this letter also to the Committee, and I am dear Mr Lavery

Very sincerely Yours

J. McNeill Whistler

[in own hand:] P.S. I should like to be assured that Mr Mac-Monnies' Shakespere has been placed on the pedestal – and that the Forains are hung –

70. To Sydney Pawling.
The design of Eden versus Whistler.

110 Rue du Bac, Paris
[Winter 1898]
later!

Dear Mr Pawling – I sent you off the little scrawl about the Baronets covers this evening in such great haste that I am afraid it may appear abrupt! –

So you must forgive! – Still it *is* odd, that request for a specimen cover – isn't it?

Now here is another disappointment! – but this time a disappointment beyond hope –

I have just seen a copy of the book in its completeness – printed from the plates sent over from London – with the latest corrections of which I had had no proof – and which Heinemann had given entirely into the hands of Mr MacColl himself –

Now among them, most important were two Butterflies – One belonging to the *"Baronets Indiscretions"* – and the other to *"Encountered"* – These I wanted to be *reduced.* The originals were perfect – probably the most spirited in the whole book – only a little too large in proportion to the rest –

I gave the new scale with great care – and indicated the placing of the new reductions – and was delighted to know that MacColl was going himself to attend to this – feeling quite safe in his hands –

You can then fancy my shock this evening when I discover that instead of my beautiful Butterflies, he has found *some other old blocks* lying about the office (discarded as early failures doubtless) and *used them!!* – Could you believe it!!? It is too painful for me to say more at present! –

Very sincerely
J McN. Whistler

71. To Christine Anderson,
The Company of the Butterfly.

110 Rue du Bac – Paris
[January 1899]

Dear Mrs Anderson – Write to Mr Chapman – Acknowledge letter
– say submitted to directors – will transmit their further advices
Will Mr Chapman say meanwhile what other Whistler Nocturnes
or marines he may have – and what would be their prices –

Also will he regard the matter as under consideration, and
send the size of "Bognor," and of any other painting he may be
willing to part with –

Write to Mr Pope of America – (have you not his address?) – :

"Sir – Knowing you to be a collector of Whistler paintings, and
possessor of very fine [works], the directors wish me to advise you
that they may shortly be able to offer you a famous Nocturne of
his, known as the *"Bognor"* – (size) considered by the critics as
the very finest among them all –

We would be pleased to hear from you immediately whether
you will entertain its purchase at £1600?

Letter to Mr Pope may wait until you hear from Mr Chapman.
Writing again directly

Let me hear from you again – tomorrow –

[unsigned]

72. Whistler and Inez Bate.
Indenture of Apprenticeship.

[20 July 1899]

This Indenture made the Twentieth day of July One thousand eight hundred and ninety nine

witnesseth that Inez Bate of Kings Heath in the County of Warwick doth put herself Apprentice to James McNeill Whistler of 8 Fitzroy Street Fitzroy Square in the County of London hereinafter called the Master to learn the Art and Craft of a Painter and with him after the manner of an Apprentice to serve from the fifteenth day of September next until the full end and term of five years from thence and following fully to be complete and ended During which term the said Apprentice her Master faithfully shall serve his secrets keep and his lawful commands obey she shall do no damage to her said Master or his Goods nor suffer it to be done by others but shall forthwith give notice to her said Master of the same when necessary. She shall not waste the Goods of her said Master nor lend them unlawfully to any nor shall she do any act whereby her said Master may sustain any loss with his own Goods or others during the said term. Without license of her said Master she shall not sell to other painters nor exhibit during her Apprenticeship nor shall she absent herself from her said Master's service unlawfully but in all things as a faithful Apprentice shall behave herself towards her said Master and others during the said term

And the said Master his said Apprentice in the Art and Craft of a Painter which he useth, by the best means in his power shall teach and instruct or cause to be taught and instructed

Provided that if the apprentice shall commit any breach of the

covenants on her part hereinbefore contained the Master may immediately discharge her, These presents shall be handed over to the said Inez Bate on the completion of the said term with a Certificate of such service endorsed thereon

And for the true performance of all and every of the said covenants and agreements the said Parties bind themselves by these Presents

In Witness whereof the said parties have hereunto set their hands and seals the day and year first above written

Signed Sealed and Delivered
>Inez Bate
>J. McNeill Whistler

73. To Charles L. Freer. *His wish for Freer to have the chief collection of his art.*

>[Paris]
>[29 July 1899]

I am delighted my dear Mr Freer that you like the pictures you speak of – and wish to keep them –

They are yours of course – and I will tell you when we meet how glad I am that they go to the group you have of distinguished work in your gallery –

And now you must yeild a point in proof of friendship and sympathy already proven!

Nothing is to be said about price in this matter – until the Blue Girl takes her place to preside –

All this you will understand completely and feel with when we meet –

Meanwhile I think I may tell you without the least chance of

being misunderstood, that I wish you to have a fine collection of Whistlers!! – perhaps *the* collection –

You see the Englishmen *have all* sold – "for 'tis their nature to," as Dr Watts beautifully puts it – whatever paintings of mine they possessed! directly they were hall-marked by the French Government, and established as of value – turning over, under my very eyes, literally for thousands what they had gotten for odd pounds! So that with the few "exceptions that prove the rule," there is scarcely a canvas of mine left in the land! While you will understand the mischievous pleasure I have in "constate-ing" this fact, and so placing the British Maecenas where he ought to be, behind the counter, and in his shop – you will also appreciate the lack of all communion between the artist and those who held his work! – and the great pleasure it gives him to look forward to other relations! –

I am glad you have the little "Cigale" – she is one of my latest pets – and of a rare type of beauty – the child herself I mean – and the painting – well the painting *[inkblot]* you see what I have said of it!!

The little Lady of Soho! I am glad you have chosen her too – I think before she is packed, I know of a touch I must add – and then she can follow you in the next steamer – But this I shall see when I come over – for I am getting stronger and hope perhaps next week I may be able to cross – If the pictures have left the International, they will have gone to the "Company of the Butterfly" 2 Hinde Street Manchester Square. – So I enclose the order. –

I have written to Messrs Heinemann to send you my book! The Baronet and the Butterfly! You must tell me how you like my campagne, if you think it worthy of West Point! –

Always sincerely

J McNeill Whistler

They will tell you in Hinde Street about the prints –

74. To the students of the Académie Carmen.
His farewell to his pupils.

Ajaccio
March 1901

Mr Whistler begs that Madame la Massière will present his com-
pliments to the distinguished students of the Académie Carmen,
journeying upwards! –

With "this strange device – Excelsior"! on their wiped and
polished palettes, as they set forth, he wishes them God speed! –

He feels even, dimly, that he should, perhaps, himself have
hastened – or, at least, have facilitated their departure – that they
might not have been distressed by some pretty sense of alegiance,
that has detained them, and separated them from their comrades –

While he regrets, then, that he did not more quickly come to
their help, and relieve the situation of all strain – for which he can
see no fitness – he cannot fail greatly to appreciate the graceful
thought of those who have bravely lingered still – to make their
curtsey to his bow – that all may be as it should, among beautiful
and well born people! –

Mr Whistler trusts, further, that all will soon forgive, as they
will at once forget, the despotic, narrow, and discouraging prin-
ciples urged upon them, in this aristocratic and intolerant
Académie! – And he desires Madame la Massière to frankly
admit, for him, the utter hopelessness, for transportation, of
these principles – their deadly danger to milder matter, together
with their "inadaptability" to all fellowship – and other amicable
uses – save always and excepting the one golden precept, so con-
tinually instilled, that "Nothing matters"! – which he commends,
as ever true, and of vast comfort in all companies! –

And so he prays Madame la Massière to lay at the feet of the
fair and distinguished Students, as herein afore said – gathered to

make their Adieux – his admirable homage – and continued de-
votion–
 Wherewith he begs to kiss the tips of their taper fingers –
 And has the honour to be,
 Always their humble, obedient, and gentle
 Servant *[butterfly]*

75. To the Revd Herbert Story, University of Glasgow. *His appreciation of the honour given to him.*

Chelsea –
20 April 1903 –

My dear Sir –
 I beg to acknowledge your personally kind letter of yesterday
– and I trust that you will convey to the Senate, my keen sense of
the rare indulgence they are extending to me, in yeilding to the
peculiar circumstances, and so graciously conferring this high
honour in my enforced absence –
 Pray present my thanks, and accept them yourself, together
with my regrets, to the distinguished body who have chosen me
as their Confrère – than which there can be no greater compli-
ment.
 I would like to have said to these gentlemen, as a reassurance,
in their generosity, that, in one way at least, the Gods have pre-
pared me for the reception of such dignity; inasmuch as they
have kept, for me, the purest possible strain of Scotch blood – for
am I not a McNeill – a McNeill of Bara?
 And I have the honour to be
 my dear Sir,
 Your obedient Servant
 J. McNeill Whistler

INDEX OF CORRESPONDENTS' NAMES

Numbers in brackets refer to the letter or other text

Richards, Stephen (Nos 49, 54)

Rose, James Anderson, solicitor and art collector (No. 20)

Royal Society of British Artists (No. 39)

Story, Revd Herbert, Principal, University of Glasgow (No. 75)

Story, Waldo, American sculptor (No. 28)

Theobald, Henry Studdy, art collector (No. 40)

Thomson, David Croal, manager of the Goupil Gallery, editor of the *Art Journal* (Nos 48, 52, 57, 59)

Victoria, Queen (No. 38)

Watts-Dunton, Theodore, 1832–1914, critic, novelist and poet, known as Theodore Watts until 1896, when he added his mother's surname of Dunton to his own (No. 17)

Way, Thomas, Snr., lithographic printer (No. 58)

Way, Thomas R. , Jr., lithographic printer (Nos 55, 56)

Whistler, Anna Matilda, 1804–1881, daughter of Dr Charles McNeill and Martha Kingsley; Whistler's mother (Nos 2, 9, 13, 23).

Whistler, Beatrix, 1855–1896, daughter of the Scottish sculptor John Birnie Philip and widow of E.W. Godwin; married Whistler in 1888; 'Beatrix' is the form of name that she preferred to 'Beatrice' (Nos 44, 46, 47, 61)

Whistler, George Washington, 1800–1849, soldier and railway engineer; Whistler's father (No. 1)

Whistler, George William, 1822–1869, civil engineer; Whistler's half-brother (No. 7)

Whistler, Helen ('Nellie'), née Ionides, 1848–1917, Whistler's sister-in-law (Nos 26, 27, 29, 51, 60); Whistler's brother Dr William Whistler ('Willie'), 1836–1900, was senior physician, London Throat Hospital.

Winans, Thomas de Kay, 1820–1878, inventor and railway engineer, son of Ross Winans of Baltimore; his sister Julia married Whistler's half-brother George (No. 10)

NOTES

Sources: Letters are originals, except where stated. Printed items, except No. 33, are from the Whistler Collection, Glasgow University Library. The following abbreviations are used:

FGA Freer Gallery of Art
GA Whistler, James McNeill, *The Gentle Art of Making Enemies*, London, 1890; second edition, 1892.
GM Robert H. Getscher and Paul G. Marks, *James McNeill Whistler and John Singer Sargent. Two annotated bibliographies*. New York, 1986.
GUL Glasgow University Library, Whistler Collection
LC Library of Congress microfilms of Whistler material, chiefly in the Pennell Whistler Collection
PWC Pennell Whistler Collection, Library of Congress
YMSM Andrew McLaren Young, Margaret MacDonald, Robin Spencer, Hamish Miles, *The Paintings of James McNeill Whistler*, New Haven and London, 1980.

1. *62 Sloane Street:* To escape the severity of the Russian winter, Whistler was living in London with his sister Deborah and her husband Francis Seymour Haden. – *My portrait:* by William (later Sir William) Boxall; now in the Hunterian Art Gallery, University of Glasgow. – *Mr Winans:* Ross Winans, of Baltimore, inventor and engineer, whose firm built engines and rolling stock for the railways constructed in Russia by Whistler's father. – *Willy:* Whistler's brother William.
 Source: GUL W661.
2. *Seymour:* Francis Seymour Haden. – *The Babie:* the Hadens' daughter, Annie, who posed for her uncle in later years.
 Source: GUL W386.
3. *Erneste:* Ernest Delannoy, French artist. – *Our property:* their completed works, including Whistler's etchings, left as security.
 Source: Original not traced; GUL H13, LB 13/4, LB 15/77; PWC 9/653–9 (all copies).
4. *Source: Original not traced; GUL H14, LB13/7, LB 15/78 (all copies).*
5. *7A Queens Road West:* his address from mid-1862 to early 1863. – *Us both:* Whistler and Joanna Hiffernan ('Jo'), his mistress and model. – *George:* his brother George William Whistler (see No. 7). – *Fantin:* Henri Fantin-Latour, French artist (see Nos 8, 11). – *The White Girl:* 'Symphony in White, No. 1: The White Girl', 1862 (National Gallery of

Art, Washington; YMSM 38), for which Jo was the model, was being exhibited at Morgan's Gallery, Berners Street. – *Thames Ice sketch:* 'The Thames in Ice', 1860 (Freer Gallery of Art; YMSM 36). – *Tom Winans:* Thomas Winans (see No. 10).
 Source: Wadsworth Athenaeum, Hartford, Connecticut.
 6. Whistler's first letter to the Press.
 Source: Original not traced; GM B. 1.
 7. *7 Lindsey Row:* Whistler's address from early 1863 to early 1867. – *Aunt Alicia:* Alicia McNeill, half-sister of Anna Whistler, died on a visit to friends in Linlithgow.
 Source: GUL W671.
 8. *Legros:* Alphonse Legros, 1837-1911, French painter. Fantin, Legros and Whistler were constant friends in the early 1860s and were known as the 'Société des Trois'. Legros' painting 'The Angelus' had been bought by Seymour Haden, who 'corrected' the perspective of the flagstones on the church floor. – *Jo:* Joanna Hiffernan (see No. 5). – *My Mother:* Anna Whistler, whose other son Willie was serving as a surgeon in the Confederate Army, came to London to escape the Civil War. – *Your picture:* Fantin's *Homage à Delacroix*, being painted for the Salon. – *Ionides:* Alexander Constantine Ionides, 1810-90, a wealthy collector, and patron of Whistler. – *Rossetti:* Dante Gabriel Rossetti, poet and painter. – *De Balleroy:* Auguste de Balleroy, French painter. – *Ribot:* Théodule Ribot, 1823–1891, French painter. – *A picture for the Academy:* 'Purple and Rose: the Lange Leizen of the Six Marks', 1864 (Philadelphia Museum of Art; YMSM 47). – *Hardy:* Hardy–Alan, Fabrique de Couleurs, 1 Rue Childebert.
 Source: PWC Box 1; LC1/0797–802; GUL Barbier Collection (copy).
 9. *A very beautiful picture:* 'Purple and Rose: the Lange Leizen of the Six Marks', 1864 (Philadelphia Museum of Art; YMSM 47). – *A group in Oriental costume:* 'Variations in Flesh Colour and Green: The Balcony', 1865 (Freer Gallery of Art; YMSM 56). – *Wapping:* 'Wapping', 1860–61 (National Gallery of Art, Washington; YMSM 35). – *Willie:* William Whistler's first wife, Ida King, had died in the spring of 1863.
 Source: GUL W516.
 10. *2 Lindsey Row:* Whistler's address from early 1867, renumbered as 96 Cheyne Walk in the early 1870s. For most of the previous year he had been away from London on an expedition to Valparaiso, Chile. – *Thomas Winans:* the eldest son of Ross Winans (see No. 1). He had lent Whistler the money for his journey to Paris in 1855 and gave him further support by buying works or making loans as necessary.
 Source: GUL W1071 (photograph of original).
 11. *I thrashed Haden:* a quarrel in Paris between Whistler and Haden concerning Haden's conduct after the death of his medical associate,

James Traer, had led to blows and the final rupture in relations between the brothers-in-law. – *Aleco:* Alexander Ionides, son of A.C. Ionides.
Source: *PWC Box 1; LC1/0850–855; GUL Barbier Collection (copy).*
12. *Nesfield:* the architect William Eden Nesfield.
Source: *GUL M436 (draft).*
13. *Debo:* her daughter, Deborah Haden. – *Speke Hall:* Liverpool residence of the Leyland family. – *My portrait:* 'Arrangement in Grey and Black: Portrait of the Painter's Mother', 1871 (Musée d'Orsay; YMSM 101). – *MGH, Margaret:* Margaret Hill, an old friend in Scarsdale, New York. – *A lovely study:* 'Annabel Lee', late 1860s (Hunterian Art Gallery, University of Glasgow; YMSM 79), commissioned by William Graham, M.P. – *Two youths who own boats:* Walter and Henry Greaves. – *Mr Rose:* James Anderson Rose, Whistler's solicitor. – *[Portrait of Mrs Leyland:]* 'Symphony in Flesh Colour and Pink: Portrait of Mrs Frances Leyland', 1871–4 (Frick Collection, New York; YMSM 106). – *Mr Leylands Portrait:* 'Arrangement in Black: Portrait of F.R. Leyland', 1870–3 (Freer Gallery of Art, Washington; YMSM 97).
Source: *PWC Box 34; LC1/0116–9, 0109–10.*
14. *The Princess:* 'La Princesse du Pays de la Porcelaine', 1863–4 (Freer Gallery of Art, Washington; YMSM 50), bought by Leyland in 1872. – *Mrs Leylands little "Nocturne":* 'Nocturne in Blue and Silver', 1871/2 (Fogg Art Museum, Harvard University; YMSM 113).
Source: *PWC Box 6B; LC4/3194–6.*
15. Source: *Walters Art Gallery, Baltimore.*
16. During the summer of 1876 Whistler lived at 49 Prince's Gate, Frederick Leyland's London home, while he was working on 'Harmony in Blue and Gold: The Peacock Room' (Freer Gallery of Art; YMSM 178). The complete transformation of his dining room, together with the price of £2000 that Whistler asked, proved to be more than Leyland had expected, and during the following year the relationship between patron and artist became acrimonious. While still developing his designs for the room, Whistler held a press view, on 9 February 1877, and distributed this leaflet. Leyland died in 1892. The room was dismantled in 1903 and sold the following year to C.L. Freer, who had it re-erected in his Detroit home before it was bequeathed to the Freer Gallery of Art.
Source: *GUL Whistler 246; GM A. 1.*
17. *Portraits of Mr and Mrs Leyland:* see No. 13. – *Portrait of Miss Florence Leyland:* 'Portrait of Miss Florence Leyland', c. 1871–84 (Portland Art Museum, Maine; YMSM 107). – *Gas matters:* Whistler had been sent an account for work done by Messrs Verity in the Peacock Room, but not paid for by Leyland, which apparently included the gas bill.
Source: *GUL W70 (draft); British Library, Ashley 4601; GM A. 27.*

18. *Harmony in Grey and Gold:* 'Nocturne: Grey and Gold – Chelsea Snow', 1876 (Fogg Art Museum, Harvard University; YMSM 174). – *Picture of my mother:* see No. 13.

 Source: Part of an interview, 'Mr Whistler at Cheyne Walk', published in the World, *22 May 1878; GA, pp. 126–128; GM A. 2.*

19. *My house:* building of the White House, Tite Street, designed by E.W. Godwin, had gone ahead in the winter of 1877–78 before full approval of the designs had been obtained from the Metropolitan Board of Works. The Board required changes to the façade, including the addition of sculptured panels. – *Mr Böehm, Mr Leighton, Mr Watts:* Sir Joseph Edgar Boehm, 1834–1890, sculptor; Frederick Leighton, Lord Leighton, 1830–1896, painter; George Frederick Watts, 1817–1904, painter and sculptor.

 Source: GUL M331 (draft).

20. *The case:* when John Ruskin criticized his 'Nocturne in Black and Gold: The Falling Rocket' (Detroit Institute of Arts; YMSM 170) as 'flinging a pot of paint in the public's face', Whistler sued for libel. Although the Statement of Claim was delivered in November 1877, the case did not come to trial until 25 November 1878. Whistler won the case, but instead of the £1000 damages that he sought, he was awarded only a symbolical farthing. – *Keen, Tissot:* Charles Keene, 1823–1891, illustrator; James Tissot, 1836–1902, painter. – *Haweis:* Revd Hugh Haweis, a neighbour of Whistler's in Cheyne Walk, preached a sermon entitled 'Money and Morals' at St James's Hall on 18 February 1877.

 Source: GUL R128.

21. *Colvin:* Sidney Colvin, then Slade Professor of Fine Art at Cambridge. – *Peter Parley:* a pseudonym used by several writers of popular general histories, dictionaries and collections of travel tales.

 Source: GUL Whistler 266, 267; GA pp. 21–34; GM A. 3.

22. *Venice:* Whistler had arrived in Venice in September, with a commission to complete a set of twelve etchings by 20 December. – *Howell:* Charles Augustus Howell, entrepreneur in art. – *Brown:* Ernest Brown, of the Fine Art Society.

 Source: GUL LB3/8.

23. Whistler's mother had left London in 1875 on account of her health and spent her last years in Hastings. – *Black Gang Chyne:* on the Isle of Wight, where Whistler had spent a summer holiday with his mother and brother in 1848. – *Nellie:* Helen Whistler, whom his brother William had married in 1877. – *Annie's future:* Annie Haden married Hon. Charles Thynne on 8 June 1880.

 Source: Original not traced; GUL W559 (copy).

24. *Source: M. Menpes,* Whistler as I knew him, *1904, pp. 22–3.*

25. *Enemies:* Seymour Haden, with Alphonse Legros, had voiced his

concern that three etchings of Venice on exhibition at the Painter–Etchers' Society (of which Haden was President) were not by Frank Duveneck, as stated, but by Whistler, who was therefore suspected of breaching his contract with the Fine Art Society. Whistler published the ensuing correspondence as *The Piker Papers*, 1881 (GM A. 4).

Source: GUL C89.

26. *Source: GUL W694.*

27. The directions are for the decoration of a room in his brother's house at 28 Wimpole Street.

Source: GUL W689.

28. Show: *'Etchings and Drypoints. Venice. Second Series'*, The Fine Art Society, opened on 17 February; all aspects of the decoration were designed by Whistler, even the livery of the attendant, who was dubbed 'the poached egg.' – *Lady Archie:* Lady Archibald Campbell, an important society figure who supported Whistler and sat for several portraits in the early 1880s. – *Prince:* the Prince of Wales. – *Catalogue:* in the catalogue, Whistler included quotations from the critics beneath the entry for each work. – *"Arry":* Harry Quilter, art critic of the *Times*, nicknamed 'Arry by Whistler after a popular music-hall song of that name. – *Hammerton:* Philip Gilbert Hamerton, art critic and writer. – *Eldoni:* H.R. Eldon, a friend of Whistler's from the mid 1870s.

Source: Pierpont Morgan Library, Heinemann Collection, MS 244.

29. *St Ives:* in early 1884 Whistler produced a number of small oils and watercolours in St Ives, where he was accompanied by Mortimer Menpes and Walter Sickert. – *Jack Chapman:* Alfred Chapman, an early family friend in Liverpool, who owned a number of works by Whistler (see Nos 45, 59, 71).

Source: Original not traced; GUL W698, LB 13/37 (copies).

30. This statement first appeared under the title 'L'Envoie'. It was included in the catalogue of Whistler's exhibition *"Notes" – "Harmonies" – "Nocturnes"* at the Dowdeswell Gallery in May 1884. When published subsequently in the *Gentle Art*, it was given the title 'Propositions – No. 2.'

Source: GA pp. 115–116; GM A. 7.

31. *Article:* 'Mr Whistler and his Artifices', by a 'Philistine', in *The Artist and Journal of Home Culture*, 1 July 1884 (GM L. 6f). The article stated, for instance, that Whistler's 'Scherzo in Blue: The Blue Girl' (YMSM 226) suffered from eczema. The draft of Dowdeswell's ponderous response, dated 17 July 1884, covers four pages (LC7/191-4).

Source: Library of Congress, Rosenwald Collection; LC7/121–22.

32. Whistler gave his *Ten O'Clock* lecture in the Prince's Hall, Piccadilly, choosing that hour of the evening in order to allow his audience to dine first. He repeated it later in the year at Cambridge (24 March) and Oxford (20 April). Twenty-five copies of the lecture were privately

printed in 1885, but although a revised proof was prepared in 1886, the text was not published until 1888. The original manuscript differs from the published text chiefly in its indication of how the lecture was delivered: the published text has longer paragraphs. The text of the lecture is almost unchanged from the manuscript to the publication. – *Hammersmith:* the Arts and Crafts colony established by William Morris at Kelmscott House, Hammersmith. – *Paul Potter:* Dutch painter, who painted a bull life-size, in 1647; it is now in The Hague. – *Murillo:* Spanish painter, whose 'Immaculate Conception' was bought for the Louvre for a record price in 1852. – *Costume is not dress:* this passage is directed against Oscar Wilde and his proposed reform of dress. – *Hokusai:* Japanese artist, 1760–1849. – *Fusihama:* Mount Fuji.

Source: *Original MS, GUL W780; GA, pp. 131–159; GM A. 8.*

33. Printed leaflet, presumably prepared by Whistler as publicity for the intended publication of his lecture in 1885 (see No. 32). The design of the leaflet is characteristically novel: the text is printed on three sheets of paper folded horizontally to form oblong pages with the sheets inserted loose one inside the other.

Source: *PWC Box 201, the only copy known.*

34. The exhibition *"Notes" – "Harmonies" – "Nocturnes." Second Series* was held at the Dowdeswell Gallery in May 1886. The gallery was decorated in brown and gold – brown wallpaper, gold wainscot and panelling, hangings of brown and yellow velvet and Indian silk, and yellow awning, or velarium. Whistler patented his design for the velarium, which was suspended from the ceiling, diffusing the overhead light to give an even distribution over the works displayed.

Source: *Library of Congress, Rosenwald Collection; LC7/90, 91.*

35. Published as an insert in the portfolio of *A Set of Twenty-Six Etchings by Whistler*, London, Dowdeswell and Dowdeswell, 1886. – *Remarque:* a small sketch in the margin of a print of an etching made to help with corrections from one state to the next or to test the biting of the mordant. Remarques should be removed before the final edition of the plate but are sometimes found even in a completed work.

Source: *GA pp. 76–77; GM A. 19.*

36. Published in an article by Malcolm C. Salaman, 'In Whistler's Studio', in *Court and Society Review*, No. 104, Vol. 3, 1 July 1886.

Source: *GA pp. 177–179; GM A. 20.*

37. Published in *Truth*, 2 September 1886. – *Gentleman of the Academy:* John Rogers Herbert, 1810–1890, had been attacked in a letter in the *Saturday Review* and defended by Labouchère in *Truth*, 19 August 1886.

Source: *GA pp. 169–172; GM B. 36; original (June 1994) with Messrs Sims Reed, London; drafts in the Hunterian Art Gallery, Sketchbook 9.*

38. *Memorial:* Whistler had been elected President of the Society of British Artists in 1886. For Queen Victoria's Jubilee the following year, he wrote and designed an address to the Queen, in which he sought Royal patronage for the Society, and this was granted. In his official capacity as President of the now Royal Society of British Artists, Whistler was invited to attend the Naval Review at Spithead in July and produced 12 small etchings.

Source: *GUL V68 (final draft).*

39. *Propositions:* these proposals were part of Whistler's campaign to reform the Society. A further introduction was to ask foreign artists to exhibit with the Society: at Whistler's invitation, Monet had four works in the Society's winter exhibition.

Source: *GUL R210 (printed circular).*

40. *Tower House:* Whistler had a studio and rooms in the Tower House, 28 (now 46) Tite Street, from 1888 to 1890. The house was one of the last buildings designed by E.W. Godwin. – *Theobald:* the barrister Henry S. Theobald bought all the works remaining unsold at the end of Whistler's 1886 Dowdeswell exhibition; he owned twelve paintings by Whistler in addition to drawings and pastels. – *Munich:* Whistler was awarded a gold medal, second class, at the Munich International Exhibition, 1888. – The letter is in the handwriting of Whistler's son, Charles Hanson (see No. 60), but is signed by Whistler.

Source: *British Museum, Department of Prints and Drawings, Alexander volume, 59-11-14-6.*

41. *The adverse vote:* members of the RSBA opposed to Whistler had just succeeded in securing the election of their candidate, Wyke Bayliss, as President, to replace him. – *Stevens:* Alfred Stevens, Belgian artist.

Source: *GUL PC 10/4–5; GA pp 205–210; GM J. 125.*

42. *Amsterdam:* Whistler spent August and September in Amsterdam with his wife. The letter is written on the hotel's headed note-paper. – *Renaissance lot:* the etchings produced on his honeymoon journey through the Loire Valley in 1888. – *Let me hear:* the Fine Art Society did not take up the offer.

Source: *GUL F164 (draft); PWC Box 5; LC4/3483–6.*

43. Source: *GUL PC 6/62.*

44. *Chinckie:* a nickname for Beatrix, or 'Trixie', whom he also called Wam and Luck. – *Stevens:* Alfred Stevens, Belgian painter. – *Chase:* William Merritt Chase, 1849–1919, American painter. – *Rosies and Nellies:* Rose Pettigrew and Helen Whistler, who had been sitting to Whistler. – *Bunnie:* nickname for Beatrix's sister, Ethel Philip. – *Exhibition:* Société Nationale des Beaux-Arts, at the Champ de Mars. – *Dannat:* William Turner Dannat, 1853–1929, American painter. – *Valparaiso:* 'Crepuscule in Flesh Colour and Green: Valparaiso', 1866

(Tate Gallery; YMSM 37). – *Sargent's "Boy"*: John Singer Sargent, 'Portrait of a Boy, Homer Saint-Gaudens and his mother', 1890 (Museum of Art, Carnegie Institute, Pittsburgh). – *Boldini:* Jean Boldini, 1842–1931. – *Gandarini:* Antonio de la Gandara, 1862–1917, French painter. – *Rosa Corder:* 'Arrangement in Brown and Black: Portrait of Miss Rosa Corder', 1878 (Frick Collection, New York; YMSM 203). *Labby:* Henry Labouchère (see No. 37).

 Source: GUL W584.

45. *One of my own works:* 'Pink and Grey: Three Figures', 1879 (Tate Gallery; YMSM 89), had been sent to Dowdeswell for sale by Alfred Chapman of Liverpool; for Chapman, see also Nos 29, 59, 71.

 Source: Original not traced; GUL P30 (copy); GA pp. 291–2; GM B. 74.

46. *Liverpool:* Whistler had accepted an invitation to be on the Hanging Committee of the Walker Art Gallery's Autumn Exhibition. In one room, known subsequently as the 'Whistler Room', he was able to follow his own principles of design, hanging works in their own space, and with a velarium (see note to No. 34). In the other rooms the number of pictures required the whole surface of the walls to be covered in the traditional Victorian manner. – *Fildes:* Luke Fildes, 'The Doctor' (Tate Gallery), had been commissioned by Henry Tate, for £3000, for his new gallery on the site of Millbank Prison.

 Source: GUL W589.

47. *[Paris]:* the printed address on the note-paper is 21 Cheyne Walk, Chelsea, the Whistlers' London address from 1890 to 1892. Whistler took a supply of headed notepaper on which to write from Paris. – *Montesquiou:* Comte Robert de Montesquiou–Fezensac had commissioned his portrait from Whistler in February 1891; he was to give more than 100 sittings before the painting was exhibited in 1894, 'Arrangement in Black and Gold: Comte Robert de Montesquiou–Fezensac' (Frick Collection, New York; YMSM 398). – *Drouet:* Charles Drouet, French sculptor. – *Grefulhe:* Elisabeth, Comtesse Greffulhe. – *Fêted:* the French Government had just bought Whistler's painting of his mother (see No. 13) for the Musée du Luxembourg. – *Heinemann:* William Heinemann, the publisher (see No. 66). – *Webb:* Whistler's solicitor.

 Source: GUL W599.

48. *33 Rue de Tournon:* during much of 1892 Whistler lived at the Hôtel Foyot, at this address, while his house at 110 Rue du Bac was being prepared. – *Album:* a portfolio of twenty-four photographs of works included in his 1892 exhibition in London, *Nocturnes, Marines and Chevalet Pieces,* at the Goupil Gallery. – *Exhibition:* the exhibition had opened on 19 March and had now closed.

 Source: PWC Box 2; LC2/1434–5.

49. Richards's address was 4 Berners Street, London. – *Nocturne of Cremorne:* 'Nocturne: Blue and Silver – Cremorne Lights' (Tate Gallery; YMSM 115). – *Two of the pictures:* 'The Last of Old Westminster', 1862 (Museum of Fine Arts, Boston; YMSM 39), and 'Variations in Flesh Colour and Green: The Balcony', 1865 (Freer Gallery of Art; YMSM 56, and see also No. 9). – *The little Thames picture:* 'Battersea Reach', 1863 (Corcoran Gallery of Art, Washington; YMSM 45). – *The sea piece:* 'Harmony in Blue and Silver: Trouville', 1865 (Isabella Stewart Gardner Museum, Boston; YMSM 64).

 Source: PWC Box 2; LC 2/1202–4.

50. *Brodequin Jaune:* 'Arrangement in Black: La Dame au Brodequin Jaune – Portrait of Lady Archibald Campbell' (Philadelphia Museum of Art; YMSM 242). – *Furred Jacket:* 'Arrangement in Black and Brown: the Fur Jacket' (Worcester Art Museum Massachussetts; YMSM 181). The sitter, here described as an obscure nobody, was Maud Franklin, Whistler's model and mistress from the early or mid 1870s until 1888. – *Princess.* 'La Princesse du Pays de la Porcelaine', 1863–64 (Freer Gallery of Art, Washington; YMSM 50; and see No. 14).

 Source: FGA 201; GUL LB4/40 (copy).

51. *John:* Dr John Cavafy, son of G.J. Cavafy. – *The present:* 'Harmony in Blue and Silver: Trouville', 1865 (Isabella Stewart Gardner Museum, Boston; YMSM 64), given by Whistler to G.J. Cavafy. – The other paintings referred to are: 'The Last of Old Westminster', 1862 (Museum of Fine Arts, Boston; YMSM 39); 'Variations in Flesh Colour and Green: The Balcony', 1865 (Freer Gallery of Art; YMSM 56, and see Nos 9, 49); 'The Coast of Brittany', 1861 (Wadsworth Athenaeum, Hartford, Connecticut; YMSM 37); 'Nocturne: Blue and Silver – Battersea Reach', 1872/8 (Isabella Stewart Gardner Museum, Boston; YMSM 152); 'Green and Grey: The Oyster Smacks, Evening', (YMSM 99); 'Nocturne in Blue and Gold: Vaplaraiso Bay', 1866 (Freer Gallery of Art; YMSM 76); 'Nocturne: Blue and Gold – Southampton Water', 1871/2 (Art Institute of Chicago; YMSM 117). – *Aleco:* Alexander Ionides.

 Source: GUL W712.

52. *110 Rue du Bac:* Whistler's home in Paris from 1892 to 1901. – *Portfolio:* The portfolio of photographs, *Nocturnes, Marines and Chevalet Pieces* (see No. 48).

 Source: PWC Box 3; LC2/1512–4.

53. *Source: GUL LB9/20.*

54. *Blue and Violet:* 'Violet and Blue – Among the Rollers', 1893 (YMSM 413).

 Source: Facsimile of original in A.E. Gallatin, Whistler's Art Dicta, 1904.

55. *Gleeson White:* editor of *The Studio.*

 Source: FGA 118.1.

56. *Portrait:* a lithograph of the portrait of Montesquiou (see No. 47). *Source: FGA 125.*

57. *Badoureau:* a print of his photograph of the Montesquiou portrait (see No. 47) now in GUL has the date of 15 June (PH4/45). – *Cliché:* i.e. a negative.
Source: PWC Box 3; LC 2/1589–92.

58. *Two forges:* 'The Forge: Passage du Dragon', and 'The Smith: Passage du Dragon' (see Thomas Way, *Mr Whistler's Lithographs. The Catalogue,* London, 1905, Nos 72, 73). The other lithographs referred to are 'La Belle Jardinière' (Way 63), 'La Jolie New Yorkaise' (Way 61), 'La Belle Dame Paresseuse' (Way 62), 'Rue Furstenburg' (Way 59), and 'The Duet' (Way 64, 65).
Source: PWC Box 3; LC2/1310–11.

59. *Chapman:* Alfred Chapman of Liverpool (see Nos 29, 45, 71). – *Pope:* Alfred A. Pope, of Cleveland, owned five Whistler paintings (see No. 71). – *The Potter picture:* 'Blue Wave, Biarritz', 1862 (Hill-Stead Museum, Farmington, Connecticut; YMSM 41), was sold for £1000 by Gerald Potter in 1894 and was subsequently bought by Pope. – *Little White Girl:* 'Symphony in White No. 2: The Little White Girl', 1864 (Tate Gallery; YMSM 52), sold by Gerald Potter to Arthur Studd in 1893 for £1400. – *Sea and Rain:* 'Sea and Rain', 1865 (Museum of Art, University of Michigan, Ann Arbor; YMSM 65). – *Old Battersea Bridge:* 'Brown and Silver, Old Battersea Bridge' (Addison Gallery of American Art, Andover, Massachussetts; YMSM 33), sold by Alexander Ionides, perhaps to H. Thorburn. – *Tanagra:* 'Tanagra', 1869 (Randolph-Macon Women's College, Lynchburg, Virginia; YMSM 92).
Source: PWC Box 3; LC2/1669–71.

60. *Lyme Regis:* Whistler had been staying in Lyme with his wife since mid September. – *Devonshire cottages:* 'Green and Silver: The Devonshire Cottages', 1884 (Freer Gallery of Art; YMSM 266). – *Mr Hanson:* Charles James Whistler Hanson, 1870–1935, son of Whistler and Louisa Hanson; he acted as Whistler's secretary for a time, chiefly in 1888–90 (see No. 40), and was married in 1896.
Source: GUL W728.

61. *Lyme Regis:* when Beatrix returned to London at the end of October, Whistler stayed on in Lyme to complete work on a number of etchings, lithographs and paintings. – *Woakes:* 'Portrait of Miss Lilian Woakes', 1890/91 (Phillips Memorial Gallery, Washington; YMSM 393). – *The Grinder:* one of Whistler's terms for himself. – *Duret:* 'Arrangement en couleur chair et noir: Portrait de Théodore Duret', 1883/4 (Metropolitan Museum of Art, New York; YMSM 252). – *Sarasate:* 'Arrangement in Black: Portrait of Señor Pablo de Sarasate', 1884 (Museum

of Art, Carnegie Institute, Pittsburgh; YMSM 315).
 Source: GUL W637.

62. *Portrait:* 'Rose et vert: l'Iris – Portrait of Miss Kinsella', (Terra Museum of American Art, Chicago; YMSM 420); although begun in 1894, the portrait remained unfinished in Whistler's studio at his death in 1903. – *Sargent:* John Singer Sargent.
 Source: Facsimile of original in Parkin Gallery exhibition catalogue, Four for Whistler, 1972.

63. *Blue and Gold Girl:* 'Harmony in Blue and Gold: The Little Blue Girl' (Freer Gallery of Art; YMSM 421), bought by Freer in November 1894 but not received by him until after Whistler's death. – *Bird:* Freer wrote to Beatrix Whistler from Calcutta in March 1895 to say that he was sending a pair of songbirds to Paris for her (GUL F443).
 Source: GUL F445 (draft); FGA 38.

64. *Portrait:* 'Brown and Gold: Portrait of Lady Eden', (Hunterian Art Gallery, University of Glasgow; YMSM 408). Sir William Eden commissioned a small portrait of his wife and, when it was nearly finished, in February 1894, he sent Whistler a cheque for 100 guineas in payment. In November Eden brought a civil action against Whistler in Paris for delivery of the picture, and in March 1895 Whistler was ordered by the court to hand it over. The result of Whistler's appeal against the order was delivered on 2 December 1897; in a final appeal in April 1900, Eden was ordered to pay all costs. Whistler published his account of his dealings with Sir William Eden (see Nos 65, 70) as *Eden v. Whistler. The Baronet and the Butterfly: a Valentine with a Verdict*, Paris, 1899 (GM A. 24).
 Source: GUL Whistler 206–218, 292; GM A. 24.

65. *Aunt Alicia:* Alicia McNeill, his mother's sister; her death in 1863 is reported in No. 7.
 Source: Original not traced; GUL H35; LB 13/82; LB 15/70 (all copies).

66. *The Financier:* Heinemann's brother Edmund. – *Kalgourlies:* Australian gold-mining shares, part of Whistler's investments. – *Phryne:* 'Purple and Gold: Phryne the Superb! – Builder of Temples' (Freer Gallery of Art; YMSM 490). – *MacMonnies:* Frederick MacMonnies, American sculptor, an associate of Whistler's in the Académie Carmen.
 Source: Original not traced; PWC 10/849–50 (copy).

67. In February 1898 Whistler became chairman of the executive council of the International Society of Sculptors, Painters and Gravers, and was elected President in April. He controlled the Society from Paris.
 Source: GUL PC 22/143.

68. The Society's first exhibition opened on 16 May at the Skating Rink, Knightsbridge, and included works by many Continental and American

artists. – *Velum:* the velarium (see note to No. 34).

 Source: Tate Gallery Archives, 72–45/262.

69. Lavery was Vice-President of the International Society. – *H.R.H.:* the Prince of Wales. – *Shannon:* James J. Shannon, 1862–1923.

 Source: Tate Gallery Archives, 72–45/263.

70. *The Baronets covers:* Whistler's published account of the Eden trial (see Nos 64, 65).

 Source: Harry Ransom Humanities Research Center, University of Texas at Austin.

71. Whistler had taken premises at 2 Hinde Street, Manchester Square, in April 1897, for the company that he established to deal exclusively in his work; Mrs Christine Anderson was its part-time secretary. – *Chapman:* Alfred Chapman of Liverpool (see Nos 29, 45, 59). – *Pope:* Alfred A. Pope, of Cleveland (see No. 59). – *"Bognor":* 'Nocturne: Blue and Silver – Bognor', 1871/76 (Freer Gallery of Art; YMSM 100).

 Source: GUL C292.

72. Inez Bate was one of his first students at the Académie Carmen and became its *massière*, or superintendent. She married Clifford Addams, another student, in 1900.

 Source: GUL A19.

73. *"Cigale":* 'Rose and Brown: La Cigale', 1899 (Freer Gallery of Art; YMSM 495). – *Lady of Soho:* 'Rose and Gold: The Little Lady Sophie of Soho', 1899 (Freer Gallery of Art; YMSM 504). – *The International:* the Second Exhibition of the International Society of Sculptors, Painters and Gravers, Knightsbridge, May – July 1899.

 Source: FGA 40.

74. Increasingly ill during the autumn of 1900, Whistler had been ordered to go abroad. He left London in December for Gibraltar, Algiers, Tangiers and Marseille, and then stayed in Ajaccio, Corsica, until the end of April 1901. Since Whistler was not in Paris, students drifted away from the Académie Carmen, and Whistler closed it down. – *Madame la Massière:* Inez Addams (née Bate, see No. 72).

 Source: GUL A5–6.

75. The doctorate awarded to Whistler by the University of Glasgow was the only academic honour that he received. The catalogue of the Memorial Exhibition in 1905 listed his principal honours: 'Officer of the Legion of Honour; Member of the Société Nationale des Beaux-Arts; Hon. Member of the Royal Academy of St Luke, Rome; Commander of the Order of the Crown of Italy; Hon. Member of Royal Academy of Bavaria; Chevalier of the Order of St Michael; Hon. Member of the Royal Academy of Dresden; Hon. Member of the Royal Scottish Academy; LL.D. of Glasgow University.'

 Source: GUL G58.